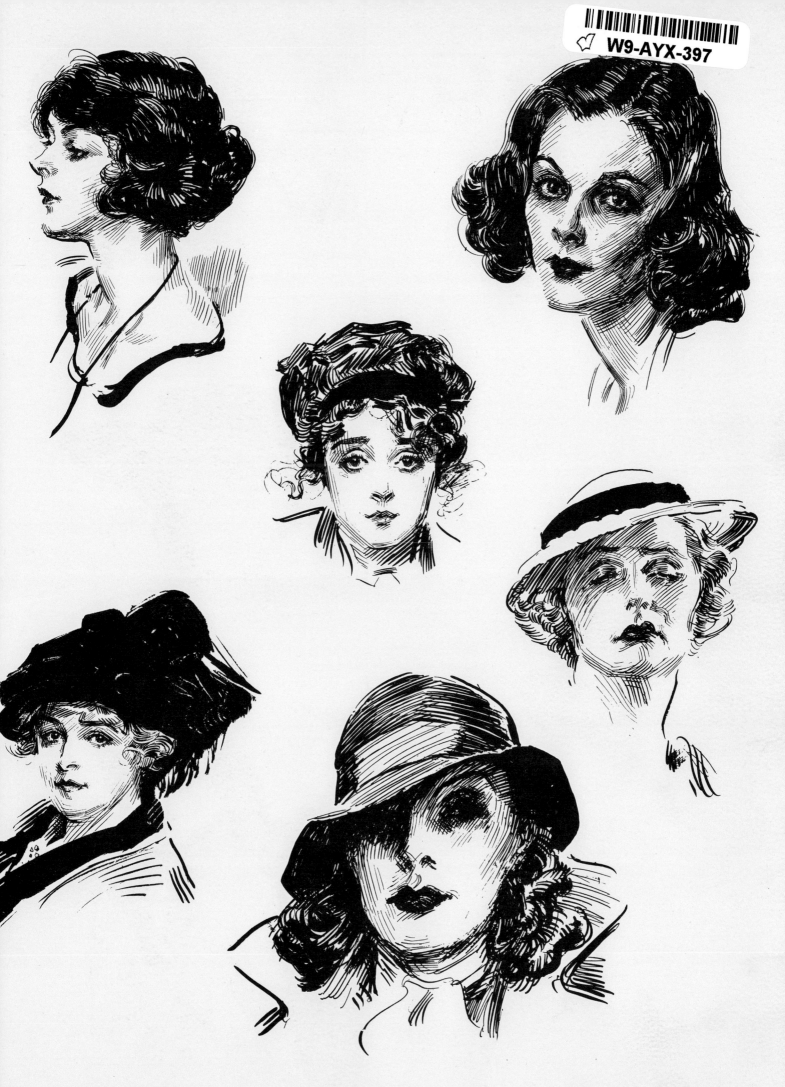

JAMES MONTGOMERY FLAGG

WATSON-GUPTILL
PUBLICATIONS

NEW YORK

JAMES MONTG

OMERY FLAGG

BY SUSAN E. MEYER

Copyright © 1974 by Watson-Guptill Publications

First published 1974 in New York by Watson-Guptill Publications,
a division of Billboard Publications, Inc.,
One Astor Plaza, New York, N.Y. 10036

Manufactured in U.S.A.

Library of Congress Cataloging in Publication Data
Meyer, Susan E
 James Montgomery Flagg.
 1. Flagg, James Montgomery, 1877–1960.
NC975.5.F55M48 741.9'73 74–9628
ISBN 0-8230-1835-0

First Printing, 1974

For Monty's dear and loyal friend
Everett Raymond Kinstler,
who made this book possible.

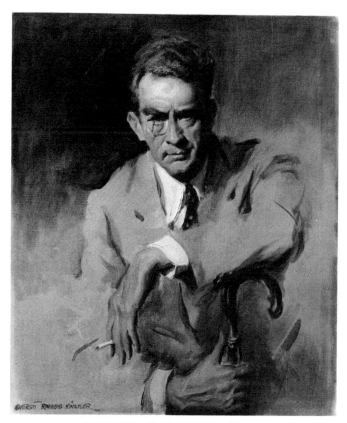

Portrait of Flagg by Everett Raymond Kinstler.

Credits for Display Pages

CONTENTS

ACKNOWLEDGMENTS

Everett Raymond Kinstler and I became friends during our collaboration on his book, *Painting Portraits*. With the feeling of fraternity only an artist can have for another artist, he referred frequently to his good friend Monty in the course of our work together. I was privileged to examine the Flagg originals in his possession, an experience I found thrilling: not only was the work itself dazzling, but I learned a great deal from Kinstler's enthusiastic and perceptive evaluation. When Watson-Guptill invited me to do a book on Flagg, I knew I would succeed only with the support and assistance of Kinstler. This he gave freely, and with good will, an expression of his love for both Flagg and me. I am deeply indebted to him for both the quantity of time and the quality of help he gave me throughout the project.

Although Flagg's output was enormous, the job of unearthing these near-forgotten illustrations and paintings was not an easy one. Ellen Zeifer was indispensable to me as picture researcher, performing the thankless job of locating posters, paintings, and illustrations buried in the archives of collections throughout the country.

Berry-Hill Galleries in New York City opened their doors to my invasion of photographers. As we tramped through their elegant quarters, we were greeted with good cheer. Their cooperation is gratefully acknowledged.

My cordial thanks go out to several other individuals who—with their assistance and encouragement—made the project better and more fun:

Georgina Challis, my assistant at *American Artist*, kept tabs on the material as it arrived and she typed the manuscript cheerfully; my editors at Watson-Guptill, Donald Holden and Sarah Bodine, never failed in their efforts to suggest alternatives when problems arose; Jules Perel, General Manager of Watson-Guptill, encouraged me to do the project from the outset, and I'm grateful for his persuasive abilities when I hesitated; Georgina D'Angelo was an expert library researcher, saving me hours of tracking down newspaper and magazine articles frequently referred to in my writing of the text; photographers eeva-inkeri of New York City (Eeva Manninen and Elvia Inkeri), performed a cumbersome job with good humor; the Lotos and Lambs Clubs returned Flagg's loyalty by extending their courtesy to me, leading me through their collections; Faith Flagg supported me in my efforts to depict her father according to my own interpretations; my own family gave me encouragement in the project during times that were difficult for them. And my dear friend Bobbie was always there to help me reassemble the pieces.

James Montgomery Flagg was an ornery critter and I'm sure he would heartily approve of my devoting one section of this page to people I can *not* acknowledge. This special section, therefore, is devoted exclusively to The Metropolitan Museum of Art, who did *not* help in the creation of this important book. The books succeeds, I think, in spite of them.

JAMES
MONTGOMERY
FLAGG:

A PORTRAIT
OF AMERICA

A PORTRAIT OF AMERICA

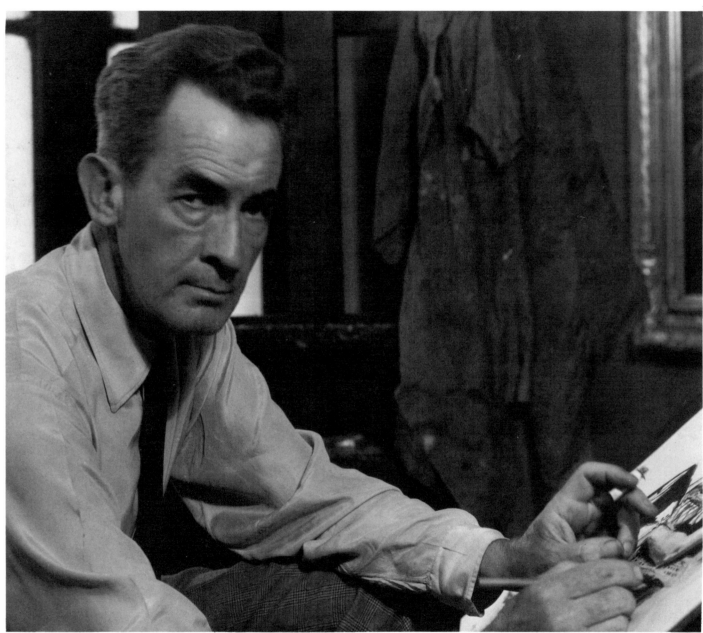

This portrait photograph by Percy Rainford was Flagg's favorite, perhaps because it conveyed Flagg's intensity without suggesting that he was humorless.

James Montgomery Flagg was not only an artist of his time, but a participant in the life he depicted. His life and work form a composite portrait of America. He captured the spirit and personality of the first half of this century in his illustrations, in his writings, in his films, and in the way he lived. He was not only America's most popular illustrator, but he was also its most conspicuous bohemian.

The world Flagg painted and drew, the world in which he lived, was the urban America of the early 20th century. Unlike many of his contemporaries, whose illustrations appeared in several of the same publications—such as N.C. Wyeth, J.C. Leyendecker, Harvey Dunn, Norman Rockwell, and Maxfield Parrish—James Montgomery Flagg was an urban illustrator. He cared not a hoot for designs that pictured a world of dream-like fantasy. He was bored by rural America, by small-town sweetness, and he never developed a taste for the dramatic American landscape of the West. Whereas some of his contemporaries relished their life in the countryside—in Pennsylvania or in New Hampshire, for example —Flagg never lived far from the city, the whirlwind movement of a growing urban culture. He traveled in the orbit of "the well-knowns," the celebrities in the theatrical, literary, artistic, and political milieu of a country struggling to establish its identity. When the theatre was in full swing in New York City, Flagg was drawing and painting the portraits of the notable performers and was writing plays himself. When Hollywood films burst forth, there was Flagg, portraying the new stars. (There was Flagg, in fact, writing 24 of his own films!) When war erupted, Flagg was illustrating posters for the military. The movement of America was recorded by Flagg in his countless illustrations that appeared in every prominent magazine in the country.

Flagg's satirical illustrations and writings—his continuing jibes at the institutions America holds sacred—do not make him less of an American institution himself. Flagg did not hope to achieve immortality—he was always indifferent to what the future held for him—but he did want to be a personality vital to the present. And he *was* headline copy for years. As time moved on, the headlines shifted to a younger generation of cultural heroes. Time can be cruel to a man so intensely part of a specific period, an artist who never attempted to transcend the present, and unearthing Flagg from the past is no easy task, so quickly has the country moved on to newer things.

It would not be in keeping with Flagg's character if this book were a historical treatise on his achievements. He had a disdain for being "whitewashed." Any accurate account of Flagg's life should, by necessity, include his incorrigible qualities as well. Keenly aware that he was an ornery fellow (*enjoying* that reputation in fact!), Flagg would quickly repudiate any suggestion that he was "nice," a term he deplored. Although he did not lack self-esteem, he held no pretensions about the permanence of his contributions, another reason, perhaps, that history has been unkind to him.

This attempt to synthesize a career as prolific and as multi-faceted as his, striving to re-create the complex and brilliant nature of the man, has been simplified somewhat by referring to his own writings: *Roses and Buckshot* (G.P. Putnam's, 1946); *Boulevards All the Way—Maybe!* (George H. Doran, 1924); *The Mystery of the Hated Man* (George H. Doran, 1916) and *I Should Say So* (George H. Doran, 1914). The details, dates, and anecdotes given here are only as accurate as Flagg's own recollection, therefore. He still appears to be the best authority on the subject.

THE EARLY YEARS

Flagg sold his first illustration, at the age of 12, to St. Nicholas for $10. The subject: illustrated Latin axioms. Courtesy New York Public Library.

James Montgomery Flagg was an impatient creature, even at birth. While his mother was visiting her parents in Pelham Manor, New York, Jimmy rushed into the scene two months ahead of schedule and was born on June 18, 1877. This impertinence characterized his activities from then on, and he claimed that he was *born* a rebel.

Flagg's intimacy with New York City dates from his boyhood; he grew up in the cosmopolitan atmosphere of a city enjoying its greatest period. His father, Elisha, and his mother, Anna, lived at various times in Brooklyn and Manhattan and he recalls his childhood simply: "all happy."

Even as a child, Flagg was blunt in stating his preferences. He adored three members of his family: his paternal grandmother whom he described as "the spirit of the family;" his uncle Francis who was Vice-President of American Express and utterly devoted to his nephew; and his father, "the last Puritan." Although he observed that his mother was a "good" woman, he had no particular affection for her, and was intolerant of what he termed "the bilge written about mothers." Flagg never lost his contempt for unquestioning adherence to traditional family values: "Loyalty to family as such doesn't seem to me pertinent. Family isn't sacrosanct to me. To hell with the snobbery of inheritance."

Flagg claims that he began to draw at the age of two, though "not very well." In need of a brush when he was eight years old, the enterprising youngster used a lock of his hair tied to a stick and painted for an entire summer with the primitive tool. These early efforts show that the boy already possessed an enormous talent for draftmanship.

By 1885 the Flaggs were living on Park Avenue near 81st Street in Manhattan. When he was 12, Jimmy entered Dr. Chapin's School, remaining there for two years, and then continued at Horace Mann School for another two years, before he decided to terminate his formal education entirely. He felt free to reach this conclusion because he had already become financially independent of his family through the sale of his illustrations.

Flagg's entry into the publishing world had begun in 1889 when he was 12 years old, the year in which he sold his first illustration to *St. Nicholas* for $10.00. *Century Magazine*, 25 years later, gave its account of this historic sale: "The year 1889 beheld the artist J.M. Flagg about to enter the art world and his

teens. In March of that year, on a Saturday afternoon, Jimmy Flagg, armed only with a few pencil sketches he had made in Central Park, overcame a boy's awe of the editorial Olympians and presented himself to *St. Nicholas* and asked to see one of the editors. The writer of these lines was told to receive the young caller, and after a few words set himself to examine the boy's drawings. There was something in those easy, unstudied lines that breathed ability and capacity so great that words of praise and encouragement seemed only a duty. They were strong and sincere words and, as Mr. Flagg said recently, sent him away 'walking on air'." ("Current Comment," *Century Magazine*, June, 1915.)

When he was 14, Flagg sold his first illustration to the humorous magazine *Life* (for $8.00) and became a regular member of the staff, an association that was to last for 20 years. He worked rapidly, even in his teens, selling about five drawings a week. By the time Flagg was 16 he was also firmly established on the staff of *Life*'s rival magazine, *Judge*.

These were exciting days for young Flagg. Bored with children of his own age, he enjoyed the company of the distinguished directors of the magazines he most admired: Tudor Jenks of *St. Nicholas*; John Ames Mitchell and James S. Metcalf, the celebrated men from *Life*; and Grant Hamilton who ran *Judge*, all of whom contributed greatly to Flagg's education as an illustrator. He was thrilled to be given the opportunity to examine the original illustrations by some of the artists whose work he respected so greatly: A.B. Frost, Abbey, Kemble, Blum, Taber, Rinehart, Smedly, Pyle, Birch, and Herford.

When he was 16, Flagg submitted his drawings for admission to the National Academy School and was turned down, so he went to study at the Art Students League. If Flagg developed remarkably as an artist, he was not inclined to attribute this to his formal art education. Years later, in a letter to the *New York Herald Tribune* he wrote: "There are no art teachers. Art cannot be taught. Artists are born that way. They educate themselves, or else they do not become educated . . . I happen to have been born an artist. Ask anyone who doesn't know. I wasted six years of my young life in art schools. As far as any benefit accruing to me from them—I was working on the outside all the time, anyway. Nothing but total disability or death could have stopped me. I had to be an artist—I was born that way . . . You can't breed an

artist. You can only breed mediocrity." (*New York Herald Tribune*, September 9, 1938.)

In spite of his resistance to the classroom itself, he formed outstanding friendships with some of his classmates at the Art Students League: John Wolcott Adams and Walter Appleton Clark (both of whom were also to become prominent illustrators) and Arthur Mario Noakes-Acton, an Englishman.

Four years later, fed up with what he called "drawing with stump and 'sauce crayon'," Flagg went to England to study, traveling in the company of Richmond Kimbrough, a friend from the League. Flagg and Kimbrough took lodgings in Bushey, Hertsfordshire, where they were officially enrolled in the class of Hubert Herkomer's school, but actually attended the school only sporadically. Frequent trips into London landed Flagg a number of illustration assignments and even the contract for the publication of his first book, *Yankee Girls Abroad*.

Flagg remained in England only a year, returning to the States in 1899, shortly after the untimely death of his companion Kimbrough.

Immediately upon his return, Flagg rushed to St. Louis to marry a girl he had met two years before in Maine: Nellie McCormick. Enthralled with her beauty, Flagg was indifferent to the discrepancy in their ages (she was 11 years his senior), and to the discrepancy in their social standing: "Here was the beautiful woman who had turned down a number of rich suitors to marry a poor but promising artist who was madly in love with her . . . Nellie was a St. Louis socialite and knew all the richest people in all the big cities; up to then a realm of society entirely beyond my knowledge. In the early days of our marriage when I was short of cash, she put her allowance at my disposal in an utterly generous and unselfish way. Be it recorded, however, for my pride's sake that this situation didn't last too long. In fact there is no period in my life when I could have been classified as an 'indigent artist'." (Be it further recorded that ten years later Flagg's annual earnings approached the figure of $75,000!)

Shortly after their wedding, the Flaggs returned to Europe (Elisha Flagg was then manager of the Lon-

At the time Flagg made this pencil sketch he was a student at the Herkomer School in Bushey, England, 1898. Courtesy Everett Raymond Kinstler.

John Wolcott Adams, also an illustrator, was Flagg's pal at the Art Students League. Although Flagg described him as "a snob," he also said, "it looked good on him." Photo eeva-inkeri. Courtesy Berry-Hill Galleries, New York City.

don office for American Express), where J. M. Flagg completed some illustration assignments and then went to study painting in Paris under Victor Marec. Despising what he regarded as the phoniness of the Left Bank, Flagg preferred living in the Etoile and was soon accepting a number of portrait commissions. Flagg's oil painting of Victor Marec was selected for exhibit in the Paris Salon of 1900 at the World's Fair, an achievement most artists would have regarded with solemn pride. In true character, Flagg was utterly unimpressed with the entire affair, and returned to America. "I found shortly that as a painter I smelled to the stratosphere."

The Flaggs were not yet willing to plant their roots, preferring instead to travel for the next four years, an experience Flagg regarded as crucial to his education. They passed these years in California, Florida, Virginia, and spent the summers in Europe.

Finally, in 1904 the time had come to roost: Flagg leased a studio apartment in New York City and directed his full energy to his illustration. The New York illustrator was fully launched in his career.

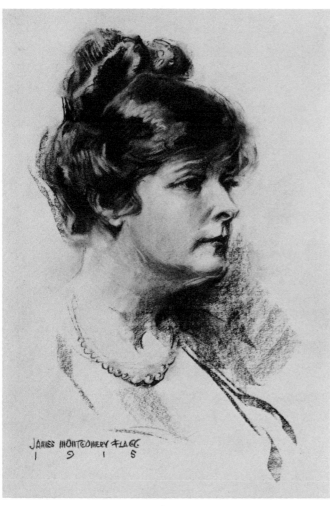

Flagg's first wife, Nellie McCormick, was a St. Louis socialite whose beauty captivated the young artist. Years later Flagg still called her "the finest woman I ever knew." Courtesy Berry-Hill Galleries, New York City.

Flagg's early illustrations suggest a curiously art nouveau influence. His first book, Yankee Girls Abroad, was published in 1900 in England by Sands & Co.

ON TOP OF THE WORLD

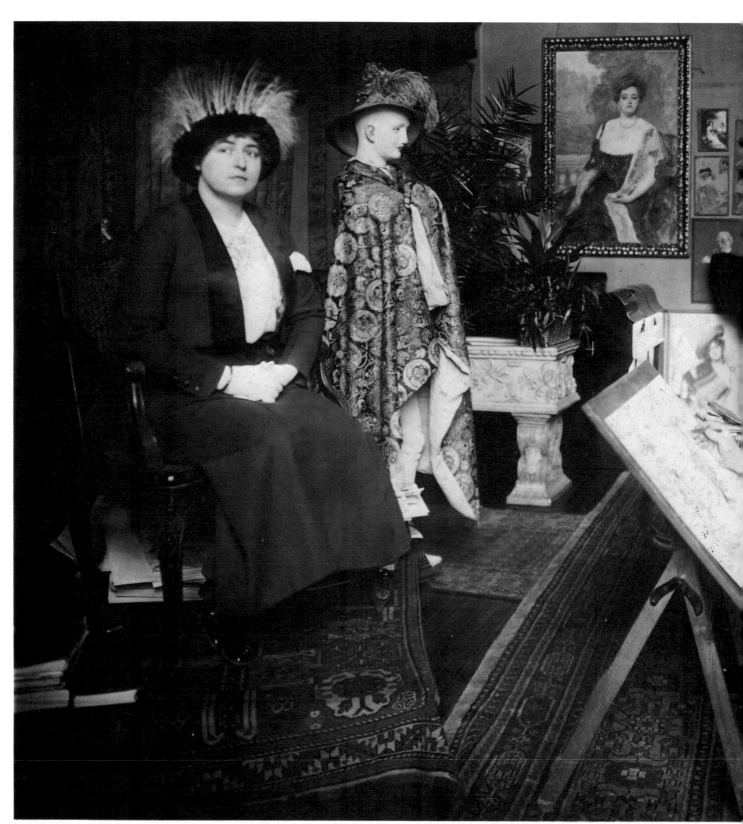

In 1910, when this photograph was taken, Flagg was living on 67th Street in a studio-apartment furnished with 16th century acquisitions made in Florence. A portrait of Nellie hangs on the far wall. Flagg worked from professional models and draped mannequins. Courtesy Everett Raymond Kinstler.

West 67th Street was an odd block in New York City: a strange mixture of unseemly tenements, modern apartment buildings, stables, and a saloon. It was on this block that Flagg selected a studio-apartment and it was here that he lived for 17 years, working at a rapid pace, and, as he observed, "sitting on top of the world." Decorated with cinquecento furniture he had bought in Italy, the studio was large and quiet, separated from the apartment sufficiently to provide him with the privacy he needed.

In the early days of this century the ambition of all illustrators was to see their work in *Scribner's*. Flagg was no exception. The prospect of an illustration appearing in *Scribner's* was of far greater significance to him than to have it exhibited at the Paris Salon of 1900. He submitted samples of his work, but the response was advice only: "Work some more and come back again." For more than a year he made periodic attempts to entice the magazine with his drawings but the only encouragement he got was the assurance that he was making progress. At last, Joseph Chapin, art editor of *Scribner's*, asked him whether he thought he could illustrate a "voodoo" story. Three other illustrators had previously attempted to make drawings for this story, only to be summarily rejected and the publication postponed. Nevertheless, Flagg eagerly accepted the assignment and at last was successful in getting his foot in the door. Thereafter Chapin invited him to contribute regularly to the esteemed publication.

Flagg also continued to work regularly for all the major publications, including *Judge, Life, Cosmopolitan, Good Housekeeping, Liberty,* and *Harper's Weekly*. (His humorous pen and inks appeared on the center spread of *Harper's Weekly* for several years and a group of them were reissued in a book entitled *City People*, published by Charles Scribner's Sons in 1909.) Every week some publication carried a Flagg illustration. His name became as familiar as the writers whose stories and books he illustrated: P.G. Wodehouse (whose character Jeeves the Butler entertained *Cosmopolitan* readers for months on end), Sinclair Lewis, W.J. Locke, and Booth Tarkington. He received so many assignments that he claimed to have averaged an illustration a day for years — and the quantity of his work reproduced during this time (as well as his earnings) substantiates the accuracy of this estimate.

Flagg was not only a productive illustrator, he was

In 1912, Flagg wrote and illustrated The Adventures of Kitty Cobb, *a satirical rendering of the sentimental story of the country girl leaving small town America for the Big City to find Love and Adventure. All of this she finds, but not in quite the form she anticipated. George H. Doran Company, 1912.*

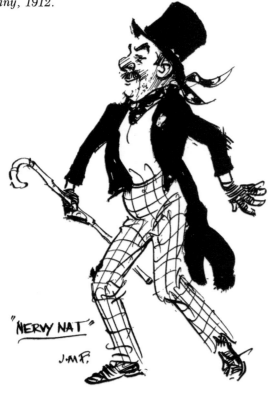

also enormously versatile. The growth and variation in his work developed as the technical capabilities of printing increased. Line engravings demanded a linear treatment and no artist — save perhaps Charles Dana Gibson — was so expert in pen and ink as Flagg. As halftone reproduction became more prevalent, Flagg displayed his prowess in opaque and transparent watercolor and oils. He worked in monochrome for halftone reproduction; with a full palette for color reproduction. He was equally skilled in charcoal and pencil. He was even a consummate sculptor. No medium was too difficult for him and, except for pastel (which he disliked), he used them all with ease.

If Flagg's cockiness in person was at times an annoying trait, in his work it was his great virtue. His uncanny skill as a draftsman and his overwhelming self-assurance enabled him to attack any assignment with vigor. He avoided trickery in his work, convinced that technical stunts were merely efforts to disguise the shortcomings of an artist lacking a true foundation or real ability. He considered mechanical shortcuts shameful, sneering at illustrators who used cameras, Balopticons, pantographs, and Lucies. In an interview with Everett Raymond Kinstler, Flagg had this to say of skill: "I would say to you who have a talent for drawing and a love of creating that you will find the greatest benefit in continually drawing from life — or even sketching; any place any time. I can draw but I cannot teach drawing. It cannot be taught. Not drawing from life. Mechanical drawing can be taught — that I know nothing about." ("Artists of Note" by Everett Raymond Kinstler, *Artist*, July, 1958.)

When asked if he had to read the stories he illustrated, Flagg retorted: "I'm going to have a flock of little cards printed, telling the real facts as to how vital it is for an illustrator to enter into the spirit of the story and actually know each character before he can picture what that character looks like. Good illustrating is far more than depicting a bit of action as described by the author." ("Flagg, Born Illustrator" by Louis H. Frohman, *International Studio*, August, 1923.)

Flagg's greatest output was in pen and ink, the medium he considered most difficult. (Actually, he used the term "penanink" loosely, because his illustrations also included a good deal of brushwork.) Working on large sheets of illustration board (approximately 22" x 30"), he began by dashing in a pencil drawing to block out his concept. From there he proceeded directly to pen and ink, rarely making corrections and seldom abandoning the drawing entirely. (He considered the casual pencil tones integral to the drawing and forbid any unknowing art editor from erasing the lines.) Although the drawing would be reduced to a small fraction of the size (5"

perhaps), Flagg felt more comfortable working large, with space to move about freely. He anticipated the ultimate reduction by spacing the lines appropriately so that they would tighten without filling-in when the drawing was reduced. Yet examination of these drawings full scale reveals his expert handling of a difficult medium, effects that are dazzling in their energy. He rarely used any form of cross-hatching, a common procedure for the pen artist, but rather achieved a full range of effects with simple, parallel lines, placed with decisive economy. Solid blacks, brushed in swiftly, could indicate a volume beneath by mere suggestion. Scratching into the black tones, he obtained reversal — white on black rather than black on white — so that he could suggest details in shadow. He worked in full control of the medium, yet the work appears effortlessly executed, spontaneous, and assured.

Flagg had his favorite models. His wife Nellie appeared in numerous illustrations; his friend John Barrymore appeared in several; Barrymore's first wife Katharine Harris was also a familiar figure in many Flagg illustrations. The majority of his models, however, were professional. These were the saucy women characterized as "Flagg girls," working their way into all the major publications and at least one (Norma Shearer) into Hollywood fame. A few of these models also worked their way into Flagg's heart. "Many of those girls were *so* beautiful; and artists are *such* fools! If I had this side of life to live over again, I'd again be just such a fool as I was!"

The Flagg girl was always the artist's ideal, regardless of the current fashions. In the 20s, when women were fashionably flat-chested, the Flagg girls were always shapely. Every beauty Flagg depicted, every woman he ever loved, met his definition of that ideal and she never changed through the years: "She should be tall, with wide shoulders; a face as symmetrical as a Greek vase; thick, wavy hair, either dark or light; thick, long lashes; straight short nose tipped up a bit at the end; her eyes so full of feminine allure that your heart skips a beat when you gaze into them. But physical beauty isn't enough. To be really beautiful a woman must have certain fundamental qualities of spirit — serenity, kindness, courage, humor, and passion."

This was the Flagg girl.

Just as his women formed the prototype of all that was beautiful, so his young men represented the ultimate in masculine good looks and charm. If these men in Flagg illustrations appear to resemble the artist, this is no illusion. In fact, Flagg posed for a number of the illustrations himself and he corresponded to the male ideal as well as any of his models. He was obviously aware of his own good features, and his satanic, carefully cultivated eyebrows became his distinctive physical trademark.

Nervy Nat Challenged To A Duel. *For four years Judge issued Flagg's accounts of Nervy Nat, "a bibulous ne'er do well and imposter who was living by his wits in Paris." W.C. Fields noted years later that he had often regarded Nervy Nat as his double.*

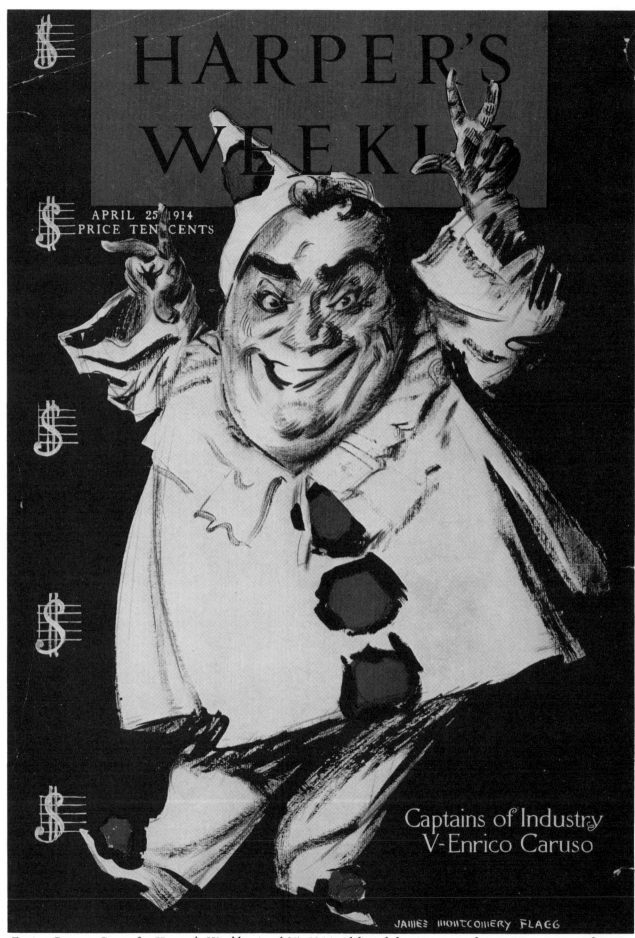

Enrico Caruso. Cover for Harper's Weekly, *April 25, 1914. Although he never met the great operatic performer, Flagg was a great admirer of Enrico Caruso. Buzzi-Peccia, Caruso's singing teacher, lived in the studio below Flagg and when Caruso came for lessons "We had to nail the rugs down to keep his wonderful tenor from blasting us out of the studio."*

Abraham Lincoln was an ideal subject for the Flagg touch: his face was not unlike Flagg's own. As he did with the Uncle Sam depicted on his famous war poster, Flagg also posed for his Abe Lincolns, using his skills for makeup and costume. He also used photographs and a life mask for reference. Top left, courtesy Berry-Hill Galleries, New York City. Above and left, courtesy Everett Raymond Kinstler.

Blindfolded... *in scientific test of leading Cigarettes,* James Montgomery Flagg selects OLD GOLD

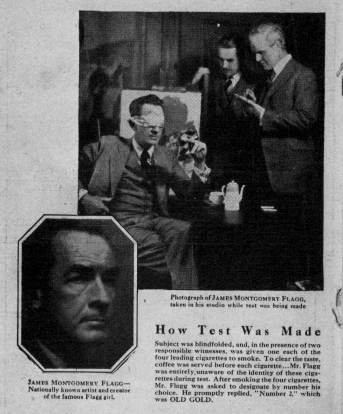

Photograph of JAMES MONTGOMERY FLAGG, taken in his studio while test was being made

JAMES MONTGOMERY FLAGG—
Nationally known artist and creator
of the famous Flagg girl.

How Test Was Made

Subject was blindfolded, and, in the presence of two responsible witnesses, was given one each of the four leading cigarettes to smoke. To clear the taste, coffee was served before each cigarette...Mr. Flagg was entirely unaware of the identity of these cigarettes during test. After smoking the four cigarettes, Mr. Flagg was asked to designate by number his choice. He promptly replied, "Number 2," which was OLD GOLD.

After this test, Mr. Flagg wrote: "Most of us smoke *names* and *think* we are smoking *cigarettes!* The blindfold test proved that to me . . . It proved also that it is difficult to tell one cigarette from another . . . except in the case of OLD GOLD . . . I spotted that . . . it suited me best even blindfolded. In fact, the man who said, '*not a cough in a carload*' knew whereof he spoke. It's the *smoothness* that identifies OLD GOLD. It needs no other trade mark."

JAMES MONTGOMERY FLAGG

© P. Lorillard Co., Est. 1760

SMOOTHER AND *BETTER*—NOT A COUGH IN A CARLOAD

Flagg's name had become a household word in the 20s and 30s. As a well-known personality, Flagg's own recommendations were a valuable commodity for advertising promotion. In these two advertisements Flagg's authoritative judgments were elicited to sell cigarettes and art materials.

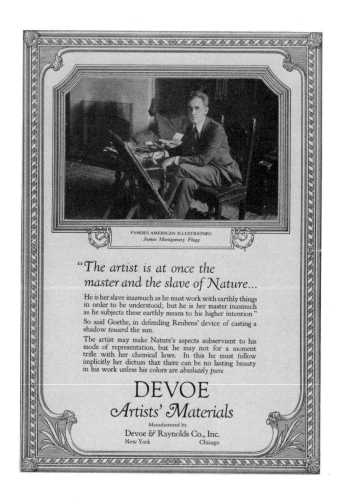

FAMOUS AMERICAN ILLUSTRATORS.
James Montgomery Flagg

"*The artist is at once the master and the slave of Nature...*

He is her slave inasmuch as he must work with earthly things in order to be understood; but he is her master inasmuch as he subjects these earthly means to his higher intention."

So said Goethe, in defending Reubens' device of casting a shadow *toward* the sun.

The artist may make Nature's aspects subservient to his mode of representation, but he may not for a moment trifle with her chemical laws. In this he must follow implicitly her dictum that there can be no lasting beauty in his work unless his colors are *absolutely pure*.

DEVOE
Artists' Materials

Manufactured by
Devoe & Raynolds Co., Inc.
New York Chicago

Because of his attachment to the great cities, Flagg was an urban illustrator. Unlike his contemporary Maxfield Parrish, Flagg was uninterested in pastoral scenes; unlike Norman Rockwell or Harvey Dunn, Flagg scoffed at the life of rural or small-town America. In all his work, whether in his easel paintings or in his satirical caricatures, Flagg described the cosmopolitan features of America. The characters inhabiting his illustrations were city people; he painted the portraits of prominent members of the American intellectual scene. Even his landscapes suggested the presence of man by including figures, architecture, industrial activity. On his automobile journey across the United States in 1924, Flagg observed the inadequacies of the midwestern scene: "The scenery is curiously different from that further east. At first I was at a loss to know why it seemed so strange and unlike regular landscape. Then it burst upon me. There were no billboards! Unless you have seen it you cannot imagine what a sordid dull thing landscape is minus billboards. Just plain sky and trees, brooks, valleys and hills! Nature is all very well in her way. As a setting for Rustless Soup and Malted Corsets and Delicious Gasoline it is perfect — but leave out those beautiful billboards and it is rather shocking — rather nude and insipid. I at least felt annoyed, I suppose because I had been brought up in a section of the country of complete landscapes — where we are civilized — a bit spoiled, perhaps one might say, beauty being taken with us as a matter of course. These poor dear people out here will, in time, arrive at our culture, and see that one simply does not take landscapes straight." (*Boulevards All The Way-Maybe* by J.M.F., George H. Doran Company, 1925.)

Although Flagg was a proficient easel painter (a one-man exhibition of 29 watercolors and four oils was held in 1948 at Ferargil Gallery in New York City), he never claimed to be a fine artist. Indeed, he was proud of his career as an illustrator. He was frequently quoted as saying, "The difference between an artist and an illustrator is that the latter knows how to draw, eats three square meals a day and can pay for them." Flagg's distaste for modern art was legendary, the most contemptible artist being Picasso: "His work is kin to the nasty scrawls chalked on an alley wall by underprivileged monster boys." Flagg was equally vitriolic in his diatribes against Renoir ("His banalities were apparently painted with pillow feathers and lipstick") and he dismissed Manet, Cézanne, and Van Gogh as charlatans. (Oddly enough, Flagg felt that Monet was the greatest landscapist in history. If this seems inconsistent with his view on modern art, he did not think so: "It's silly to speak of 'modern art.' There's no such thing. Art is good or bad, time has nothing to do with it.")

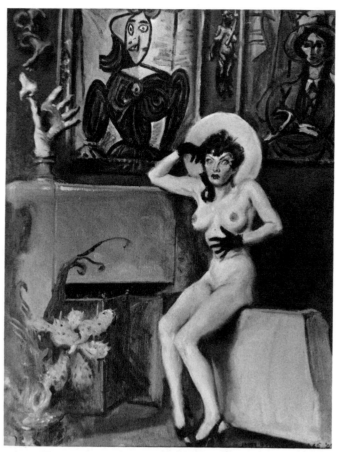

Flagg lampooned Picasso in this oil painting entitled Something She Ate? *Yet even in his attack on modern art Flagg painted a remarkably good abstraction, an accomplishment he would have ridiculed.*

It is not surprising that Flagg's great hero was John Singer Sargent, an artist who displayed the vigor and facility Flagg desired in his own work. He admired Sargent's draftsmanship, a gift he also found in the work of Velasquez but not in that of Whistler. In spite of Flagg's respect for the artist's talents, Flagg did not like Sargent when they met in London. "Sargent was more English than the English; in fact, not to be too refined about it, his manner was snotty." Nevertheless, he never lost his high regard for Sargent's gifts.

Flagg did not stay in New York City the year round. For over 30 years he spent the summer months in Biddeford Pool, Maine, where he owned four acres of shorefront property and lived in the home he designed. In the autumn he would return to Manhattan, to the boisterous, active pace he loved. In 1921, feeling cramped in his 67th Street studio, Flagg decided to lease a new studio apart from his living quarters. He selected one on West 57th Street and continued to work there for many years. New York was his home and his life.

CAPERS WITH THE CRONIES

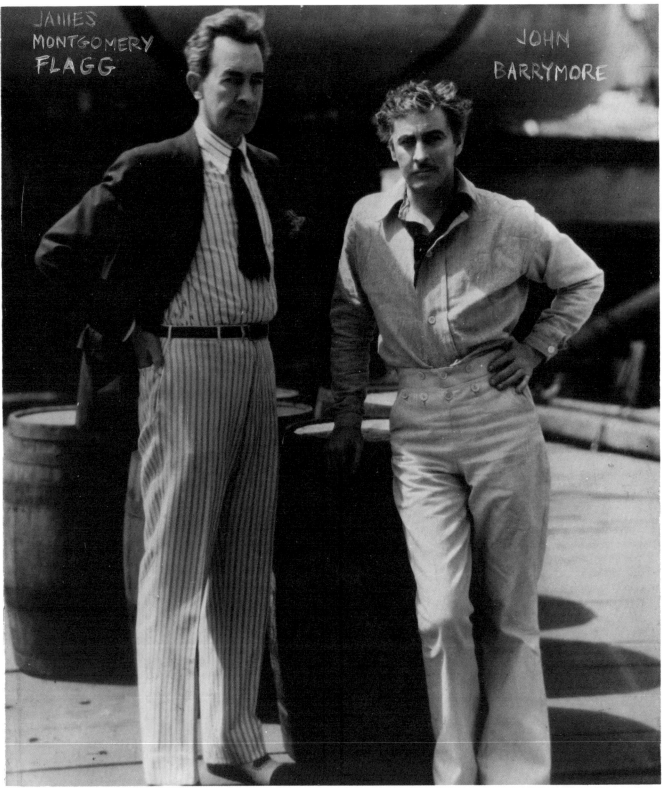

Flagg knew all the Barrymores—Ethel, Lionel, and John—and their uncle John Drew. "My life would have been much duller without them," Flagg admitted. For years he and John cavorted around New York City, a notorious pair of fun-loving trouble-makers. This photograph was taken at the time Barrymore was filming Moby Dick. Courtesy Everett Raymond Kinstler.

In boasting that he "made friends and enemies lavishly, "James Montgomery Flagg did not exaggerate. He was detestably candid and would have been proud to acknowledge that he won enemies more easily than friends. He valued honesty above all: "As a rule the world tries to squash, with pragmatic and worldly-wise apothegms, anyone who says what he thinks . . . so we live in a world of Near-Freedoms, especially the Near-Freedom of Speech."

Flagg exercised his freedom of speech freely, and chose his friends accordingly. He preferred the company of individualists, talented creative men who also mocked the conventional world.

Flagg was identified with the Roaring Twenties, the frenzied whirlwind of decadent urban life. In fact, he was in the limelight for 35 years, an intimate associate of the most notable entertainers, writers, and artists of the era. The carefree, bohemian camaraderie of the hard-working, heavy drinking, stunt-making circle of friends is gone now. Yet when it was in full motion, Flagg was at its core: James Montgomery Flagg was never far from the action.

Quick to attack an artist's work he despised, Flagg was thoroughly generous in praising the work of artists he admired. With them he exchanged ideas and models freely. High on the list of artist friends were John Wolcott Adams, Walter Appleton Clark, Wallace Morgan, Charles Dana Gibson, and Arthur William Brown.

Flagg's friendship with Walter Clark dated from their days as students at the Art Students League. Clark and his wife lived across the hall from Flagg's studio and Flagg referred to Clark as his most intimate friend. At the time that Flagg was illustrating the double middle page of *Harper's Weekly,* Clark was handling the double middle page of *Colliers.* They would swap ideas they felt most appropriate to their purposes. "I loved and admired Walter; a grand human and a great artist . . . to my mind he was second only to Howard Pyle as America's number one illustrator." Flagg particularly admired Clark's ability to paint without models. "It seems fantastic that today he is unknown except by some of the old-timers who still recognize that no artist now living is his superior." Clark died at 30. Flagg and John Wolcott Adams carried his ashes to Woodlawn to bury them.

Arthur William Brown, affectionately dubbed "Brownie" by all who knew him, was another out-

standing illustrator of the period, particularly noted for his sprightly illustrations in *The Saturday Evening Post.* Although Brownie did use a camera and pantograph in his work (mechanical stunts Flagg abhorred), Flagg never had an unkind word about his friend: "Everybody in our gang loves Brownie for one reason: nothing is too much trouble for him to do on behalf of a friend. When we are stuck—about anything at all—we call Brownie. He knows the answer always, and if he doesn't know it, he'll put you in touch with the feller who does. There never was such a man." Flagg would recall time and time again two excursions to Hollywood with Brownie made "just for fun."

The warm bonds of friendship did not prevent Flagg from voicing his appraisal of work he disliked. Although he loved Rube Goldberg and Ham Fisher, he ridiculed the comics they created. "In America, next to baseball, funnies have become the most popular of our obsessions. I am looked upon as a leper because I dislike both of these things." Rube Goldberg, according to Flagg "was famous the world over for his failures. He can't draw and his inventions never work . . . his contention was that anyone who made a mark on a piece of paper, which anyone else could recognize as meaning something, was an artist. Rube is so modern. I am fond of cartoonists. They are a very intelligent race of men, except that they have a curious complex. They all think they can draw."

This distaste of comics did not interfere with his affection for Ham Fisher any more than it did with Goldberg: "Fisher was one of my best-loved friends . . . we had continuous pleasure insulting each other in private and in public . . . he is so keen, so well-informed; his wit is sharp and his imaginative humor is boundless—it is incredible that none of all this ever gets into his strip of 'comic stuff' called *Joe Palooka.*" Fisher had a winsome personality. "He knows everybody and works like a beaver to make everybody know him. He will put up with all sorts of jerks, just to add to his popularity."

Even when he was an adolescent, Flagg loved good entertainment. In the 1890s he haunted the theatre almost nightly, and his passion never diminished. If, in the 90s he adored comic opera at Herald Square, he also loved the films and stars of Hollywood years later. His social and professional life was linked to the entertainment world throughout his

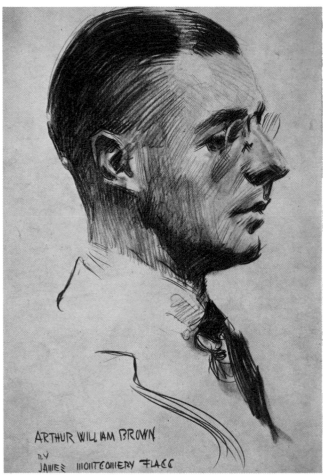

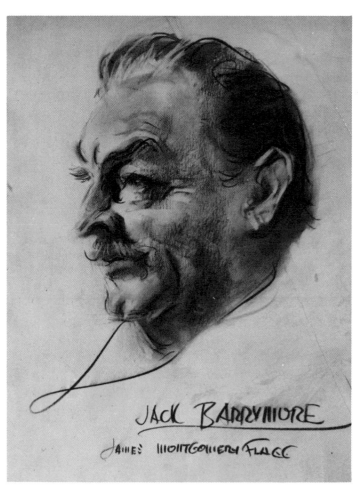

Arthur William Brown ("Brownie") was one of Flagg's favorites. A popular illustrator for Saturday Evening Post, Brownie and Monty traveled together to Hollywood twice. Brownie was "the man-of-the-world with a heart." Courtesy Everett Raymond Kinstler.

Years later, when both Flagg and Barrymore were working in Hollywood, they again saw each other frequently. This drawing, made in 1941, was made in what Flagg termed "The last phase of the Great Guy." Courtesy Everett Raymond Kinstler.

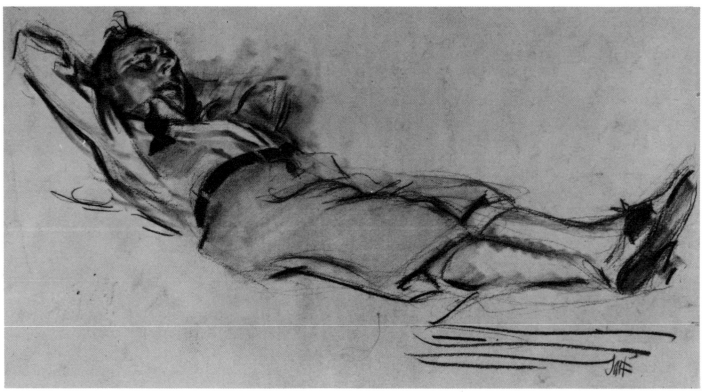

Rube Goldberg was a great pal, even though Flagg never developed a taste for his cartoons. Photo eeva-inkeri. Courtesy Everett Raymond Kinstler.

career: he drew and painted the famous entertainers; he produced, wrote, and acted in dozens of annual shows presented by the clubs of which he was an active member; he wrote and acted in 24 of his own films. His intimate friends always included a number of actors and actresses.

John Barrymore's friendship with Flagg was notorious. At the time Barrymore was married to his first wife, Katharine Harris, the couple saw a great deal of the Flaggs. As an actor, Barrymore was a genius ("In whatever role Jack played he was great"), but Flagg also loved the man: "A great scholar, a great actor, a great occultist, a great drinker, a great swordsman, a great conversationalist, a great companion, a great wit and great gent . . . I want to underline the fact that in spite of Jack's drinking, he had something that transcended this obvious weakness, that shone through the unhappy fumes like a sunrise through mist. People who loved him know that."

Flagg felt deeply about Barrymore. Did he see something of himself in the great actor? Indeed, they had a number of traits in common ("possibly the less admirable ones," as Flagg himself admitted): two handsome young men who could afford to laugh at the world, enjoy good drinking and beautiful women, and who both discovered the pain of solitude when the world moved on without them.

Flagg knew and enjoyed all the Barrymores—Ethel, Lionel, and John, as well as their Uncle John Drew. Years later his description of the Barrymore family was widely circulated: "There never were such a people on sea or land, they are the most charming humans, the most talented, the wittiest, the most delightful people ever given the bum's rush out of Heaven; and at the same time probably the most self-centered, spoiled, irresponsible leprechauns ever to crawl out of a hollow tree. It was like this. Either you took them as they were—or else! Personally I loved them without demanding much. For my part, life would have been much duller without them."

Out of this spirit of conviviality and camaraderie emerged the notorious New York clubs, the institutions that characterized the spirit of the city in the decades between 1910 and 1930. "One of the most pathetic impulses of Americans is their urge to form clubs", Flagg observed years later. "I think it's a form of infantilism springing from an inferiority complex; a fear of loneliness and a desire to expand the little ego." Yet Flagg himself was an avid club member, and his escapades with his cronies continued to amuse him for many years.

A small group of writers and artists associated with the best publications of the day founded the Dutch Treat Club in 1911. Unwilling to undertake the complex responsibilities of maintaining a clubhouse, the group met on Tuesdays for lunch in restaurants

As the creator of the comic strip, Joe Palooka, Ham Fisher was also subject to Flagg's insults. Nevertheless, Flagg enjoyed his friendship with Fisher and took particular pleasure in satirizing the cartoonist's facility with women. This painting by Flagg is just one example of their private joke. Courtesy Everett Raymond Kinstler.

In his first gala presentation (1914), Flagg wrote and produced (with musician Bill Daly) The Chicken. Flagg acted the part of the devil and was made up for the performance by John Barrymore himself. Culver Pictures.

and enjoyed the conviviality of each other's company until the club grew too large for Flagg. The collaboration of writers, artists, and musicians produced scandalous and hilarious shows for the annual banquets. In the first show presented by the Dutch Treat Club (entitled *The Chicken*), Flagg wrote the book and Bill Daly the music. Flagg was an ideal personality to perform in these productions: his voice was rich and expressive, and he had a flair for acting. Playing the part of the Devil, Flagg asked John Barrymore to make him up for the part. According to Barrymore's specifications, Flagg ordered a wig with black hair and two pink horns. A chin beard decorated the face and Barrymore painted the eyes with liquid aluminum and outlined them in black, claiming that he had learned these skills from the great Russian performer Chaliapin. The show, presented at Delmonico's, was a great success and Flagg continued to write another every year.

Flagg also belonged to the Society of Illustrators, (he wrote, produced, and acted in a number of their spring annual shows). Taken with the potential of these amateur presentations, the Shuberts produced a Broadway version of one of the shows called *Artists and Models*.

Flagg was also given lifetime membership to the Lotos Club in exchange for a portrait he made of Mark Twain and maintained a close association with the club for many years. (The club still owns several Flagg paintings and illustrations.) Flagg was also a member of the Lambs Club. (Would he be amused or enraged to hear that the club had added clothing to his nudes that hang on dining room walls, an addition they felt necessary when the club admitted women?) For years Flagg was also a member of the Artists and Writers Club and the Players Club.

Flagg's escapades with his cronies were always amusing to him. His annual ten-day trips to Palm Beach with the boys, the ruckus of the parties, the jocular pranks they played on each other: ribald, boisterous, and always witty. "We strive to annoy" was his motto.

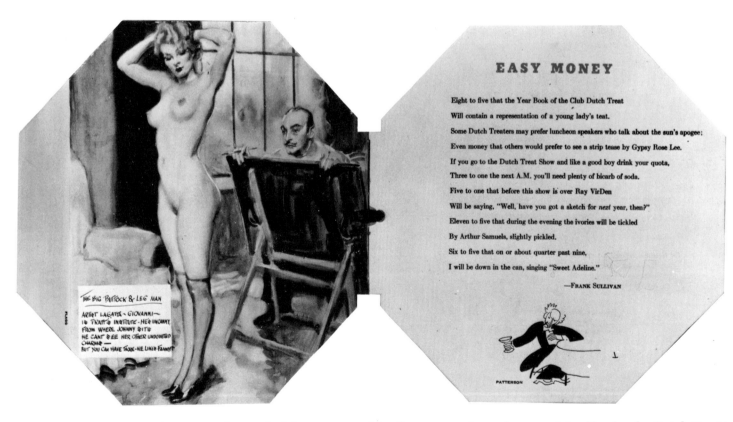

Each year, in words and pictures Flagg poked fun at some of his favorite people in the annual booklet for the Dutch Treat Club. Here, the illustrator John Lagatta (known to be partial to abundant buttocks and shapely legs in his illustrations) is Flagg's target.

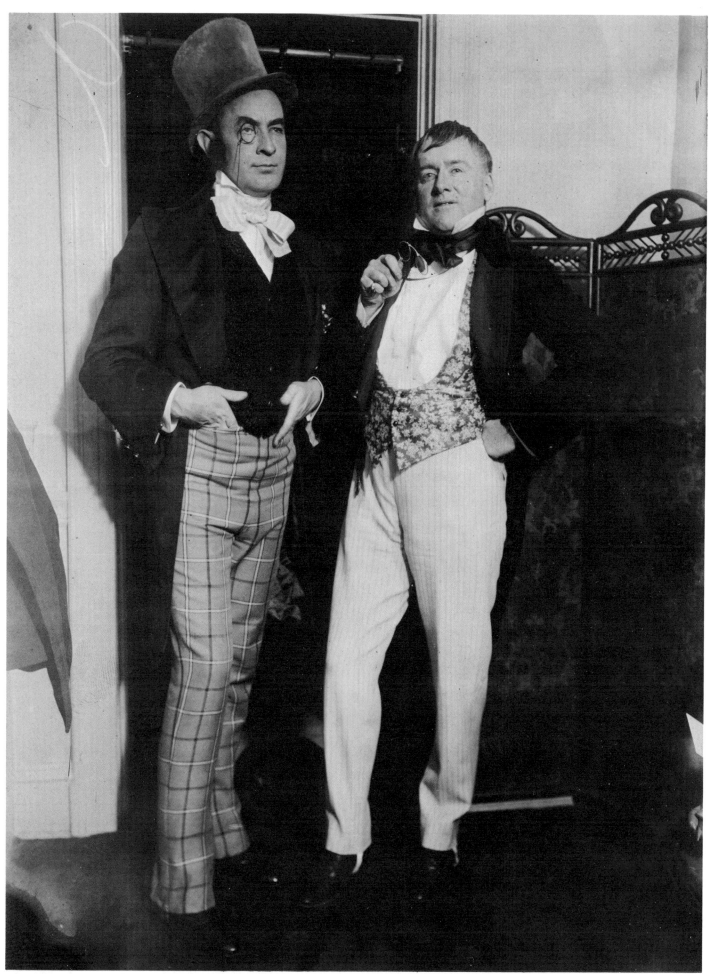

In 1915, Flagg performed with Max Foster, sporting the monocle he so enjoyed wearing as a prank through the years. Culver Pictures, Inc.

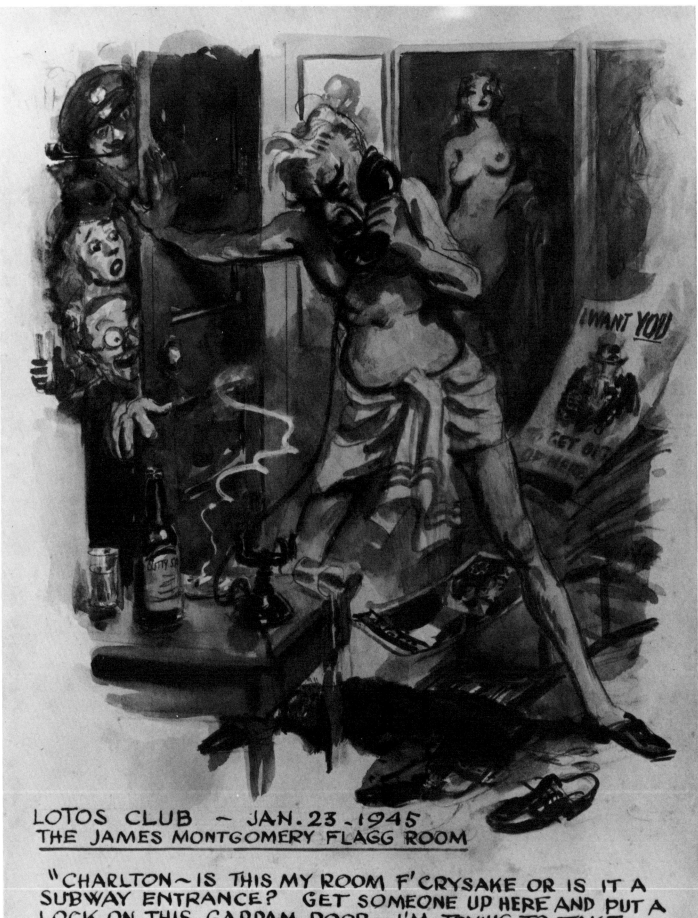

LOTOS CLUB ~ JAN. 23 - 1945
THE JAMES MONTGOMERY FLAGG ROOM

"CHARLTON ~ IS THIS MY ROOM F' CRYSAKE OR IS IT A SUBWAY ENTRANCE? GET SOMEONE UP HERE AND PUT A LOCK ON THIS GARDAM DOOR ~ I'M TRYING TO TAKE A BATH!"

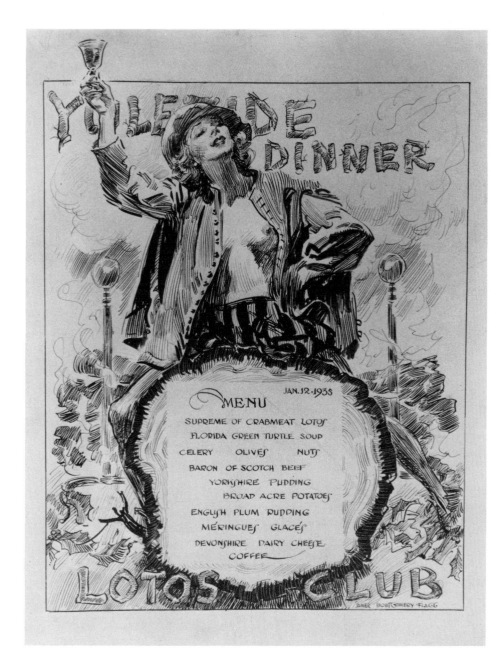

In spite of his heavy work load, Flagg always found time to volunteer some illustrations to the Lotos Club. The James Montgomery Flagg room no longer exists in the present Lotos Club on 66th Street. Although the collection is greatly diminished, the Lotos does still own several pieces by Flagg, including these advertisements of club programs.

(Left) Flagg lived next door to the Lotos Club, then on 57th Street, for several years and was a familiar figure in the building. The James Montgomery Flagg room, decorated with paintings and drawings by the artist, was a public attraction and Flagg made this silly drawing to suggest that his privacy was being invaded. Photo eevainkeri. Lotos Club, New York City.

THE WORLD TRAVELER

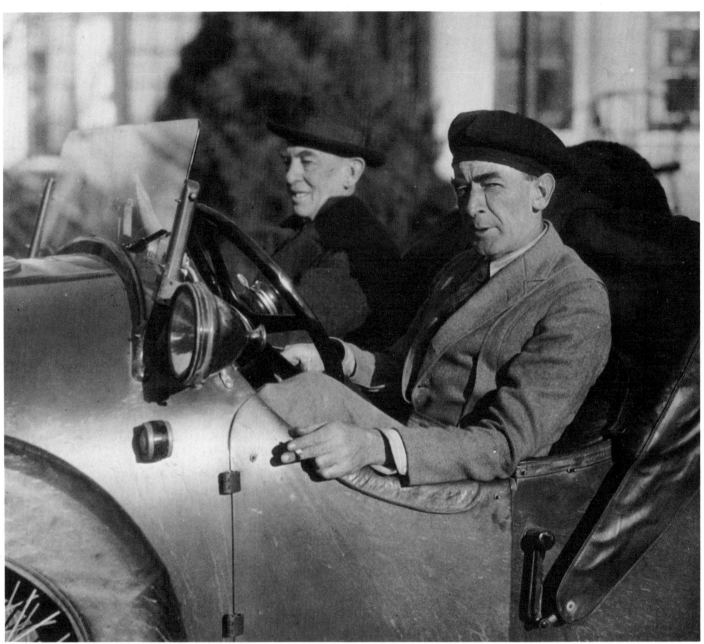

Flagg's Kissel sports car was his pride and joy. This photograph of Flagg and his father, Elisha, was taken in 1926, moments before they left on a trip to North Carolina. Acme photo.

Flagg was an avid traveler. From the time he was 22 years old, he made 18 voyages to Europe. He lived in England and France and traveled throughout the entire continent, painting the cities and people wherever he went.

He was no less fascinated with the United States. Long before the availability of airplanes, Flagg traveled thousands of miles throughout the States, by car or train. He made his first West Coast trip by train about 1903, and several more of these cross-continental journeys followed. Flagg relished these excursions with a child-like enthusiasm, an adventurer's delight.

He was equally child-like in his devotion to the automobile and he took pride in his expertise as a motorist, a skill he acquired as early as 1901. Sporting his duster and goggles, Flagg savored the two-and-a-half day trips to Biddeford Pool, Maine. His first automobile was a second-hand Thomas Flier. Later he graduated to a $4500 Columbia Silent Knight which was a disappointment because it didn't go fast enough to suit him. At $6200, the Simplex was his ideal automobile, the swankiest car of the day. After World War One, he purchased a sports car, the Kissel, buying a new one each year for 14 years.

In 1924 he made a trans-continental journey in the Kissel. From his adventures on this trip he wrote *Boulevards All the Way—Maybe!* a humorous account of the primitive road conditions west of Kansas City and how he overcame the obstacles in his path.

In this book Flagg draws an amusing parallel between the motorist and the average American citizen: "The greatest drawbacks to motoring, for any but the turtle temperaments, is the inescapable impulse to keep going—to keep up the pace, and not to be able to stop. The continuous motion forward begets a habit of mind, and the mere thought of stopping, except from exhaustion, is repugnant. The average American is sadly deficient in the art of contemplation, of meditative serenity. He has a national contempt for physical inactivity; anyone who is not violently busy in America, doing something that is visibly fluttering to the eye, is a waster, a slacker, and a dead one."

Although written in jest, these words accurately describe Flagg himself as an average American.

On one of their summer excursions to Europe, Flagg and his wife Nellie spent two weeks in Holland where he painted every day. He loved the windmills and sailboats that decorated the canals, but was irritated by the throng that would gather around him as he worked. Photo eeva-inkeri. Courtesy Everett Raymond Kinstler.

In 1903 Scribner's assigned Flagg to write and illustrate an article describing the manufacture of musical instruments in Germany. Traveling to the little town of Markneukirchen in Bavaria, Flagg completed the assignment satisfactorily, despite the fact that he knew no German and knew nothing about musical instruments. Photo eeva-inkeri. Courtesy Everett Raymond Kinstler.

THE POSTER YEARS

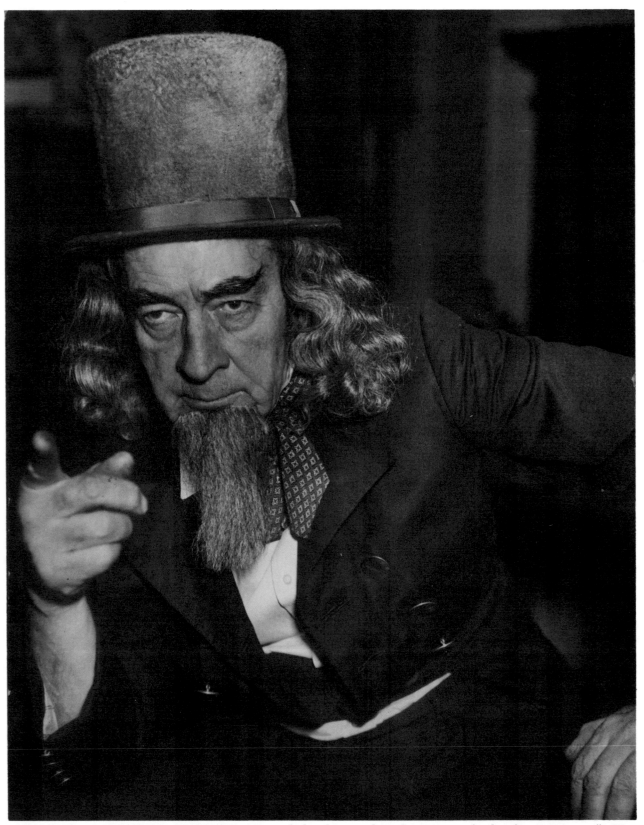

Although photographed in 1942, Flagg maintained that he posed in this manner for his famous poster "I Want You" in 1917. International News Photo.

Fortunately, Flagg was already too old to fight by the time World War One erupted, because he did not have the proper attitude for battle: he was convinced that men went to war for excitement, not for noble ideals. Actually, the United States profited more from Flagg the Artist, than they would have from Flagg the Warrior. In 1917 New York Governor Whitman appointed Flagg State Military Artist.

Today Flagg is remembered more for his poster "I Want You" than for any other achievement of his career. Strange as it may seem, this artist whose work was exhibited every week in all the major publications was made immortal by this single poster, a minute fraction of his total output. Yet if he is to be remembered for any one thing, this poster is the most obvious selection. Originally drawn for the cover of *Leslie's Weekly*, "I Want You" was to become the most famous poster of both world wars, an estimated four million copies issued in the first World War and about 400,000 in the second.

The idea for "I Want You" probably derived from Alfred Leete's British poster depicting Lord Kitchener, "Your Country Needs You." Flagg did not deny or admit to the similarity, but felt the question was irrelevant. For an artist who freely dispensed ideas, he did not hesitate to borrow either. How well the idea was handled was far more interesting to him than its origin.

Formerly a benign old man in stars and stripes, Uncle Sam was transformed by Flagg into a compelling leader who meant business. Never again would Uncle Sam be regarded in quite the old manner.

Posters for recruitment required an official body of artists. The voluntary organization responsible for producing these posters was the Division of Pictorial Publicity launched by a group of artists, with Charles Dana Gibson as chairman. During the entire course of the war the group met once a week at Keene's Chop House in New York City to discuss the government's requests. A "captain" was appointed to expedite the desired posters: he would select an appropriate artist for the assignment, approve the sketch made by the artist, then pass the sketch along to Committee Headquarters in Washington. Upon approval, the poster would be completed by the artist.

Flagg's Uncle Sam poster was so successful that he stopped attending the weekly meetings. "I became horribly bored with rising toasts." Although he con-

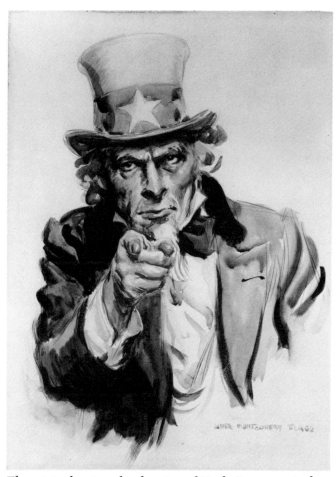

The original watercolor drawing of Uncle Sam appeared on the cover of Leslie's Weekly *before it was considered for the poster. Collection Smithsonian Institution.*

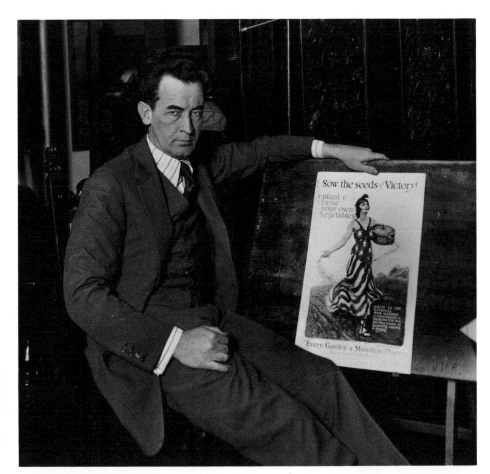

(Right) As an official military artist, Flagg created 46 posters during World War One. This photograph, taken in 1918, shows Flagg with one of his posters "Sow the Seeds of Victory" which was also run with other words: "Will You Have a Part in Victory?" Brown Brothers photo.

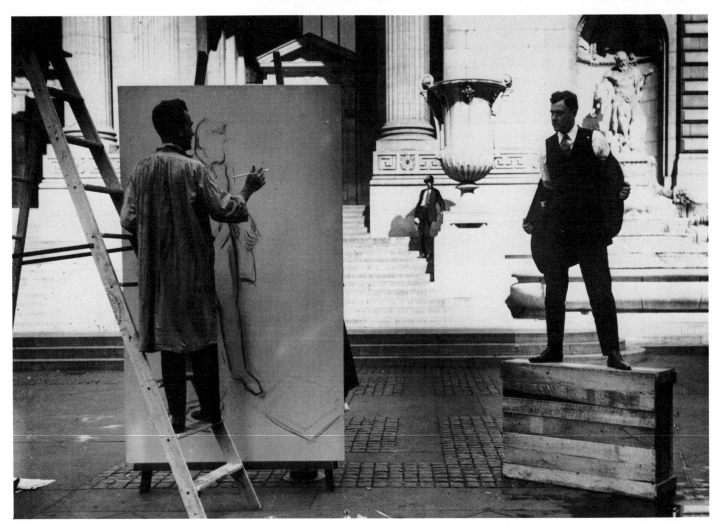

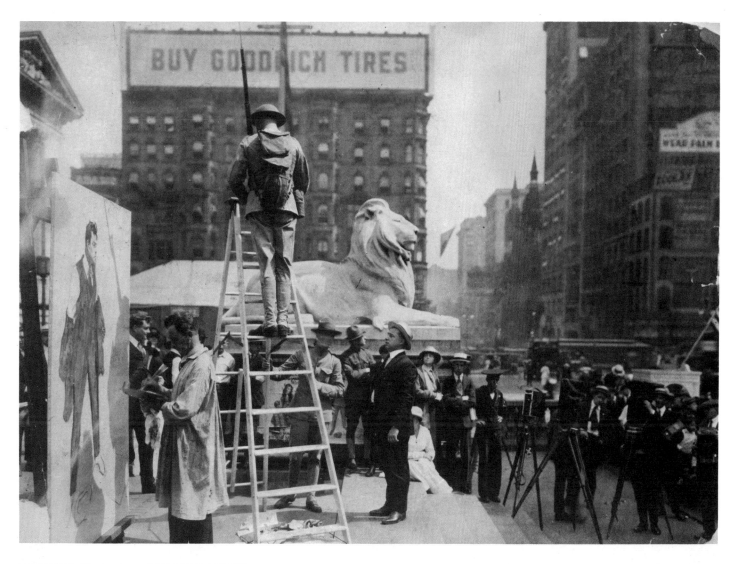

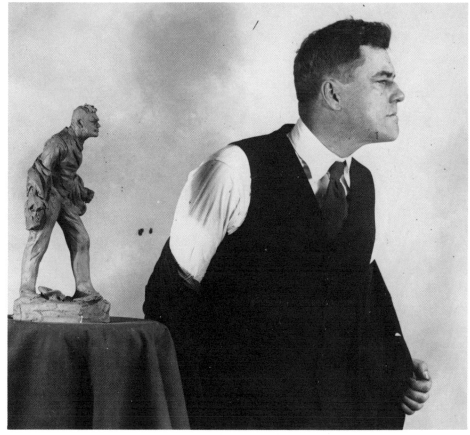

The great forum for war publicity during World War One was the New York Public Library. On these steps Flagg painted "Tell That to the Marines," a poster that transformed an insulting phrase into a battle cry. Flagg also made a clay model of the same subject. Photos this page, courtesy Everett Raymond Kinstler. Photo opposite page, bottom, Culver Pictures, Inc.

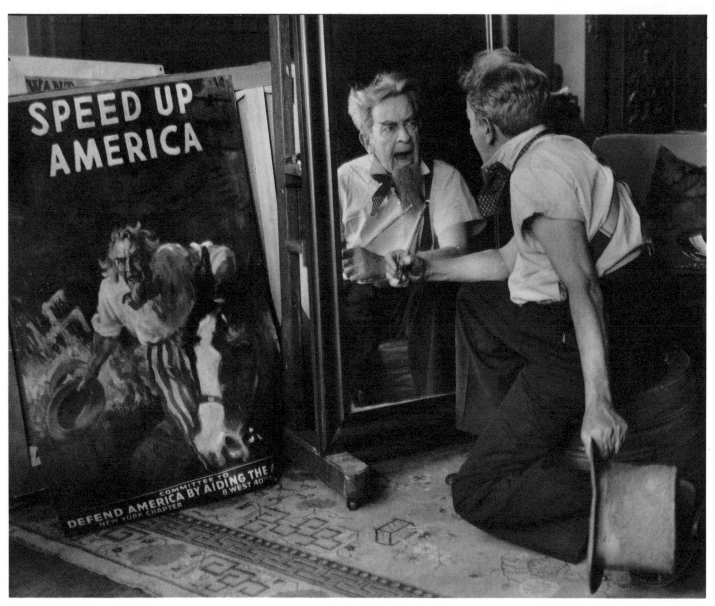

Here Flagg demonstrated for the photographer the method he used to pose for his World War Two poster, "Speed Up America." (The poster was called "Wake Up America" originally, but the title was changed later.) International News Photo.

(Right) In World War Two, Flagg continued to be active in designing posters, resuming the position he had held in World War One as an official military artist. International News Photo.

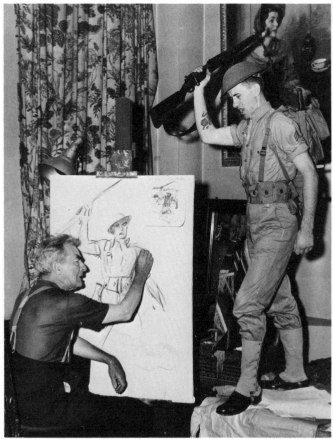

In 1941 Flagg painted the poster "The Marines Have Landed." Here the model, a sergeant from the Marine Corps, posed for the poster in Flagg's studio. Wide World Photos.

The model posed in full gear, Flagg painted the 1945 poster "Coming Right Up!" in his studio. Air Transport Command photo.

tinued to be a member of the group, he worked alone and during the course of the war he designed 46 posters.*

The New York Public Library on 42nd Street became the forum for publicity campaigns during World War One. A crowd would gather on the steps to watch the artists paint recruitment posters; entertainers came to perform on the steps; thousand-dollar Liberty Bonds were sold in exchange for portrait drawings. Arthur William Brown recalls his collaboration with Flagg on the Library steps: "Flagg did the figures and I smeared in the background. We used live models and, with a girl wrapped in stars and stripes, we did one on a scaffold high up in Times Square. The wind was strong; the street below looked safe and inviting." It was on these steps that Flagg painted "Tell that to the Marines," a phrase that had previously implied the Marines would believe anything. The powerful man removing his jacket for battle in Flagg's poster transformed this insulting phrase into a battle cry. Later Gus Edwards and Al Jolson both wrote songs with the same title, using the same meaning in the phrase as Flagg had.

Flagg's ink and wash posters of World War One were widely circulated. Cloaked in white robes or in stars and stripes, the Flagg girls now represented America itself: seductive and courageous, proud and hopeful. Flagg girls continued to carry the message loud and clear to millions of Americans throughout the war.

Although Flagg demanded a high income (at one time he was supporting eight relatives), he was not averse to voluntary work when he felt the cause warranted it. And his clubs were perpetually in need of the artist's services. Flagg frequently accepted requests to make posters that would feature important activities in the Lotos Club, The Lambs Club, and the Dutch Treat Club. Done for his personal pleasure, these posters document Flagg's enthusiasm for city living.

These announcements are one-of-a-kinds, not designed for reproduction, and—like his easel paintings—reveal another aspect of this artist's multi-faceted personality.

Flagg's work for the government brought him into contact with officials outside of the war offices. In the 30s he completed a series of posters for the Department of Forestry and in 1937 was invited to present one of these posters to President Roosevelt himself. (Franklin Roosevelt was not the only President Flagg had been introduced to. Years before, he had made a drawing of President Theodore Roosevelt, and he

*Unfortunately, few of these posters are extant. For the record, be it noted that The Metropolitan Museum of Art in New York City has in storage eight of these rare posters from this period. Because of their fragile condition, several requests to see or photograph these posters were denied me. The book suffers from their absence.

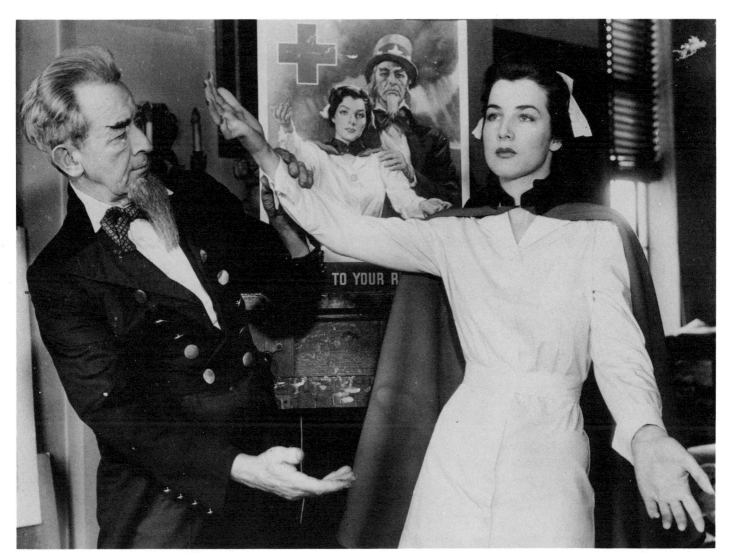

(Above) Flagg's Red Cross Poster was widely circulated throughout World War Two. For the news photographer, Flagg re-created the manner in which he posed his favorite model of the time, Georgia McDonald, for the poster. Uncle Sam was, naturally, Flagg himself. International News Photo.

(Right) A Red Cross fund raising poster designed by Flagg was placed on counters throughout the country. Courtesy The American National Red Cross, Washington, D.C.

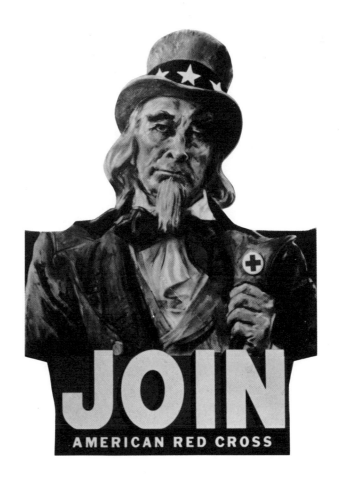

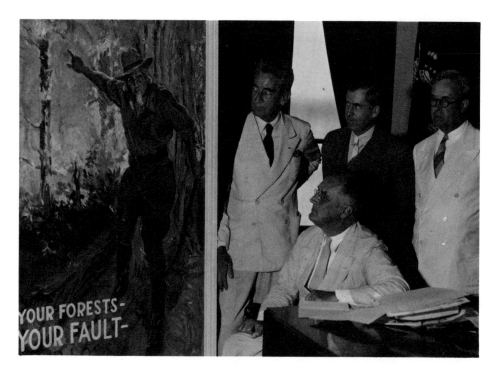

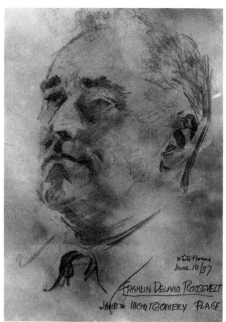

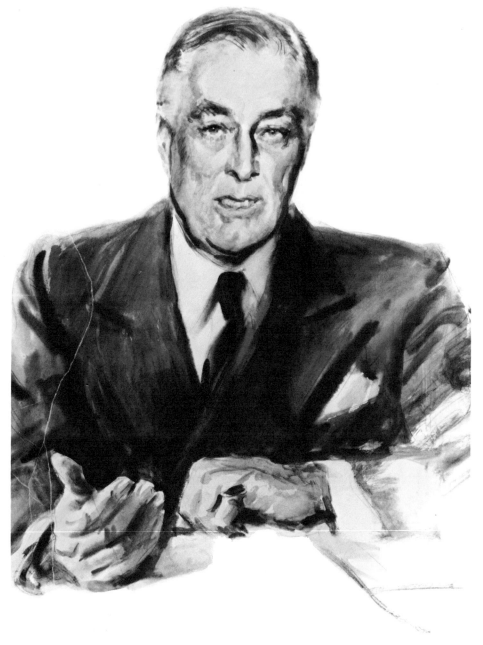

(Right) At one meeting with President Roosevelt, Flagg made a quick study in watercolor. Photo eeva-inkeri. Courtesy Berry-Hill Galleries, New York City.

(Top Right) In his 1937 meeting with President Roosevelt, Flagg presented a poster at the White House for forest conservation. Standing to the right of Flagg are Henry Wallace (Secretary of Agriculture) and Karl H. Clapp (Associate Forester). Courtesy U.S. Forest Service.

(Above) After presenting the poster to the President, Flagg asked permission to make a quick sketch of Roosevelt from life. When shown the sketch, the President remarked "It has flair!" Courtesy U.S. Forest Service.

had met President Taft in Biddeford Pool, Maine. But F.D.R. was Flagg's favorite.) Flagg had always admired F.D.R. in public life and was equally impressed with the man in person, for he was not only forthright (a quality Flagg particularly respected in people), but he had a sense of humor as well. Immediately after the presentation of the poster at the White House, Flagg asked the President if he could make a quick portrait sketch of him, a request Roosevelt accepted with enthusiasm. After making the 20-minute sketch, Flagg showed it to F.D.R., asking if he liked it: "It has flair," said Mr. Roosevelt, "I don't know what a flair is . . . but it has a flair."

Flagg met the President only once again, in Washington, to present him with a poster for the Infantile Paralysis drive, but they did correspond with each other on several occassions. In one of these exchanges F.D.R. praised Flagg for saving the cost of a model by posing himself as Uncle Sam in the poster

"Jap You're Next!" "By the way, I congratulate you on your resourcefulness in saving model hire. Your method suggests Yankee forebears."

As an ardent supporter of F.D.R., Flagg painted posters for his reelection—one of which he presented to Eleanor Roosevelt—and deeply mourned his death in 1945, calling the late President "one of our noblest Americans."

Flagg's posters for World War Two reflected the tastes and mood of the 40s as his World War One posters had reflected the teens: splashy, contrived paintings had replaced the satirical, decorative pen and ink washes. This was the temper of the times, and the fatigue of the great illustrator. Flagg was already 64 when the United States entered the second war, a man who had enjoyed life intensely, but who had also suffered the pain of a passing era and a passing youth. His private agonies had begun to appear in his work.

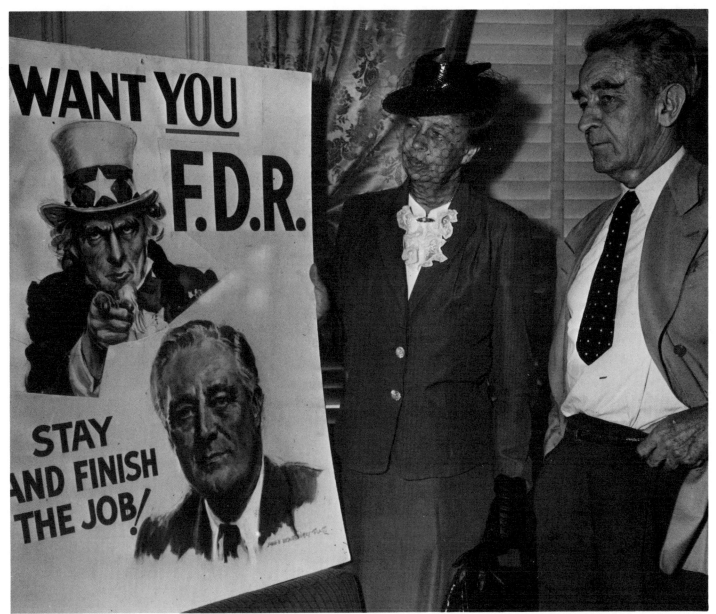

Flagg designed a campaign poster for the reelection of F.D.R. He presented the original to Eleanor Roosevelt at the Hotel Astor headquarters of the Independent Voters Committee of the Arts and Sciences for Roosevelt. Culver Pictures, Inc.

THE PRIVATE LIFE OF A PUBLIC MAN

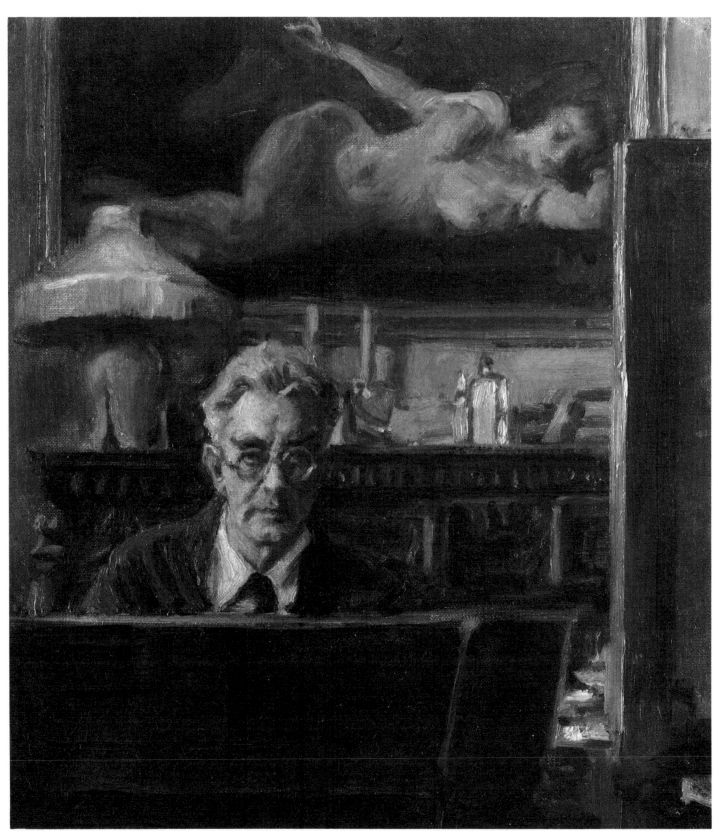

It is no accident that Flagg included his painting of Ilse in this 1941 self-portrait. Ilse occupied an intense and intimate part of his life for many years. Photo courtesy Everett Raymond Kinstler.

"I have never had any slight interest in homely ladies—no matter how charming and intelligent they are reputed to be. They do not exist for me." Every woman in Flagg's intimate life was beautiful and young. And he had lots of them.

For 23 years Flagg was married to Nellie, but the marriage was not without frequent interruptions. Flagg regarded Nellie as more of a mother to him than his own mother had been; more of a mother, in fact, than a lover. Although they separated periodically during their 23-year marriage, Flagg admired Nellie and she, in turn, "had no illusions about him." Obviously she knew of his weakness. His autobiography contains references to other beauties who particularly captivated him; he had affairs with some of these women; others he simply desired from a distance: Barrymore's first wife, Katharine Harris; Catherine Dale Owen; Mitzi, his model; Greta Garbo, and perhaps many others never mentioned in his writings. Flagg implied that he had many affairs, but lack of interest (certainly not discretion) prevented him from discussing at length these burned-out embers. "There is an utter lack of honest evaluation in regard to what is called 'a love affair.' In ninety-nine cases out of a hundred the proper name would be 'lust affair;' if people were honest, which few are . . . love, while it begins with physical desire and passion, is more, much more, than that. It is a matter of growth, of quality, of breeding, of strong sympathy, of shared troubles and joys. In other words, a roll in the bed with honey isn't love! And the tragic part of it is that you never learn this until you're past the age for it to happen to you again."

In 1923 Nellie died and Flagg remarried the following year. He refused to discuss his marriage to the young and beautiful Dorothy Wadman, who had been his model, referring to this episode simply as the "worst mistake of my life." Only those who knew him intimately were privy to the news that his second wife, only a few years after the birth of their daughter Faith, suffered a severe psychiatric breakdown. For the rest of his life, Flagg supported his wife in an institution, and he never remarried.

Flagg was already 48 years old when his daughter was born. His lifestyle was not ideally suited for paternity, but within his limitations he attempted to make the best life for her he could. Faith was a beautiful child and Flagg adored her, painting and drawing her portrait frequently as she grew through

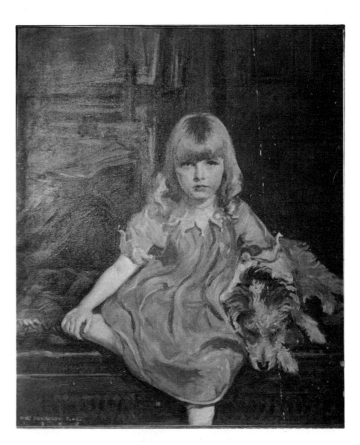

In his paintings and drawings of his daughter, Faith, Flagg displayed a tenderness seldom seen in his other work. Not an ideal father, he was nevertheless devoted to his only child. Photos courtesy Everett Raymond Kinstler.

the years. These tender portraits record the softest side of Flagg's personality, visual documents, perhaps, of the side he had little time or inclination to show to others.

Flagg described Ilse Hoffmann as the great love of his life. If ever he spurned the notion of love at first sight, he altered his sentiments when he laid eyes on Ilse for the first time in his studio. Yet from the moment she came to his studio as a model, the relationship between them was touched with tragedy.

Flagg's second marriage had already collapsed and he was defenseless against this unpredictable German beauty named Ilse. Half Flagg's age, Ilse was a complex and unhappy woman. Enraptured with her beauty, Flagg felt perpetually compelled to paint her, in spite of her being a poor model because she hated to pose. He was dazzled by her physical grace, her humor and intelligence, by her good taste and her coquettish manner. Even her unhappiness evoked Flagg's protective instincts, and he cared for her in a way he had never before experienced. For almost three years their relationship continued, intensely gratifying for both, until her interest began to dwindle. She wanted to be married; he, knowing the limitations of marriage, refused. She became promiscuous, would ridicule him in public, teasing him unmercifully and, finally, in the most hurtful gesture of all, introduced him to the man she intended to marry.

Flagg would see Ilse periodically (and unwillingly) between her unhappy marriages and they resumed their relationship after she left her second husband. In spite of the pain they each inflicted and endured, the rapport between them persisted until the end.

Ilse committed suicide in her apartment one night. Flagg never fully recovered from the loss.

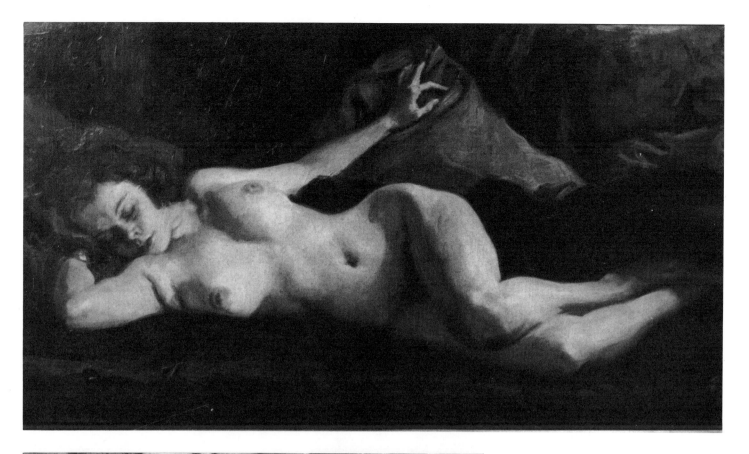

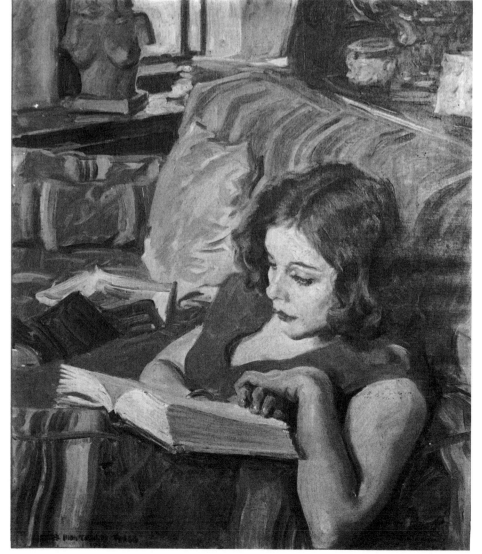

(Above) Treasuring his nude of Ilse Hoffmann, Flagg hung the painting over his mantelpiece in his 57th Street studio. The painting disappeared mysteriously from this room immediately after Flagg's death. Photo courtesy Everett Raymond Kinstler.

(Left) Because she hated to pose for long periods of time, Ilse was frequently painted while engaged in some activity. Being an avid reader (particularly of macabre books), she submitted to this painting without interrupting her train of thought. Photo courtesy Everett Raymond Kinstler.

(Opposite page) Flagg and Ilse Hoffmann attended an exhibit of Flagg's paintings and drawings. This is a rare photograph of them together. International News Photo.

I Mean to Say!

By JAMES MONTGOMERY FLAGG

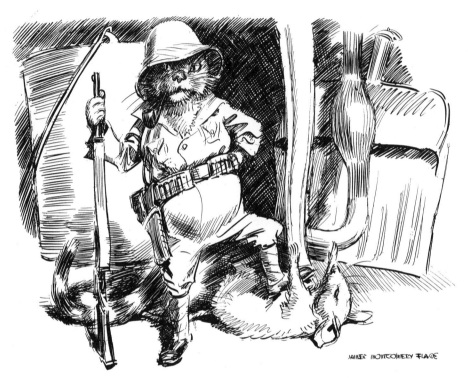

Conscience Vaseline

THERE was a photo in the "roto" of a Sunday paper of a great dead bear. The caption below it explained that this animal was forty years old—he had been a decent enough citizen to get away with forty years— and that he had been killed because he had killed some deer!

The implication was of course that the big-hearted hunter who had stopped old Bruin—as Ring Lardner would call him—from padding about the woods had performed a noble, necessary act of righteous retribution.

This ferocious beast had wantonly murdered some innocent, harmless deer with eyes like motion picture stars. He deserved to die. Especially if he was dumb enough not to know that these same dainty-footed deer were desired as targets by gentlemen with rifles.

Beasts kill for food. Gentlemen for pleasure. But gentlemen seem to feel better about it if they call it something else. Some pussyfooting weasel word like "sport".

their bunnies by the billion. They had to or themselves go under. They were at least honest about it. They didn't say it was because the rabbits were killing the dear little field mice. When they kill wolves in the West they do it to save themselves and their stock.

But it's nauseating when false sentimental reasons are given, when men become furiously virtuous and pretend to be shocked at the cruel slaughtering of the weaker animlas by the stronger. And these same people killing animals weaker than themselves, by the millions, behind the mask of sport or outraged sensibilities.

I was highly entertained last summer over the controversy in England over the alleged cruelty of the American rodeo, bulldogging, etc. Such criticism was funny coming from people who have "stag hunts"—Hunts! The stag is brought to the fields in a van and then turned—lashed—loose, with a whip, when the bewildered animal stands wavering at the tail of

Men in the great abbatoirs who kill pigs have as much right to call their doings sport. At least I have never heard of their protesting noble alibis or that the pigs snapped at them and they slew them in self defense!

There are reasons for everything people do. Sometimes they are not nice reasons, not reasons that boost their self esteem, so they employ other ones to fool the nitwits.

In the dim future when the animals are more enlightened, go to high school and have Rotary Clubs and cigarette coupons, I can see a photo in the roto of a Sunday Cat's Meow. The picture shows a pompous and complacent cat in a pith helmet, standing with one foot on the dead body of a mouse. The caption under it reads:

MARAUDER SLAIN!

Tom Tortoise-Shell, the well known big game hunter and his quarry.

This fierce sabre toothed old villain who has long been a terror near the

In 1927 Flagg began to write a weekly syndicated column entitled I Mean to Say! *Three columns of his text, accompanied by his pen and ink illustrations dealt with outlandish subjects taken for granted in everyday civilized life.*

From the outset of his career as an illustrator, from the time he sold his illustrated Latin axioms to *St. Nicholas* in 1898, James Montgomery Flagg interlaced his pictures with the printed word. He loved good writing. Small wonder that this articulate man, with many opinions and a rapier wit, was a frequently published writer himself.

Flagg did his first professional writing at 16 when he was sent by *St. Nicholas* to report on the Chicago World's Fair of 1893, an assignment for which he was paid $15 for 1500 words. In London his *Yankee Girls Abroad* was published in 1900. Between 1904 and 1908 Life Publishing Company published four Flagg books of limericks: *Tomfoolery*; *"IF", A Guide to Bad Manners*; *Why They Married*; *All in the Same Boat*. Collections of his satirical short stories were published in book form in 1914 and 1916 by George H. Doran Company: *The Mystery of the Hated Man and Then Some* and *I Should Say So*. For four years he wrote and illustrated *Nervy Nat* on the back page of *Judge. The Adventures of Kitty Cobb*, a Flagg version of the country girl who comes to the big city to find love and adventure, was published in 1912. A humorous account of his trans-continental automobile journey—*Boulevards All the Way–Maybe!*—was published in 1924. And his autobiography, *Roses and Buckshot*, was published by Putnam's in 1946.

Furthermore, during the course of these busy years, Flagg still managed to find time to write 24 short films, a weekly syndicated column entitled *I Mean to Say*, annual playlets for his club banquets (one of which—*The Critic*—was adapted for Broadway production) and countless other items that never appeared in print!

Like his drawings, Flagg's writings were sharp and targets were generally the conventions society holds sacred: motherhood, marriage, politics, children and pets. He dubbed his characters with such irreverent names as Mrs. Pearl Prunepincher, Matthew J. Pillweather, Stark N. Aked. Paul is the typical browbeaten husband, Polly the wife who subjects her man to the absurdities of social living: dinner parties, fashions, travel, picnics.

During World War One, Jack Eaton, backed by Eltinge Warner, invited Flagg to write the scripts for a series of silent film shorts. Flagg wrote the scripts, and the team created 12 films entitled *Girls You Know*. These were so popular that Flagg agreed to write 12 more ambitious film satires for two-reelers.

HORSE SENSE

Sir Charles bought a horse for a guinea,
And the brute was so dreadfully skuinea,
 That a friend said: "Of course
 It was meant for a horse,
But he hasn't got room for a whuinea!"

Limerick from All in the Same Boat, *Life Publishing Company, 1908.*

A Difference.

If you have no manners and you don't give a rap
 And you generally act like a boor
You're only eccentric, if millions you own—
 You're a vulgar old rip if you're poor.

Limerick from Tomfoolery, *Life Publishing Company, 1904.*

The Grouchy Swell

This beautiful person won't speak to a soul;
 He has a dull week on the water;
His people, you see, had bought Standard Oil
 When the shares sold at two for a quarter!

Limerick from "If," a Guide to Bad Manners, *Life Publishing Company, 1905.*

DO YOU SEE?

Intuition, deduction, observation as well,
And a masterful knowledge of life,
All figure as naught in our efforts to find
Why this pair became husband and wife!

Limerick from Why They Married, *Life Publishing Company, 1906.*

Acting in a few of the films himself, Flagg satirized his favorite subjects: The Western Film (*Perfectly Fiendish Flanagan*), Tarzan of the Apes (*Beresford of the Baboons*), Prohibition (*The Last Bottle*), Douglas Fairbanks (*One Every Minute*), and the proverbial Love Story (*The Bride, The Conductorette,* and *Hick Manhattan*).

Flagg was proud of his feat: he had actually written humorous films that did not rely upon slapstick. He was particularly proud of a review he received in the Boston publication, *The Eighth Art*: "James Montgomery Flagg's short film satires continue to be the only worthwhile productions of the current comedy field. They have real cleverness, snap and sparkle, speed and originality and go a long, long way toward reconciling the sophisticated to the moving picture theatre. Particularly so when discriminating taste has been so long nauseated by the stupid inanities of the 50-odd clowning buffoons who pose as screen comedians."

In view of the success of these films, Flagg was asked to write a two-reeler for the Marines and the official film for the Red Cross. Although he was urged to sign a contract with Eaton for more films, he refused: "It didn't amuse me anymore." The Red Cross production was his last.

Flagg could never have survived in a world lacking humor. "Without laughter life would not be bearable to me. If I were sent by the cerulean brass hats to heaven and I found no laughter, I would get the hell out of there if I could."

Strangely, one of the last poems he wrote, never published, was without humor. Here are a few lines from this long poem:

Flying past my window I saw a butterfly,
Its wings slowed down with city soot,
A stranger from a bluer sky.
A lepidoptera, delinquent,
 tired of home pasture land,
Of gray stone walls by graceful ferns,
Of hidden brooklets gliding gently through tall grass
Where sweet-flags stand in clear water—
Wet, watchful frogs—still as green china . . .
Some careless ones call this Peace.
It's never peace as long as creatures breathe
Although it has beauty—in spots.
But the sooty, bewildered butterfly in 57th Street,
Zigzagging wearily past my studio window
Knew nothing of this.
He was restless, he wanted excitement.
Who shall blame him?
He'll drop exhausted to the pavement later
And a gangster's brat will step on him
And laugh unmusically.
Oh, yes, you give a damn!
It's life you're seeing . . .
One day they'll step on you!

HOLLYWOOD CELEBRITIES

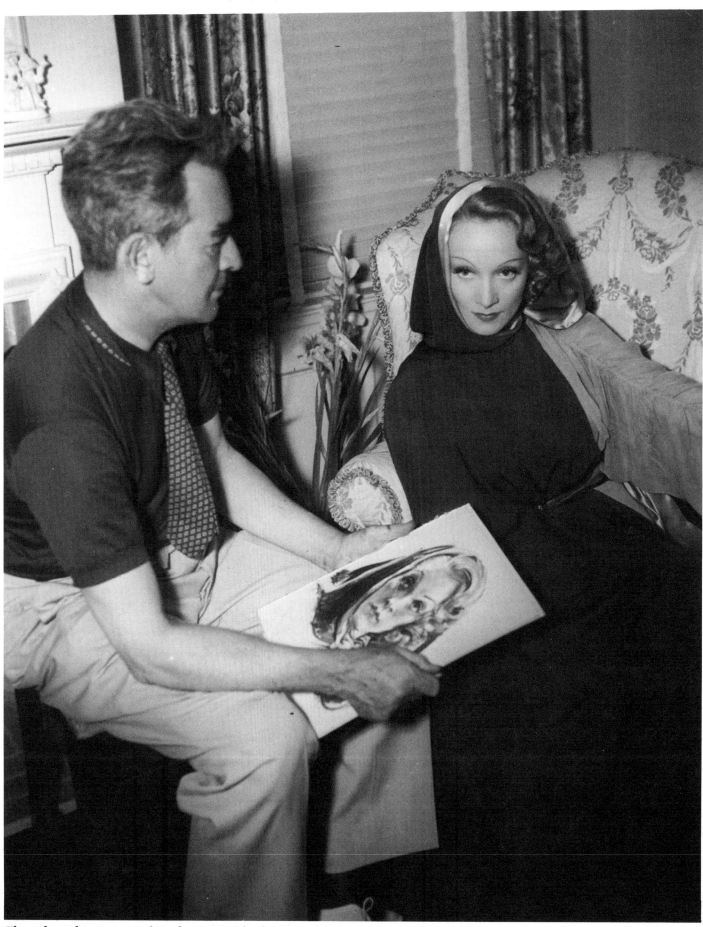

*Flagg drew this portrait of Marlene Dietrich while she was filming **The Garden of Allah** in Hollywood. He was astonished that she expressed no interest in seeing the finished drawing. Photo courtesy Everett Raymond Kinstler.*

Flagg's humor was his eloquence. Through laughter he expressed all his sentiments, including admiration. Insults, particularly when they were made publically were frequently an indication of love; those who knew him well recognized the difference.

He enjoyed leveling insults at actors and considered himself an authority on the subject: "I don't think acting is a high art," he said in a 1928 article appearing in *Theatre* magazine. "Only actors think so. I am backed up by one fairly well-known actor —Jack Barrymore. He told me years ago that acting was not much. All you had to do, said he, was to put some red paint on your nose and walk on! I didn't fully agree with him; I felt that you also had to put on a pair of pants."

A natural actor himself, Flagg observed in the same article: "A successful actor needs animal magnetism, good looks, the power of observation, a first class set of bowels, a temper, some culture, presence of mind (as in auto driving), lots of friends and no family ties; a little imagination helps too, And I forgot to mention—engagements."

Why bother with actors? "I have always been a theatre person. I like actors—some of them. But I wonder if all that swank is necessary! Maybe it keeps them up, between engagements. A theatreless world would be dreadful."

And those who knew Flagg were convinced that a life without actors would have been a lonely world for him. He thrived on the excitement of the theatre. When the focus of the entertainment world shifted from the legitimate theatre in New York City to the gala films in Hollywood, James Montgomery Flagg was not far behind. His portfolio included the portraits of every notable actor or actress of the times. Until the 50s Flagg's charcoal portraits of these film dignitaries appeared in each issue of *Photoplay*. A portrait by Flagg meant an actor had arrived.

Flagg made his first trip to Hollywood in 1903 and returned several times through the years. He raised his glass at countless parties, enjoyed the company of beautiful women, and made many friends (and enemies) as usual.

Finding discretion an unnecessary bore, Flagg never hesitated to declare his opinions of the celebrities he drew and painted. Like the drawings, his commentaries were forthright, bluntness being a virtue he valued highly. So quotable was he that his remarks appeared regularly in the press and a group

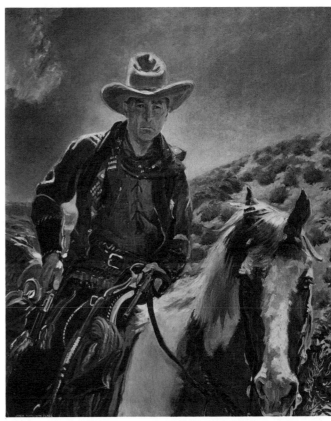

Flagg painted this portrait of his great friend William S. Hart while he was in Hollywood in 1924. He painted Hart and the horse separately because the horse was so restless. With a gun in each hand Hart sat patiently in a saddle that had been placed on an old barrel in the garden. After ten sittings the painting was complete, Hart complaining regularly that his face was tired from holding the ferocious expression for so long. Photo courtesy Everett Raymond Kinstler.

A more finished portrait was required for this great beauty of her day, Madeleine Carroll. He drew her portrait several times. International News Photo.

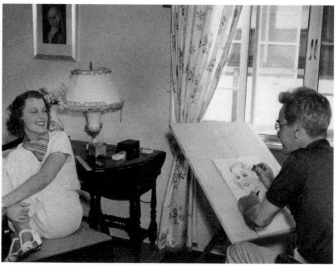

Flagg drew the singing star Jeanette MacDonald in her Hollywood dressing room at the time she was filming San Francisco with Spencer Tracy and Clark Gable. Photo courtesy Everett Raymond Kinstler.

Shortly after he won an oscar, Emil Jannings sat for a Flagg drawing. Jannings inscribed this photograph in German. Courtesy Everett Raymond Kinstler.

Gary Cooper was one of Flagg's favorites. Shortly after making this drawing in the broiling sun, Flagg joined him for a cup of tea indoors. Flagg was amused by this choice of beverage.

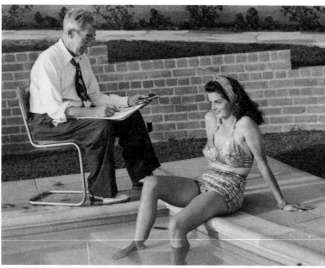

When he sketched Jane Russell at her swimming pool in Beverly Hills, she confessed that she liked Flagg because he reminded her of her grandfather. Photo courtesy Everett Raymond Kinstler.

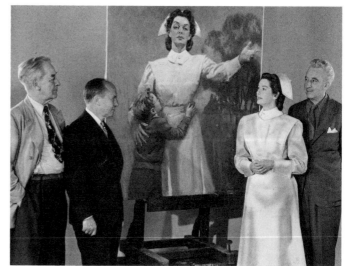

Shortly after he completed this painting of Rosiland Russell as Sister Kenney, she patted Flagg on the shoulder and said, "You certainly can paint, you old bastard." Flagg regarded this compliment from Russell as a genuine accolade. Photo courtesy Everett Raymond Kinstler.

of his drawings and commentaries were collected in a volume entitled *Celebrities*, published by Century House in 1951. In fact, his remarks were so often repeated that few know where they actually originated.

The list of actresses he considered most beautiful included Hedy LaMarr ("It would be only a blind and deaf man who wouldn't fall in love with her. She would be the only living woman I would forgive for not having full breasts"), Joan Fontaine ("She has everything"), Greta Garbo ("I can think of no woman I would prefer to draw and paint"), Merle Oberon ("Much more beautiful to meet than to see, even on the screen"), Rosiland Russell ("There's a grand gal").

Even when the joke was played on him—rather than the reverse—he didn't mind repeating it. For example, he loved to tell the story of drawing Jane Russell ("Perhaps the last word in sultritude") at her swimming pool. As they left the pool, she took his arm seductively and told Flagg that she liked him. Enormously pleased with himself, Flagg asked what she liked about him. "You remind me of my grandfather," she replied. He had no comment.

When Katharine Hepburn swept into his studio for her sitting, characteristically dressed in flowing trousers, she sat down and put her foot on the coffee table. "When do we begin?" she asked Flagg. "As soon as you sit like a lady," he retorted.

Marlene Dietrich surprised him by her indifference. She sat silently for almost two hours as he worked on the drawing. When he announced that he had completed his work she said "good," rose, and took leave without expressing any interest in seeing the drawing.

Although he preferred drawing what he called "the young lovelies", he found them to be pretty much alike in later years. Well after the 20s, Flagg admired the new crop of beauties: "I appreciate the new fashion of their having regular women's breasts, so that one can predetermine the sex at a glance."

Flagg's comments about the actors he drew were equally to the point: W.C. Fields ("The greatest and subtlest low comedian of his era"), William Powell ("A special favorite of mine, intelligent, witty, sensitive to others, and a gentleman. I'm sure he wouldn't mind my saying I classed him with Barrymore."), Victor Mature ("Almost too good looking, but no swish about him."), Bob Hope ("World famous for his giving joyous laughter to millions. Maybe he *is* funny!")

Flagg's great Hollywood friend was William S. Hart, an actor noted for his expert handling of two flashing six-guns in the many Western films he made. At the time Flagg satirized Hart in his film *Perfectly Fiendish Flanagan*, he did not know the actor. Too slow to recognize that Flagg's film was satire, Hart's Eastern movie associates grew alarmed when they saw the film, fearful that Flagg was stealing Hart's material. They alerted Hart to the peril, but when Hart finally saw the film privately, he recognized instantly the humor and "nearly ruptured himself laughing." They became good friends shortly after this episode, Flagg staying for two weeks with Hart in Hollywood after making his arduous cross-country journey by automobile in 1924. "What he portrays on the screen—a fine, clean soul, simple, dogged, strong, passionate in his likes and hatreds, a keen sense of humor, a lover of animals—it is all there." During this visit Flagg painted Hart's portrait in the garden.

On one of his visits to the West Coast Flagg met Greta Garbo at a party. They spent the entire evening together, each equally spellbound, paying no attention to anyone else at the party. "Her combination of character and beauty enthralled my imagination and this 12-hour affair, although emotional, was curiously sexless. That sounds odd, even to me, thinking as I do of Garbo as nothing if not a siren." Two years after that party, Flagg returned to California and tried to get in touch with her, but the spell was over and she refused to be disturbed by him. He never saw her again. Flagg remarked 20 years later: "I've always regretted that I was stupid enough not to take Garbo up on her offer that night to come East and be my model. I can't guess what would have happened—but it would have been worth it!"

His Hollywood drawings for *Photoplay* mark the last phase of the artist's work. Before long, even Hollywood passed him by.

THE FINAL YEARS

"I really died twenty years ago, but nobody had the nerve to bury me," James Montgomery Flagg said sadly. "I'm sick of illustrations and they're sick of me."

Yet even in his final years, Flagg never lost the spikey public image he had worked so long to perfect. Newspaper interviews with Flagg appearing periodically continued to portray him as the sassy personality he had always been. His witty commentaries on modern art and beautiful women still appeared in journals: "Physically attractive women are the most plentiful thing produced in America. My only regret is that (with failing eyeseight) I miss seeing the new beauties."

Flagg was repelled by the values of the new generation. Refusing to withdraw into the serenity of old age, he struck out at the new values, alienating a generation that no longer needed him: "We overplay and overemphasize 'youth' and make a race of unbearable smart-alecks. Anyone who has traveled knows how badly American kids are reared. They are allowed to 'express themselves' to the disgust of all civilized people. No artist could look at them with anything but disgust."

And elsewhere: "I know why there are so many pretty girls in New York. All the ugly ones are in college."

He continued to ridicule the new generation of artists: "The most amazing aspect of the whole modern movement to me is the fact that such brazen and obvious nonsense could have been foisted on the public, even the United Sheep of America." His beloved publications no longer demanded his services, preferring photography to original illustration. (He called *Life* a "photomural.")

As Flagg entered into his late years, he found himself virtually alone in the two hostile worlds he found intolerable: an art world that he did not comprehend and the world of old age, which he deplored.

Indeed, in the art world the torch had been passed on to a younger generation of artists. Just as Flagg was contemptuous of the work being produced by younger artists, so had it become fashionable—for those who remembered him at all—to denigrate Flagg's achievements. In *Art News*, for example, a reviewer called his charcoal portraits "full of obvious tricks" and his oil paintings "either too slick or too dry." Another reviewer labeled "Flagg's draftsman-

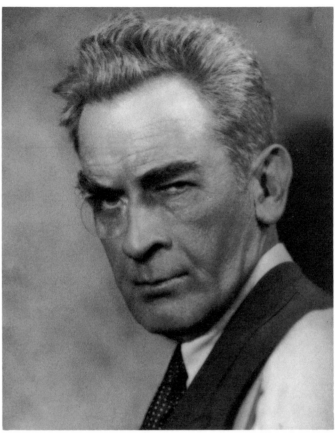

Although he never actually wore one, Flagg liked the idea of being portrayed with a monocle. He welcomed an opportunity to wear the monocle for this late photograph by Hal Phyfe.

ship and interpretation clever, but superficial, projecting a bluster that masked his artistic limitations." Reviews of his autobiography, *Roses and Buckshot*, contained personal swipes against the author: he was an "ego-maniac," he had "an exaggerated sense of self-importance." Yet these attacks, in themselves, would not harm a man who was so well-practiced in the art of making enemies. He was, after all, confident in his worth as an artist, and no reviewers could diminish that value. Moreover, what pained Flagg far more was being ignored, not being singled out for rebuke. Obscurity was more frightening.

Above all, it was old age that he could not accept: "I loathe what that ruthless sadist Time does to everything. I know what he has done to me—to the last wattle and potgut." In a paper delivered in 1960 to the American Life Foundation Institute on Aging, G.L. Freeman presented a moving account of Flagg's attitude to his advancing age: "I hate old age like a flower cut off from life and wilting, even the recall of a

gay past gives an unbeautiful picture and a nauseating smell."

For a man who had—from his teens—been in the spotlight, these final years in his studio on 57th Street, his failing eyesight (the result of two heart attacks) preventing him from working any longer, were unbearable for him. As Freeman quoted Flagg: "I can't stand the look of my present age. All my life I have been a worshipper of that beauty of human form you see in some men and women. All my life I have associated with the clever and witty, the brains you find in some people. Is it any wonder I don't like to look at the physical mess and mental dullness that has set in for me? As far back as I can remember, I've been in the limelight; now I'd rather be dead than be passed by, ignored."

Unlike many of his contemporaries, Flagg lived to see himself drift into obscurity, a painful process for one who never cared about the future. He may have been proud of his youthful abandon ("I've always been more interested in battling life today than in trying to build a dead tomorrow"), but he paid a price for it. In his younger years he made many friends, but the friendships were neither lasting nor profound, and for all his merry escapades with beautiful women, Flagg was without consistent female companionship in the end. In fact, his closest friends in the final years were much younger than himself: "I rarely see most of my best friends nowadays. Some I don't see because they're dead; others are practically dead. I'm old enough to be the father of most of my pals, because I don't enjoy people my own age, they're shot and worn out."

One of his most devoted friends during these last, lonely years was a young artist (almost 50 years Flagg's junior), Everett Raymond Kinstler. A promising illustrator himself, Kinstler came to Flagg's studio regularly and Flagg shared some of the happiest hours of his final years in the company of this young and gifted artist who had admired the work of the elder illustrator since childhood.

James Montgomery Flagg died on May 27, 1960, three weeks before his 83rd birthday. Appropriately, for Flagg had always been headline copy, his obituary appeared on the front page of New York papers. He was buried at Woodlawn Cemetery in New York, and only 20 people came to pay their last respects to a man who was once "sitting on top of the world."

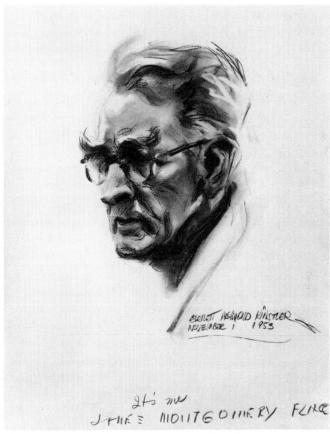

A young artist, Everett Raymond Kinstler, came to see Flagg at his studio on 57th Street. Introducing himself as an illustrator who had been greatly influenced by Flagg's illustrations, Kinstler became a devoted friend to the elderly artist through the final years of his life. After completing this drawing, Kinstler asked Flagg to make his own notation. Flagg's vision was already so poor that two attempts were required before he succeeded in writing out his name on the sheet without running off the edge.

In this last photograph of Flagg, he is pictured with his friend Kinstler. Flagg died two months after the photograph was taken, in 1960.

CHRONOLOGY

June 18, 1877. Born, Pelham Manor, New York, the son of Elisha and Anna Elida (Coburn) Flagg. Lived at Willis Avenue, Mott Haven, New York.

1880. Family moved to boarding house in Brooklyn.

1881. Moved to 144 Monroe Street, in Brooklyn with entire family: mother, father, grandmother Flagg, two uncles (Will and Francis), two aunts, cousin Stewart and cousin Mabel.

1884. Moved to 317 East 86 Street with the entire Flagg family.

1885. Moved to 1429 Park Avenue with parents and sister.

1889–91. Attended Dr. Chapin's School

1889. Sold first illustration to *St. Nicholas.* These illustrated Latin axioms appeared in an 1890 issue.

1891–93. Attended Horace Mann School.

1892. Already established on staffs of *Life* and *Judge.*

1893. Left school permanently; sent to Chicago to write on World's Fair for *St. Nicholas.*

1894–98. Attended Art Students League.

1898. Went to England with Richmond Kimbrough to study painting at Hubert Herkomer's School.

1899. Returned to America. Married Nellie McCormick in St. Louis. Returned to England with Nellie. Flagg's family now living in London, where Elisha Flagg worked for American Express.

1899–1900. *Yankee Girls Abroad* published. Went to Paris to study painting under Victor Marec. Became a portrait painter. Portrait of Marec hung in Paris Salon of 1900. Returned to America.

The Willard-Dempsey Fight, *the only mural Flagg ever painted, still hangs in Dempsey's restaurant in New York City.*

1900–04. Traveled with Nellie throughout America and Europe.

1903. *Scribner's* sent Flagg to Germany to write and illustrate an article on instrument-making.

1904. Flaggs settled in New York. Took studio on 67th Street.

1904–08. Four books of Flagg limericks published by Life Publishing Company.

1909. *City People* published.

1911. Dutch Treat Club founded.

1912. *The Adventures of Kitty Cobb* published.

1914. *The Well-Knowns as Seen by James Montgomery Flagg* and *I Should Say So* both published.

1916. *The Mystery of the Hated Man* published.

1917–19. Flagg designed 46 World War One posters.

1917–1920. Wrote 24 short silent films, produced by Jack Eaton.

1921. Rented studio on 57th Street. Continued to live on this block until his death.

1923. Nellie died.

1924. Married Dorothy Virginia Wadman.

1925. *Boulevards All the Way–Maybe* published. Daughter Faith born.

1929–1937. Flagg's association with Ilse Hoffmann.

1936–37. Two summer trips to Europe with father.

1937. Flagg's first meeting with Franklin Roosevelt.

1946. *Roses and Buckshot* published.

May 27, 1960. Died in New York City.

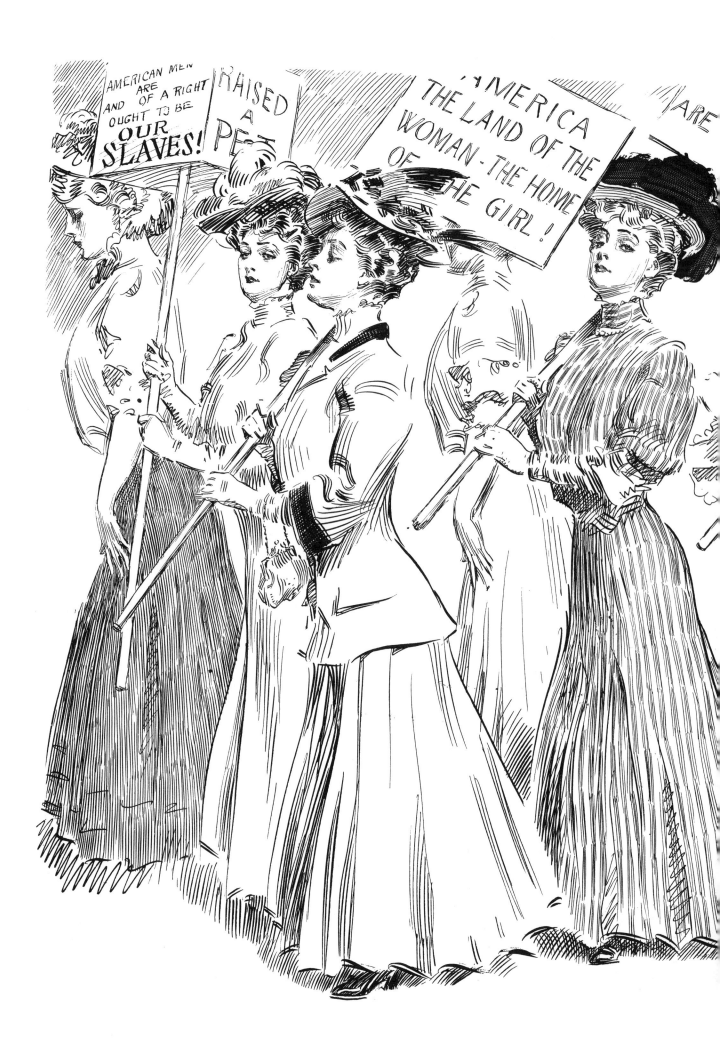

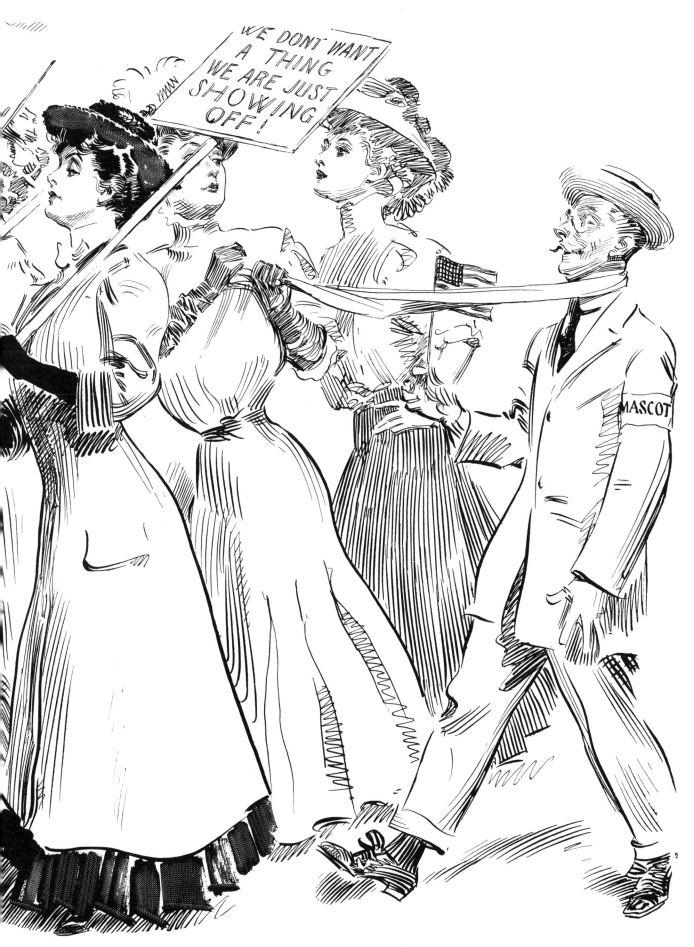

JAMES MONTGOMERY FLAGG

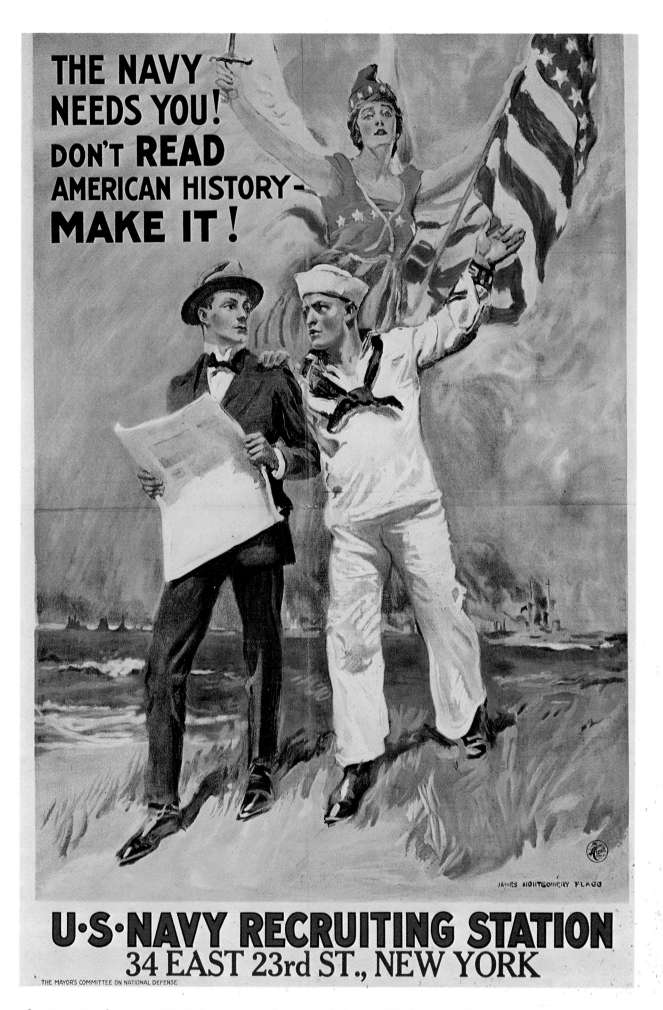

The Navy Needs You, 1918. Collection Naval Historical Center, Washington, D.C.

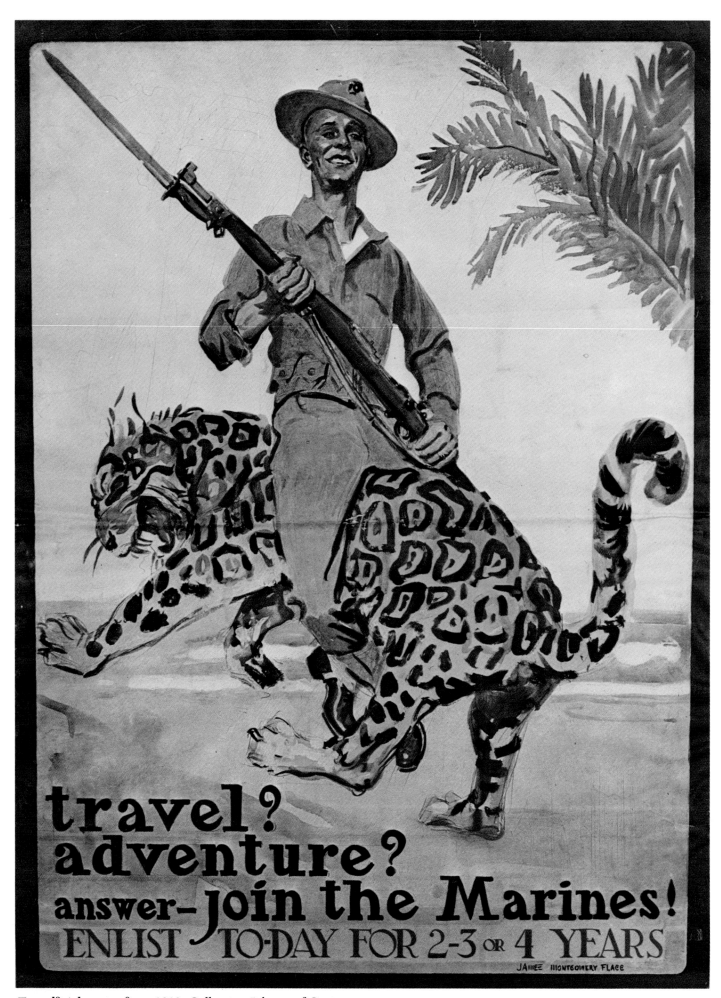

Travel? Adventure? ca. 1918. Collection Library of Congress.

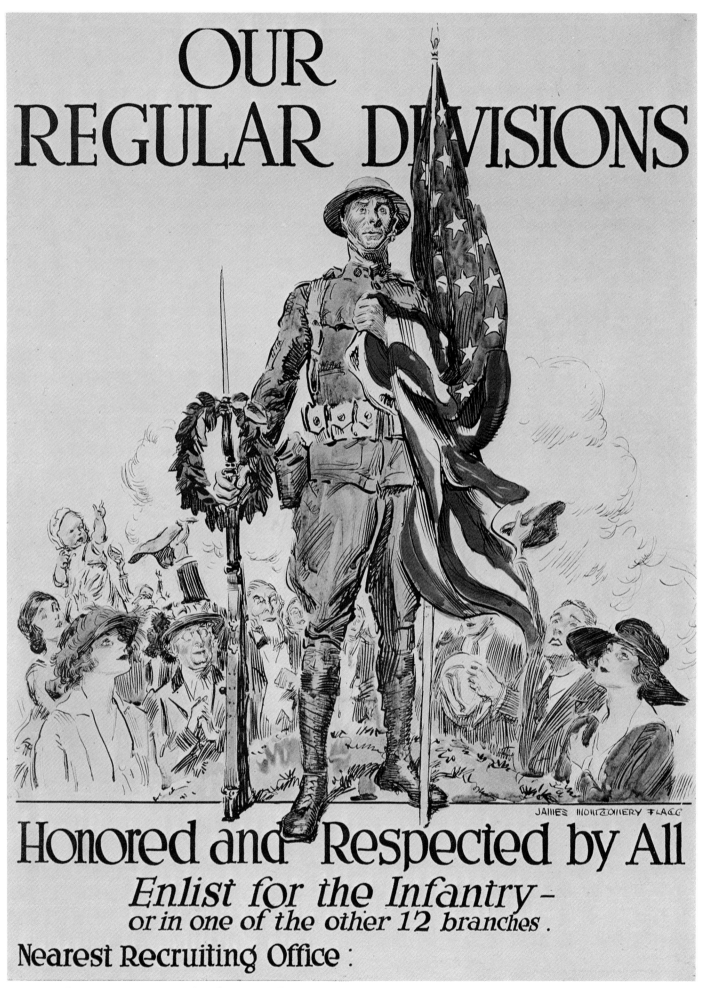

Our Regular Divisions, Honored and Respected by All, 1918. Collection Library of Congress.

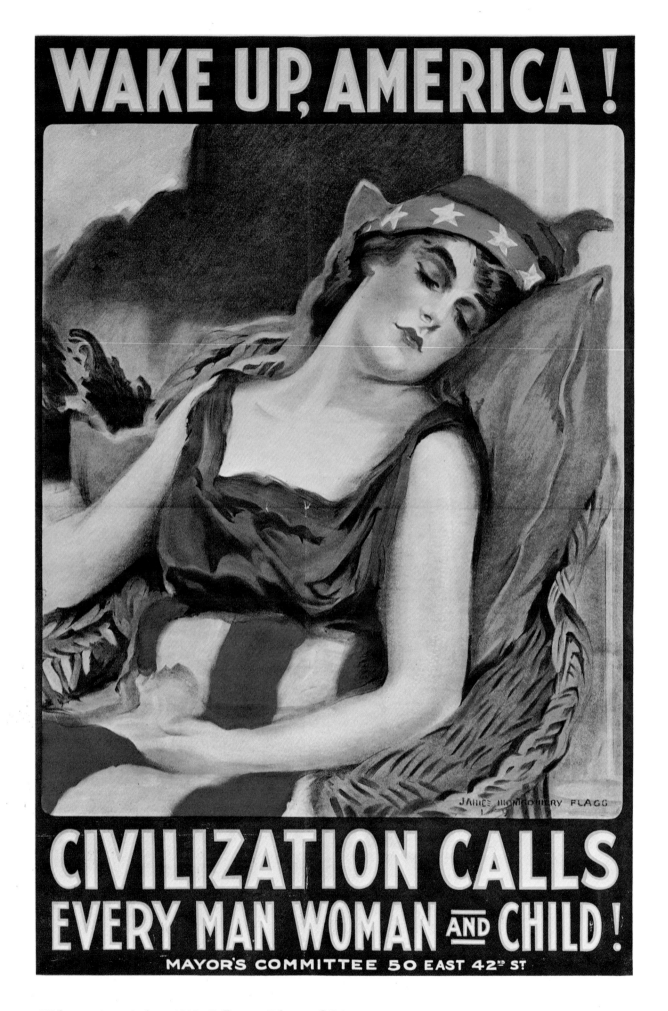

Wake up, America! ca. 1918. Collection Library of Congress.

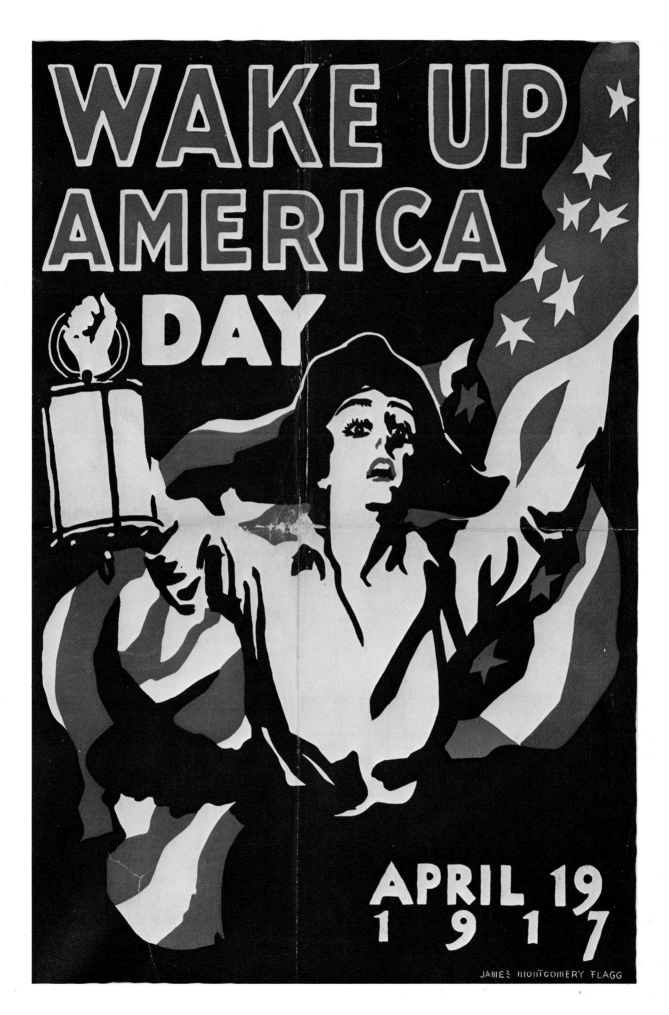

Wake Up America Day, 1917. Collection Library of Congress.

Together We Win, ca. 1918. Collection Library of Congress.

Hold On To Uncle Sam's Insurance, 1918. Collection Library of Congress.

Stage Women's War Relief, 1918. Collection Library of Congress.

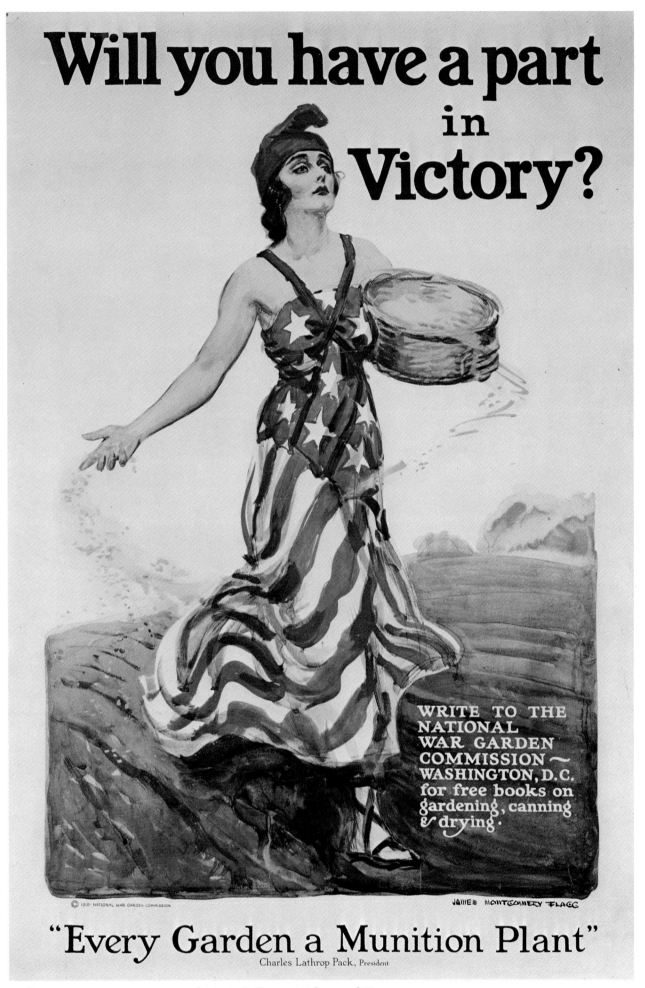

Will You Have a Part in Victory? 1918. Collection Library of Congress.

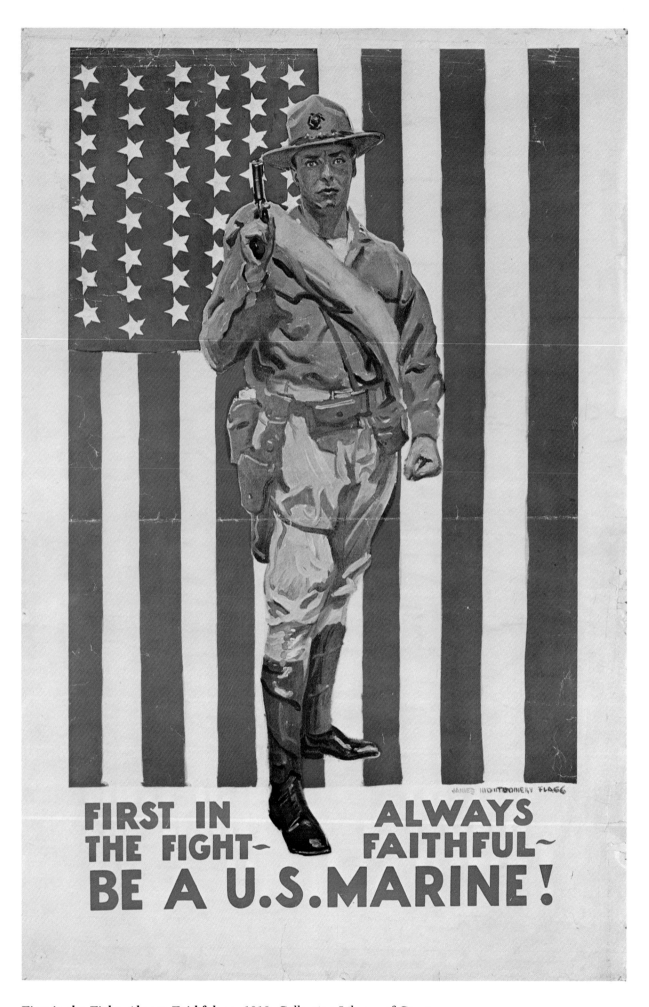

First in the Fight, Always Faithful, ca. 1918. Collection Library of Congress.

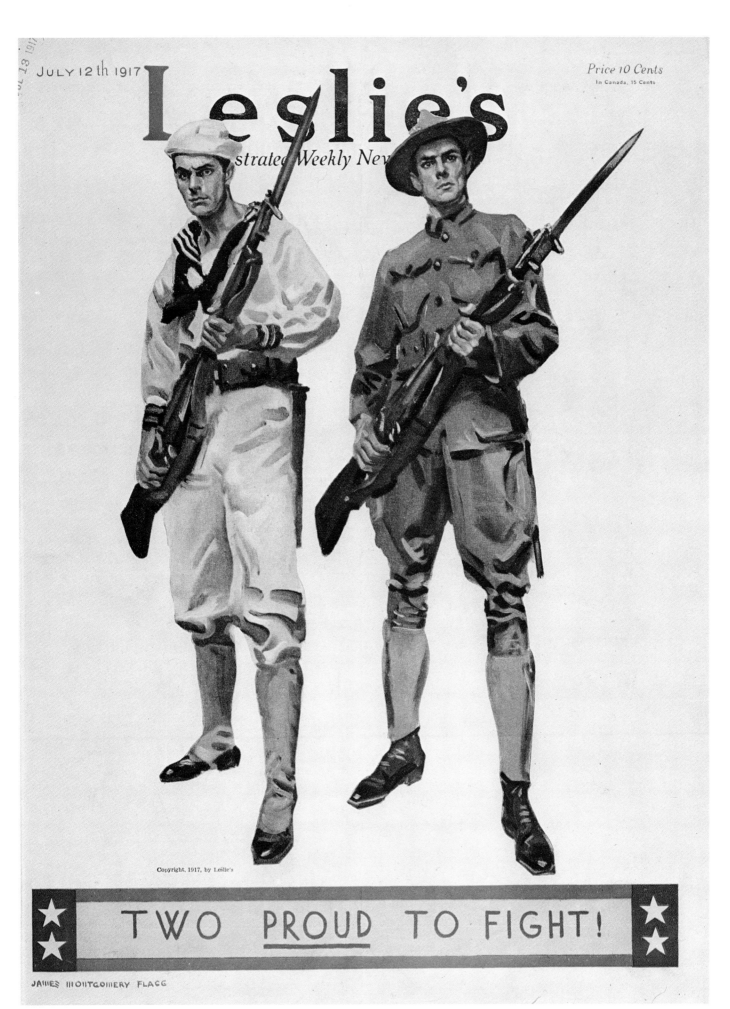

Two Proud to Fight. Cover for *Leslie's Weekly*, July 12, 1917. Courtesy New York Public Library. This design for the magazine cover was used for a War poster.

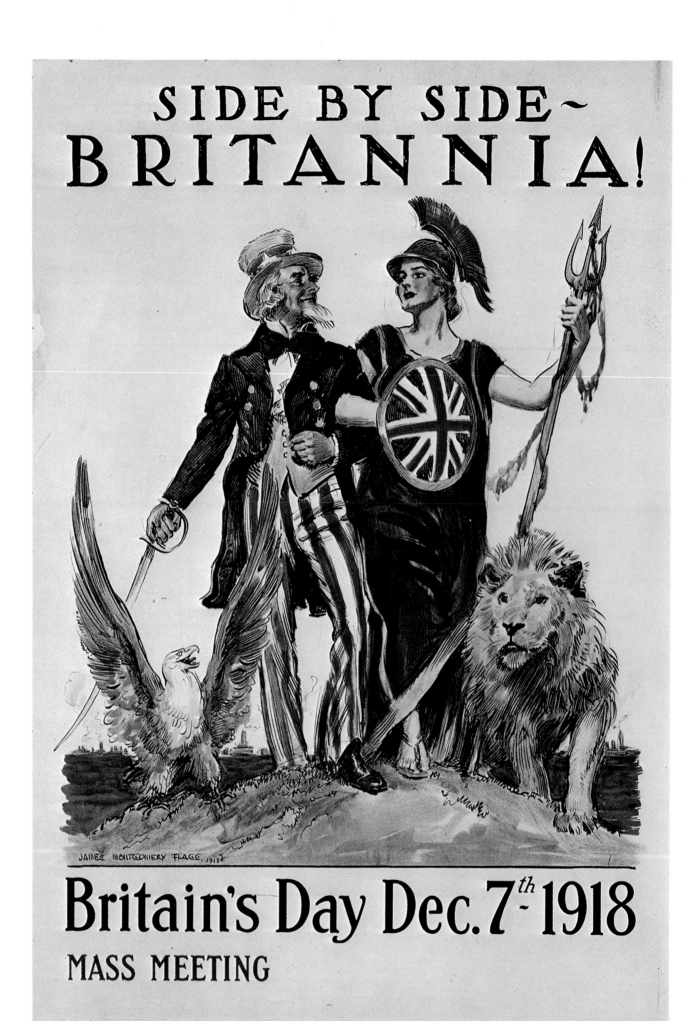

Side by Side, Britannia! 1918. Collection Library of Congress.

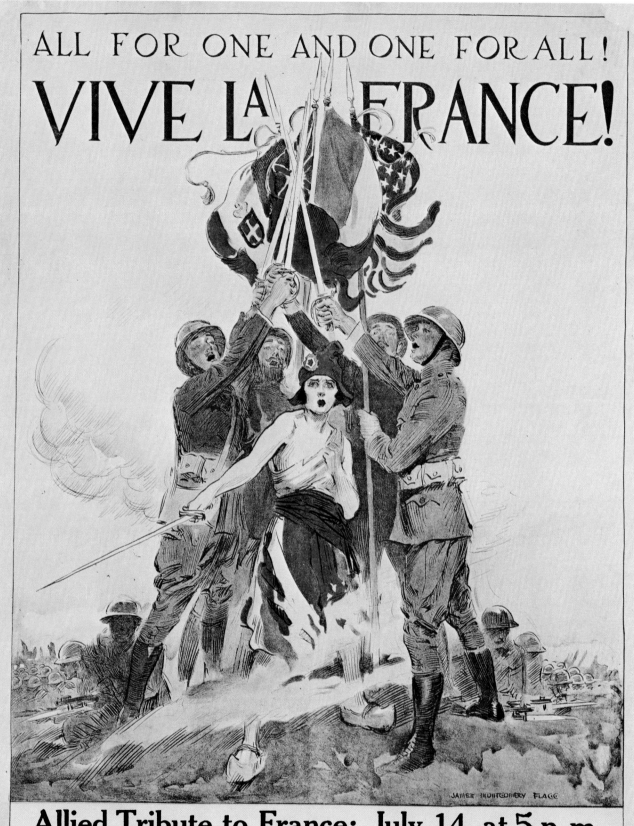

Vive La France, ca. 1918. Collection Library of Congress.

Boys and Girls! You Can Help, 1918. Collection Library of Congress.

I Am Telling You, 1918. Collection Library of Congress.

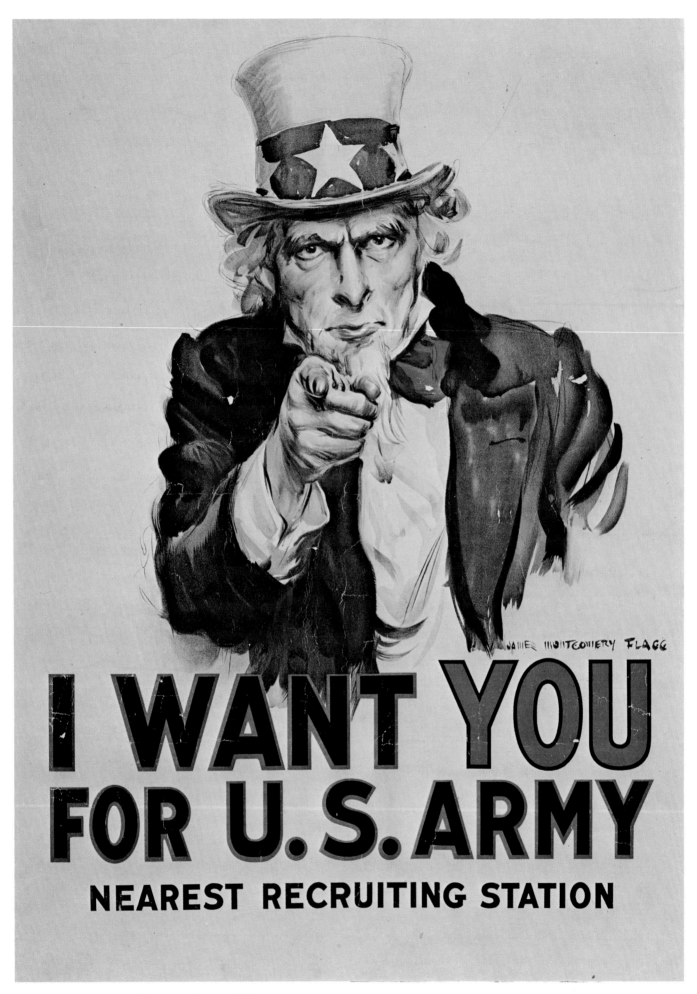

I Want You, 1917. Collection Library of Congress.

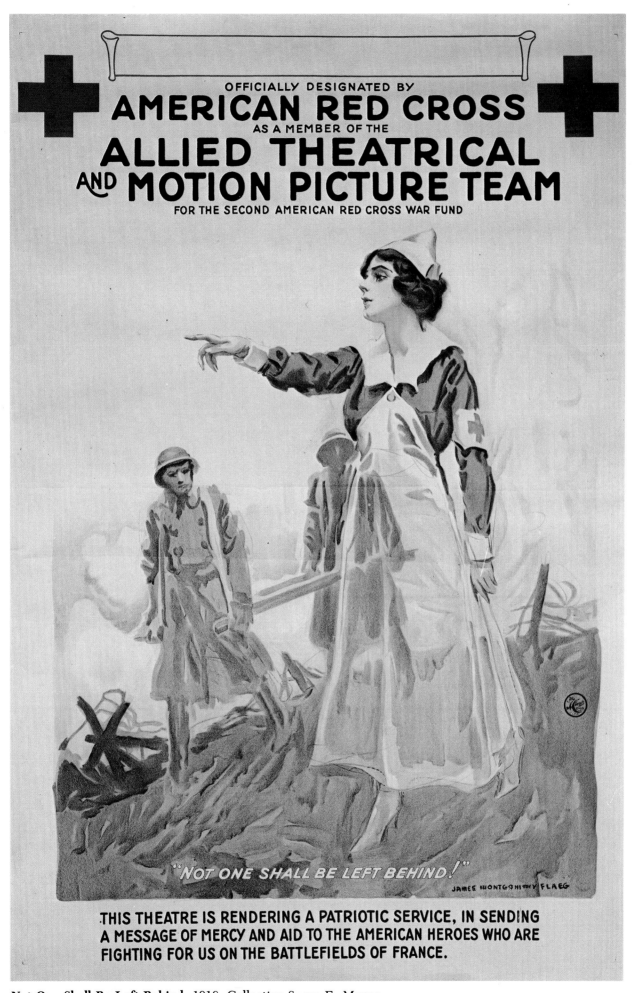

Not One Shall Be Left Behind, 1918. Collection Susan E. Meyer.

TELL THAT TO THE MARINES!

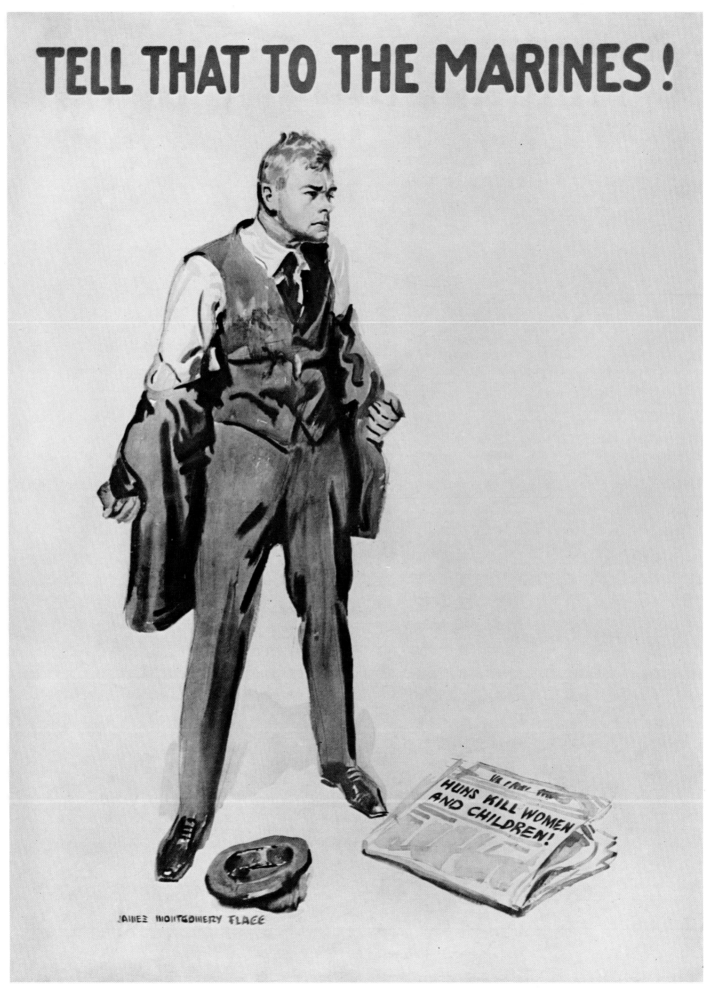

Tell That to the Marines! 1918. Collection Library of Congress.

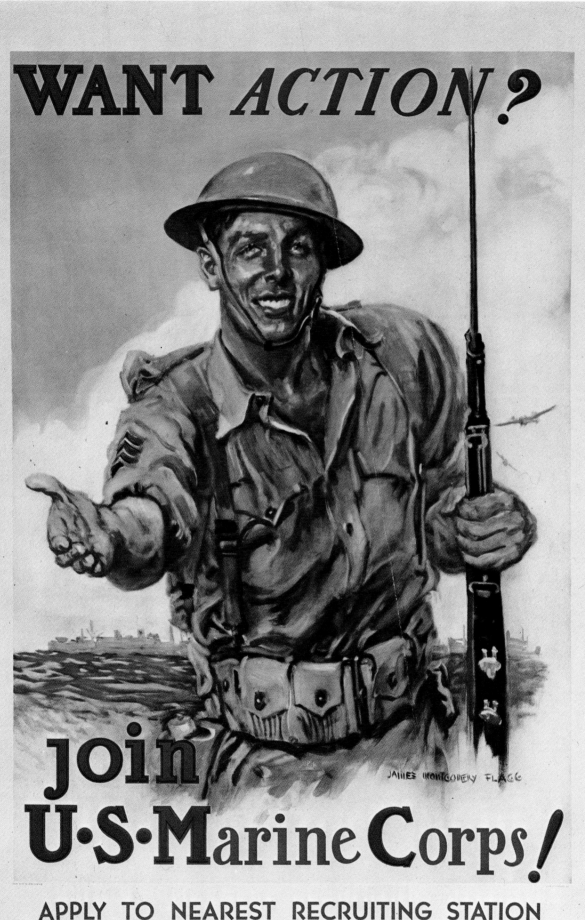

Want Action? Join U.S. Marine Corps! 1942. Collection Library of Congress.

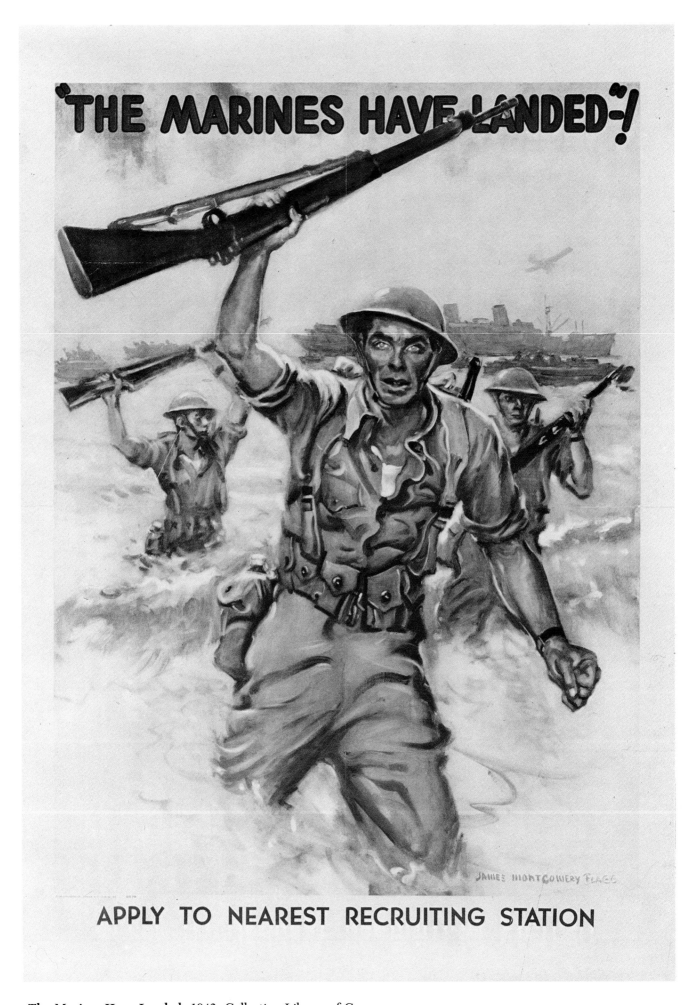

The Marines Have Landed, 1942. Collection Library of Congress.

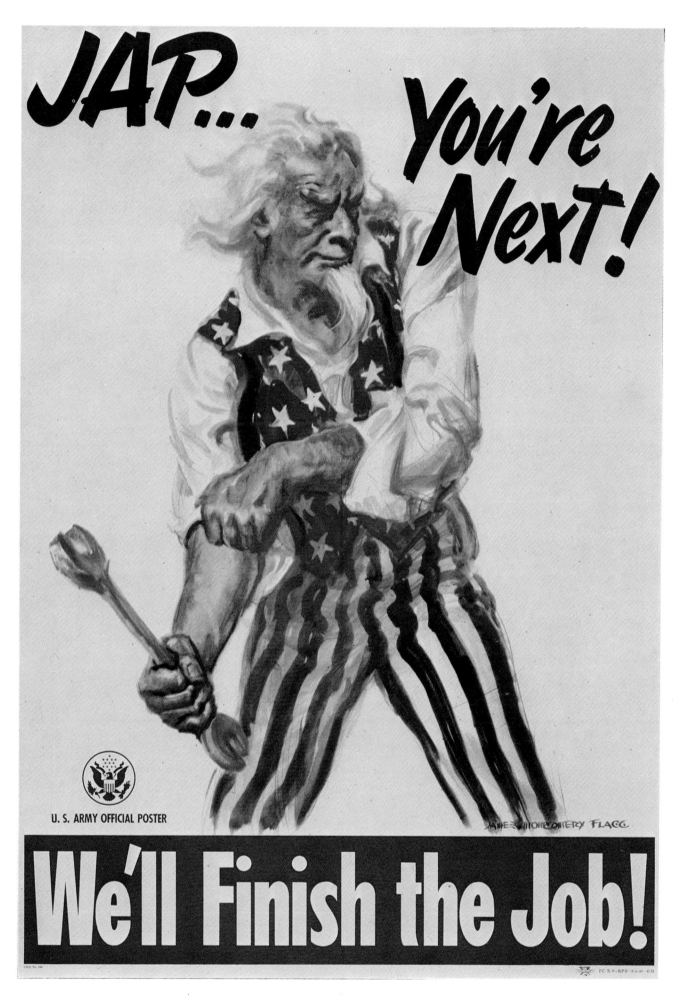

Jap, You're Next! 1942. Collection National Archives.

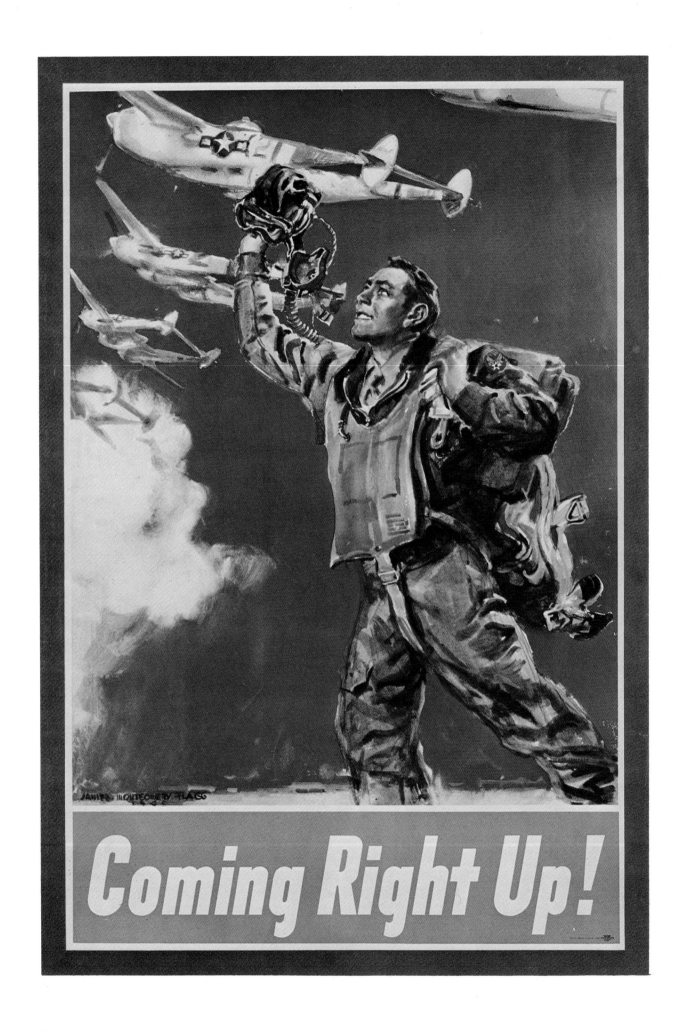

Coming Right Up! 1945. Collection Library of Congress.

The U.S. Marines Want You, 1942. Collection Library of Congress.

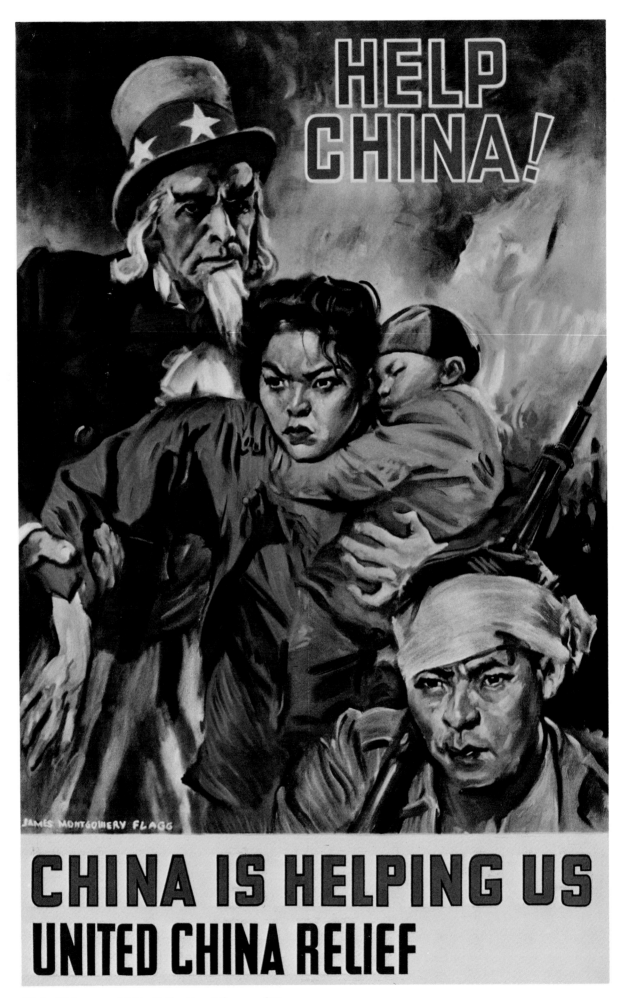

Help China, ca. 1944. Collection Library of Congress.

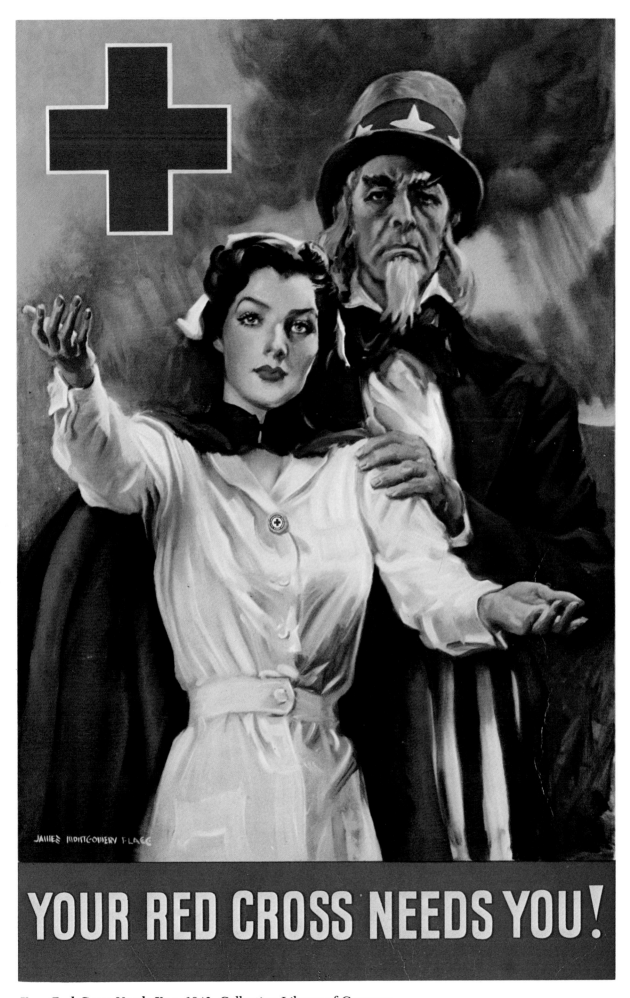

Your Red Cross Needs You, 1942. Collection Library of Congress.

You Can Lick Runaway Prices, 1944. Collection Library of Congress.

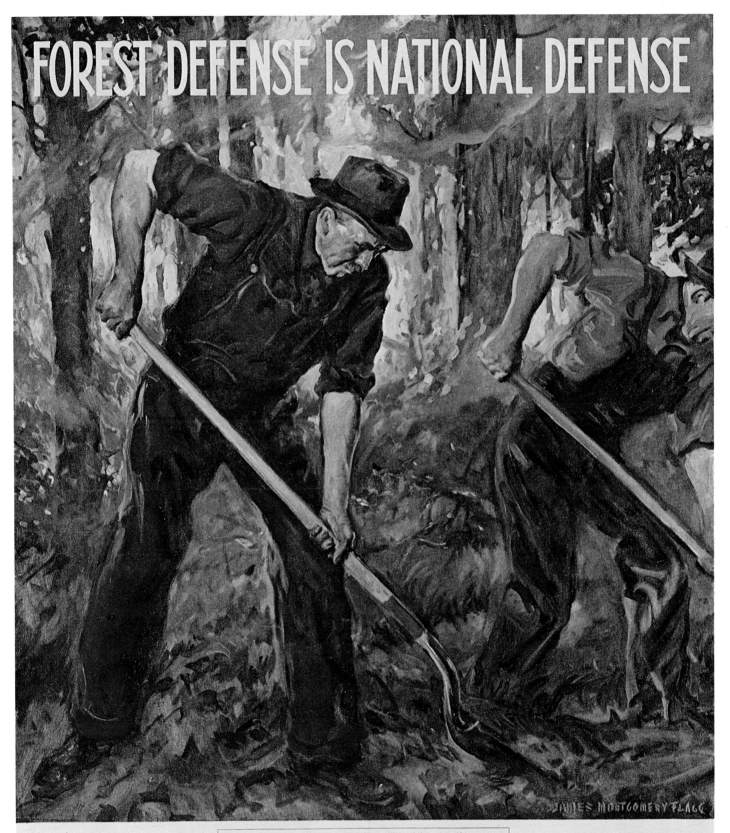

FOREST DEFENSE IS NATIONAL DEFENSE

Reprinted from The American Weekly, April 6, 1941

HOW TO PREVENT FOREST FIRES

MATCHES. Be sure your match is out. Break it in two before you throw it away.
SMOKING. Smoke only while stopping in a safe place clear of all inflammable material.
TOBACCO. Be sure that pipe ashes and cigar or cigarette butts are dead before throwing them away. Never throw them into brush, leaves, or needles.
MAKING CAMP. Before building a fire scrape away all inflammable material from a spot five feet in diameter. Dig a hole in the center and in it build your campfire. Keep your fire small. Never build it against trees or logs or near brush. .
BREAKING CAMP. Never break camp until your fire is out—dead out. Always leave a clean camp.

HOW TO PUT OUT A CAMPFIRE. Stir the coals while soaking them with water. Turn small sticks and drench both sides. Wet the ground around the fire. Be sure the last spark is dead.

BRUSH BURNING. Never burn slash or brush in windy weather or while there is the slightest danger that the fire will get away.

EXTINGUISH any small fire you can.

REPORT any fire you discover. Go to the nearest telephone and ask for the local Forest Ranger or Fire Warden.

Thank you.

Forest Defense is National Defense, ca. 1937. Collection National Archives.

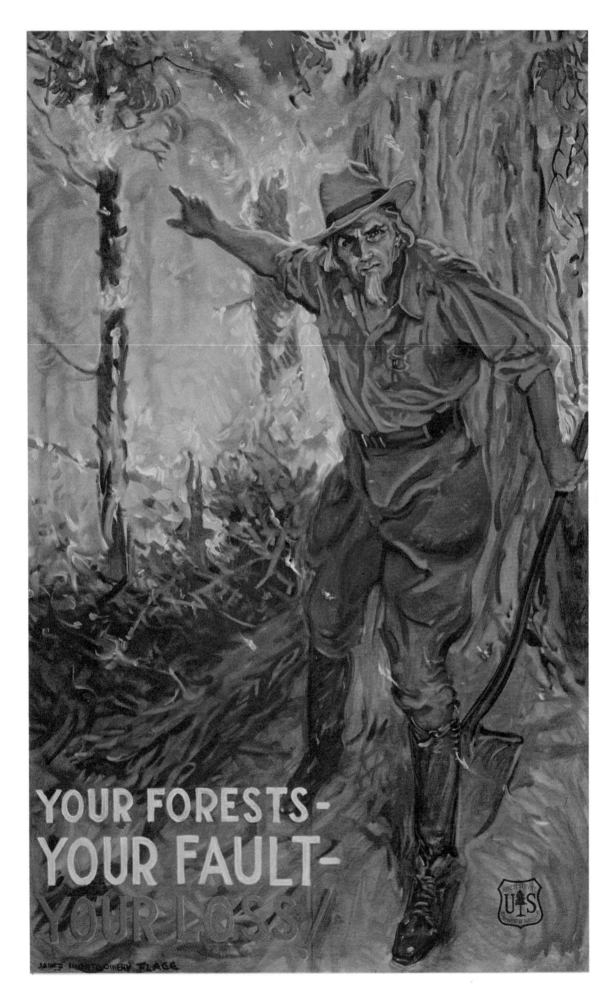

Your Forests, Your Fault, Your Loss! 1937. Collection National Archives.

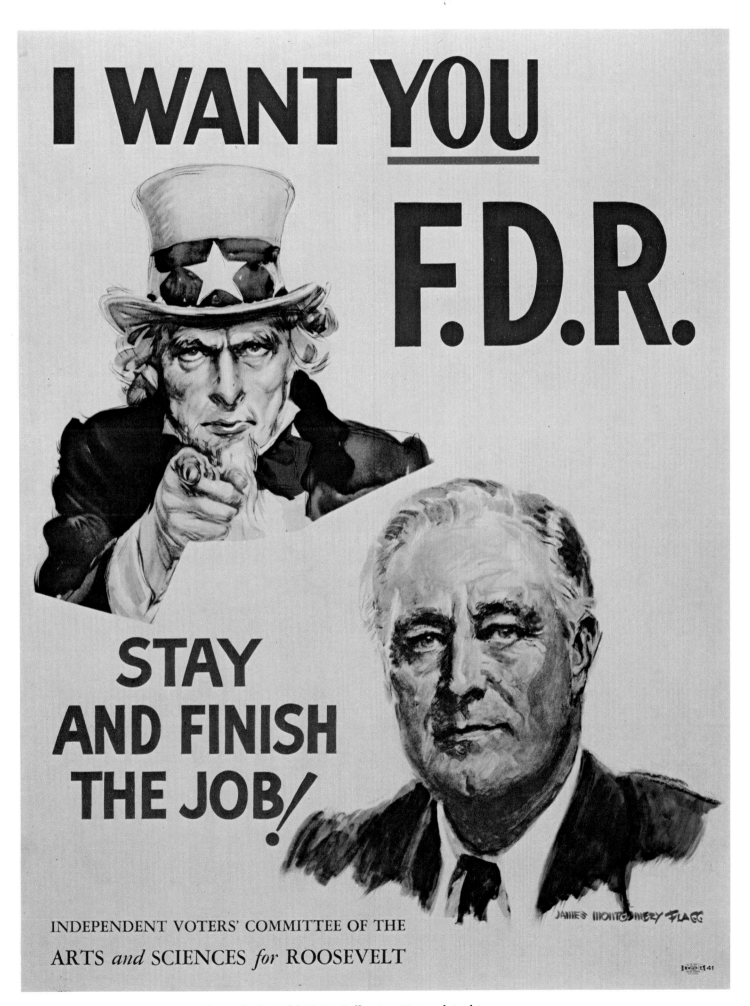

I Want You F.D.R. to Stay and Finish the Job! 1941. Collection National Archives.

Poster for Annual Lotos Club Minstrel Show, 1931. Collection Lotos Club, New York City.
Even a busy illustrator made time for personal use of his talents.

Poster for Annual Lotos Club Minstrel Show, 1932. Collection Lotos Club, New York City.

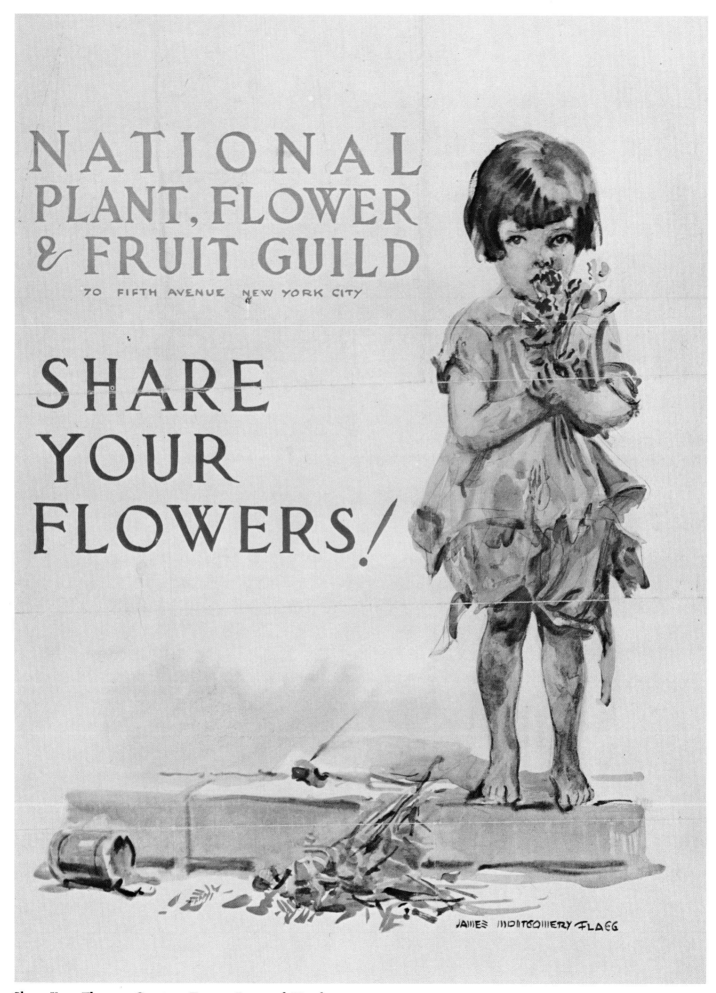

Share Your Flowers. Courtesy Everett Raymond Kinstler.

PEN AND INK ILLUSTRATIONS

In which Kitty Cobb, having an imperative craving for the city of big hopes—and the inexhaustible sum of $130—parts from her parents and Pleasant Valley. Although she is affectionate she sheds no tears. SHE is not being left behind. No, gentle spectator, she does not pine for the stage. Of course this apathy in regard to the allurements of the footlights is abnormal. Otherwise Kitty is a healthy American Girl. She is tired of the monotony of country life. Ed Randall, her mute and inglorious lover, hears the end of the world coming on down track. One tragic tear trickling down the sunburned nose is his last tribute to the girl that couldn't care.

Her Departure. Illustration for *The Adventures of Kitty Cobb*, George H. Doran Company, 1912.

In which Kitty has started to go out canoeing with that pup, Stevens. Bob, who was watching them came up to Stevens and, after telling him what he thought about three or four things, pushed Stevens into the water. He then took Stevens' place in the stern of the canoe. Kitty, as may be observed, is secretly gratified at this proof of Bob's jealousy. For what, next to a boiled New England dinner, is so satisfying as somebody's jealousy if you're mad at them and love them?

You Would, Would You? Illustration for *The Adventures of Kitty Cobb*, George H. Doran Company, 1912.

In which Kitty is having her eyes opened to married life by Mrs. Teune Owing, an older married woman. Mrs. Teune Owing, having picked out a rotter as a mate, logically declares that all men are alike and dilates bitterly on the consistent nastiness of males. Kitty being inexperienced cannot discount these cynical generalities. She will not believe that her Bob is like that—but there seems to be a chill in the sunshine. She believes she will walk back to the hotel.

Are All Men Alike? Original illustration for *The Adventures of Kitty Cobb*, 19¼" x 27¾". Courtesy Berry-Hill Galleries, New York City.

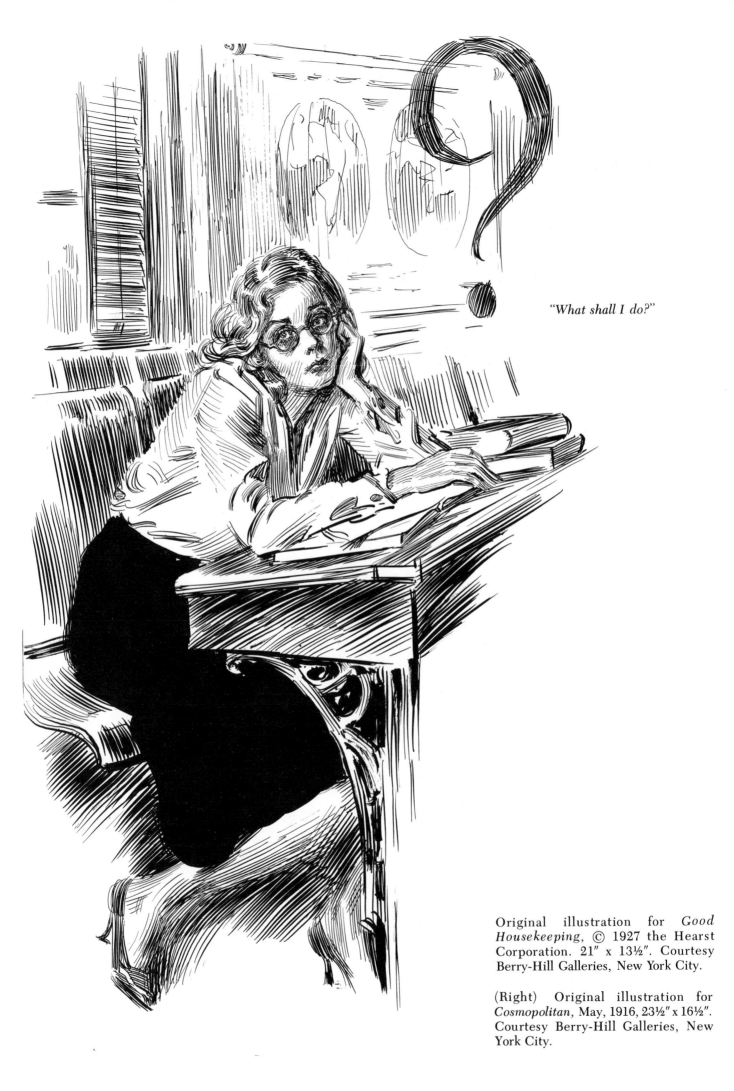

"What shall I do?"

Original illustration for *Good Housekeeping*, © 1927 the Hearst Corporation. 21″ x 13½″. Courtesy Berry-Hill Galleries, New York City.

(Right) Original illustration for *Cosmopolitan*, May, 1916, 23½″ x 16½″. Courtesy Berry-Hill Galleries, New York City.

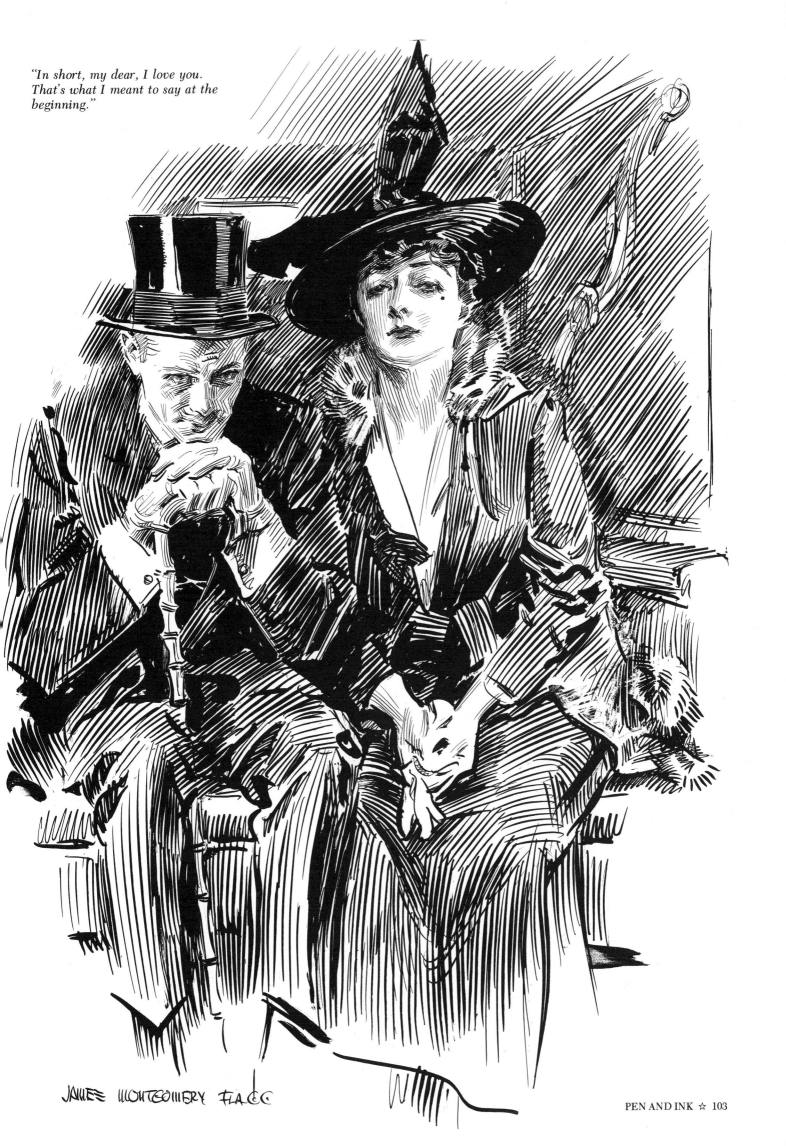

"In short, my dear, I love you. That's what I meant to say at the beginning."

JAMES MONTGOMERY FLAGG

Peaches and Cream. Illustration for *City People*, Charles Scribner's Sons, 1909.

OYSTERS EVERY STYLE

HOT MINCE PIE

PROPRIETO... IS NOT RESPONS... FOR HATS OR C... UNLESS CHECK...

JAMES MONTGOMERY FLAGG

Quick Lunch. Illustration for *City People*, Charles Scribner's Sons, 1909.

JAMES MONTGOMERY FLAGG

Original illustration for *Liberty*, 1926, 28⅞″ x 22⅞″. © 1926 by Liberty Weekly, Inc. Courtesy Everett Raymond Kinstler.

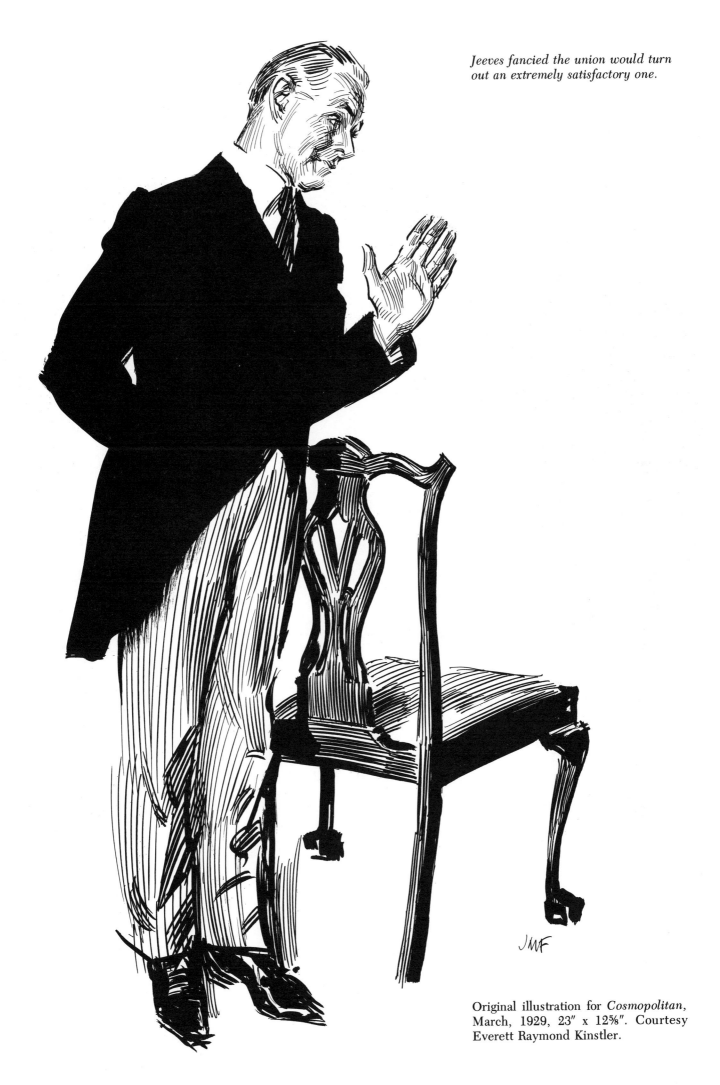

Jeeves fancied the union would turn out an extremely satisfactory one.

Original illustration for *Cosmopolitan*, March, 1929, 23″ x 12⅝″. Courtesy Everett Raymond Kinstler.

"In mourning?" Bobbie asked, eyeing the trouserings.
"Rather natty, aren't they?" I said.

Original illustration for *Cosmopolitan,* January, 1930, 23″ x 29″. Courtesy Everett Raymond Kinstler.

*"Yo-ho-ho, Jeeves! In fact, I will go further.
Yo-ho-ho, and a bottle of rum!"*

Original illustration for *Cosmopolitan*, December, 1929, 23″ x 29″. Courtesy Everett Raymond Kinstler.

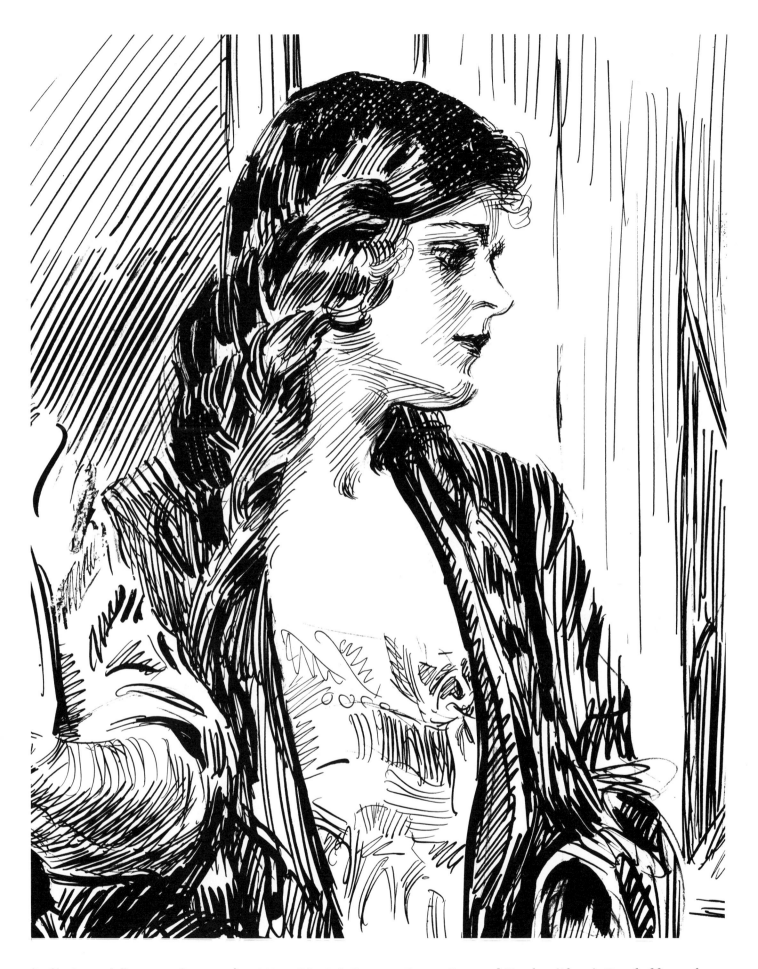

(Left) Original illustration for *Hearst's*, 1920, 28⅞″ x 23″. Courtesy Everett Raymond Kinstler. (Above) Detail of figure shown actual size. Only by examining Flagg's drawings at the scale he actually worked, can one fully appreciate the artist's prowess. Flagg used a brush in passages of his work. Here the hair has been brushed in, then scratched with a sharp instrument, breaking up the solid black and creating the textural quality of abundant hair. The robe has also been casually brushed in.

"Even if I were free."

Original illustration for *Liberty*, 1935, 23″ x 29″. © 1935 by Liberty Publishing Corp. Courtesy Everett Raymond Kinstler.

"Are you going to tell us we are in the wrong apartment again?" Sneered the Bloke. "My answer to that," said Freddie, "is yes—and no. I assure you that this lady is a complete stranger to me."

Original illustration for *Cosmopolitan*, May, 1931, 22¼″ x 28¼″. Courtesy Berry-Hill Galleries, New York City.

Selling Slogans. Original illustration for *Life*, 26¾" x 21¼". Courtesy Berry-Hill Galleries. New York City.

DETOUR TO BOSTON
DETOUR TO LYNN
DETOUR TO SALEM
AND BACK AGIN!

LITTLE BOY BLUE
COME BLOW YOUR HORN!

HI, DIDDLE DIDDLE!
ROAD-HOGS IN THE MIDDLE
YOU HAVE TO GET INTO THE DITCH
THE ROAD-HOG LAUGHED
TO SEE SUCH SPORT
AS YOU CALL HIM A PERFECT GENTLEMAN!

SING A SONG OF BOOTLEG
CASES FULL OF RYE
FOUR AND TWENTY COPS
CHASING IT ON HIGH
WHEN THE STUFF WAS OPENED
THE COPS BEGAN TO SING
"SWEET ADELINE"- "THE GLOAMING"
AND ALL THAT SORT OF THING!

JACK SPRATT COULD DRIVE TO THE LEFT
HIS WIFE COULD DRIVE TO THE RIGHT
THEY HAD TWO STEERING WHEELS PUT IN
WHICH SOLVED THE QUESTION QUITE!

LITTLE BO-CORD
HAS LOST HER FORD
AND CANT TELL WHERE
TO FIND IT -
LEAVE IT ALONE
AND IT'LL COME HOME
WAGGING ITS TAIL-LIGHT
BEHIND IT!

JAMES MONTGOMERY FLAGG

Sing a Song of Bootleg, 26¾" x 21¾". Courtesy Berry-Hill Galleries, New York City.

Science. Original illustration for *Harper's Weekly*, 1907, 17¾" x 27". Courtesy Berry-Hill Galleries, New York City.

The Drama. Illustration for *City People*, Charles Scribner's Sons, 1909.

*"God's hand was in the whole thing I wouldn't wonder!" said Mrs. Mulcahey.
'Lizbeth was surprised to see something mischievous in Grammar's look.*

Original illustration for *Cosmopolitan*, May, 1924, 15″ x 27½″. Courtesy Berry-Hill Galleries, New York City.

If Wishes Were Figures. Illustration for *City People*, Charles Scribner's Sons, 1909.

JAMES MONTGOMERY FLAGG

John Beatty, twenty-four and handsome and rich. Original illustration for *Cosmopolitan*, July, 1923, 28½″ x 22⁷/₁₆″. Courtesy Everett Raymond Kinstler.

Good Night, Sweet Prince

BY GENE FOWLER
ILLUSTRATIONS BY JAMES MONTGOMERY FLAGG

"There's no escape," Lionel told Jack. "We're in the cul-de-sac of tradition."

The hastily rehearsed Jack blew up. "Where do we go from here?" he asked.

"I AM NOT a constant reader of the calendar," John Barrymore said to his brother, Lionel, one day, "but Uncle Jack informs me that I am twenty-one years old."

"What do you propose to do about it?" asked Lionel. "Vote?"

Jack replied sadly, "It begins to look as though I'll have to succumb to the family curse, acting."

The brothers were sitting in the Cafe Boulevard, a little Hungarian restaurant on Second Avenue in New York. Lionel was properly sympathetic. "I know just how you feel." He sighed like a ferryboat. "There is no escape for us. We are in the cul-de-sac of tradition." Lionel had a drink of red wine, then asked, "Did Uncle Jack finally influence you?"

"Partly Uncle Jack, but also my stomach. It abhors a vacuum." Jack, too, had some red wine. "If I do stumble onto the stage," he said, "I'll not be any good. Then I'll have to come back to painting."

Lionel smacked his lips, wiggled his brows, then said, "You'll certainly fail, unless you try. But if you try . . . you're hooked forever."

The first great bell-beat of tragedy sounded for John Barrymore just a short time later in that year of 1903. The sudden evil occurrence was the collapse of his father's once brilliant, gay mind. Maurice Barrymore, at 56, entered a private sanitarium, where he was destined to spend the last two years of his life. After he died, young Jack would sit for hours turning the pages of his father's books.

It was about the time of his father's illness that young Jack was assaying his first role. He was on the stage, yet hardly of it and had revealed little evidence of the powers locked inside himself.

His first appearance as a professional actor was for a single night when he substituted for Francis Byrne in the Philadelphia tryout of *Captain Jinks of the Horse Marines.* The hastily rehearsed Jack blew up in his lines.

His sister, Ethel, a principal in *Captain Jinks*, went into an hysterical state which Jack described "a cross between hilarity and strangulation." Her brother muffed his lines, then demanded loudly, "Where do we go from here?"

As if this were not enough, the mischievous actor took a curtain call by himself. When the play moved to New York, Jack was not in the cast. . . . **(Continued tomorrow)**

"What's happened?" Jack said. "I'm scared stiff."

The ball was for Miss Harris.

In quarrels, Jack would reenact sword-brandishing scenes.

AS A young actor, John Barrymore assumed many of the courtly mannerisms of his Uncle John Drew—and much of his wardrobe. Whenever he needed replenishments, he would borrow from Drew, his "beau ideal."

Many persons were becoming concerned over Jack's drinking and with good cause but Barrymore managed to get stage roles. He held onto parts in *Magda* and *Glad Of It* and at last, in 1909, he scored a comedy triumph in *The Fortune Hunter.*

Lionel and Kid McCoy came backstage to congratulate him. "What in hell has happened?" Jack asked.

"You'll live," Lionel prophesied.

"But I'm scared stiff," the new stage hero said. "I heard thunder in the applause. A sign of storms to come."

The celebrants stayed up in a cafe all that night.

There was a rain effect in the play and rain always exercised a sublime influence on Jack Barrymore. He loved to listen to a natural downpour, once observing, "It sounds like all the little beggars in the world tapping their canes and crutches on the roof as they go out to ask for bread."

And the stage shower, artificial as it was, became in Barrymore's fancy a symbol of his own loneliness of heart. It made him think of a fireside—and of taking a wife. One night, after changing to evening clothes, he left the theatre to find a genuine rain falling.

He called a hansom cab and went to a ball being given for Katherine Corri Harris, a taffy-haired beauty of the social register. A few months later, the 19-year-old beauty married the 28-year-old victim of the rain.

But there was little happiness in the match. Though the inexperienced girl tried hard not to quarrel with Barrymore, they quarreled frequently. Perhaps the bottle was the cause. Jack merely explained, "Unhappiness increased the drink, and drink increased the unhappiness."

In the spring of 1914, when he was 32, Jack undertook a Byronic flight to Italy. He was still married to Katherine. Not even intimates knew whether marriage or uninspired roles provoked the journey.

Whatever the cause of the hegira, its effect upon Barrymore and the theatre as well, would eventually be expressed in terms of meteors. In travels about Italy with young playwright Edward Sheldon, Jack readied himself for dramatic heights. . . .

(Continued tomorrow)

"What have you done to me?" Jack shouted.

At "L'amour," ladies swooned.

He hurled the bouquet into the audience. It struck a woman.

DETERMINED to fix his attention on the more serious aspects of the drama, John Barrymore returned from Italy early in the summer of 1914 He soon triumphed in *Justice*, playing the part of William Falder, a tragedy-marked bank clerk.

The amazement of critics at the actor's sudden "size" is understandable. It was as if "Honey Boy" Evans had put off his burnt cork to sing Faust at the Metropolitan.

Paradoxically, while Jack was preparing for his first romantic role, his wife was obtaining a divorce. The play, Peter Ibbetson, went on, however, with the lovely Constance Collier as Jack's leading lady.

Barrymore had misgivings about both lyrical words and an auburn wig. When he came on stage, there was a gasp from ladies in the audience. Convinced that he looked like a "pink marshmallow," Jack tore off the wig when he retired to the wings and hurled it at Miss Collier.

"What have you done to me?" he shouted. "Never before have I been booed on the stage!"

The actress painstakingly convinced Jack that the great "Oh!" was an exclamation of wonderment from the ladies compelled to gasp at his beauty.

The explanation pleased the virile Barrymore even less. He had no patience with the host of feminine admirers, which later occasioned an ominous moment.

It was at the end of the first act. At this point, Peter (Jack) picked up the Duchess of Towers' bouquet. He pressed the flowers to his lips and murmured "L'amour." It sent the ladies into near swoons.

On this particular evening, some girl in the gallery, hysterical with delight, giggled. Jack called out: "Damn it! If you think you can play this better than I can, come on down and do it."

He hurled the bouquet into the audience. It struck a woman in the face. The curtain fell. Barrymore stomped off-stage to his dressing-room to lock himself inside it.

Sounds of outrage came from the audience. The actors stood as if paralyzed. The manager of the theatre, purple and blowing, charged round from the pass-door.

"I'll bring a damage suit," he shouted. Miss Collier calmed him and asked that the curtain rise for the second act. He said the audience would throw things. "They're waiting. Go ahead, but if you're killed, don't say I didn't tell you." Then the curtain rose amid deadly silence. . . .

(Continued tomorrow)

Jack received the wildest sort of applause . . .

At his studio, he was childishly content.

Later, he quarreled with his beloved . . .

AS IF ready to exercise some terrible judgment, the audience waited for Jack Barrymore to reappear after hurling the bouquet. The cast was terrified.

The moment arrived, and Jack arrived with the moment. He entered with profound self-assurance. He was casual. And now the presence that mysteriously was his on any stage, spread its electric influence over the whole house.

He received the wildest sort of applause. Cheers even, and the waving of women's kerchiefs. The theatre manager sank on his knees, either to pray or to keep from collapsing on his face. No one was sued.

But after many successful weeks, Barrymore tired of his part. That was his destiny, to tire of parts. He closed the play and in October of 1917 found sanctuary on the top floor of a century-old house off Washington Square

in New York. He transformed an attic into a studio which he called "the Alchemist's Corner."

Only one woman was admitted to this startlingly decorated abode. That was the chambermaid. At her, Barrymore thundered, "Don't remove the cobwebs!" He made a garden on the roof and there was childishly content to feed the birds.

But fame—and love—would not let him hide. A repertory company was formed around him and Jack hurled himself with tempestuous sincerity into *Richard III*.

As if that were not enough, he entered upon a second courtship, the stormy results of which caused him to declare, "When archeologists discover the missing arms of Venus de Milo, they will find that she was wearing boxing-gloves."

This second romance with the lovely and talented Blanche Oelrichs, whose poetry bore the name Michael Strange, was love on the grand scale. Their fevered anxieties, unreasonable jealousies, trumped-up quarrels and giddy sufferings, all these perverse agonies of mind testified to the presence of an unendurable ecstasy.

Barrymore would leave the theatre, take the train to Atlantic City where Michael Strange was residing, quarrel with his beloved and race back to New York for the curtain.

The crash occurred. Jack was able to appear as Richard for only four weeks before he was at the point of a breakdown. The nerve-frazzled actor, remembering his father's tragic end, was truly frightened. Was he in danger of losing his own sanity . . . ?

(Continued tomorrow)

Music. Illustration for *City People*, Charles Scribner's Sons, 1909.

(Left) Original illustration for *Good Housekeeping*, 1923, 23″ x 29⅛″. © 1923 the Hearst Corporation. (Above) Detail of figure shown actual size. Flagg was uncanny in his ability to swiftly indicate form and color with a complex interweaving of strokes. Even skin tones—traditionally a difficult feat for the pen and ink draftsman—presented little difficulty to Flagg. Courtesy Everett Raymond Kinstler.

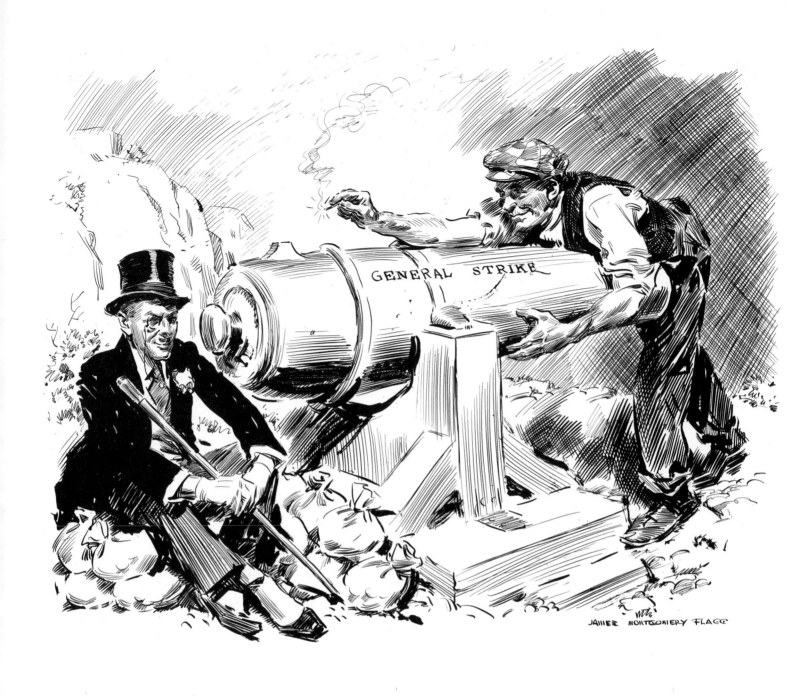

Backfire. Original illustration for *Hearst's*, 1921, 23″ x 29″. Courtesy Everett Raymond Kinstler.

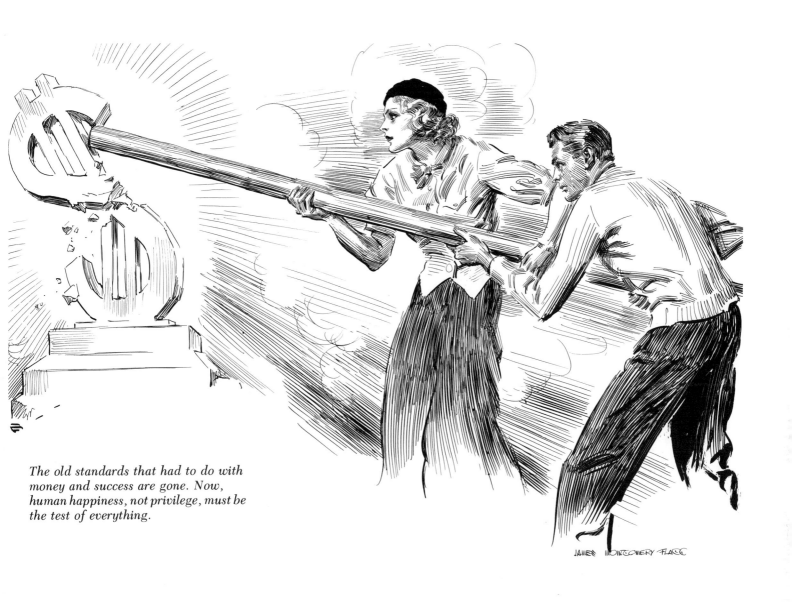

The old standards that had to do with money and success are gone. Now, human happiness, not privilege, must be the test of everything.

Original illustration for *Good Housekeeping*, June, 1933, 19″ x 28″.© 1933 the Hearst Corporation.Courtesy Berry-Hill Galleries, New York City.

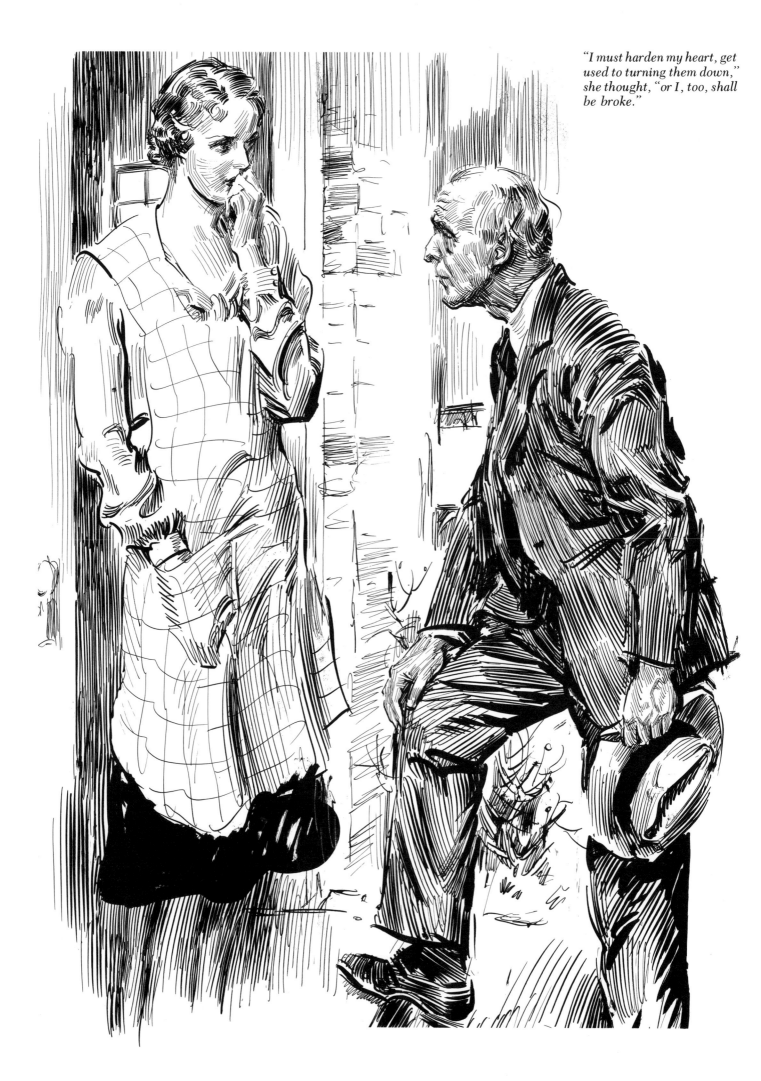

"I must harden my heart, get used to turning them down," she thought, *"or I, too, shall be broke."*

"*At each of the last two weddings at which I officiated, the bridegroom died.*"

(Left) Original illustration for *Good Housekeeping*, January, 1934, 24½″ x 17¾″. © 1934 the Hearst Corporation. Courtesy Berry-Hill Galleries, New York City.

Original illustration for *Liberty*, 20″ x 24″. Reprinted with permission Liberty Library Corp. Courtesy Everett Raymond Kinstler.

In the Monkey House, 20½″ x 27¾″. Copyright Ledger Syndicate. Courtesy Everett Raymond Kinstler.

The LADY bishopess was breathing heavily. She had the appearance of a tank which is missing on one cylinder. "Save me, Percy!" she gasped.

Original illustration for *Cosmopolitan*, May, 1930, 22″ x 34″. Courtesy Everett Raymond Kinstler.

(Overleaf) **Two Arrivals.** Original illustration for *Harper's Weekly*, March, 1907, 19½″ x 27¾″. Courtesy Berry-Hill Galleries, New York City.

Freddie ambled up to the girl like a courtly mustang,
meaning only to scatter light and sweetness on every side.

JAMES MONTGOMERY FLAGG

"Down I went and down accompanied me Miss Lura de Lura, to her great mortification."

(Left) Original illustration for *Cosmopolitan*, May, 1931, 26½" x 18¼". Courtesy Berry-Hill Galleries, New York City.

(Above) Original illustration for *Liberty*, May, 1931, 23" x 29". © 1931 by Liberty Weekly, Inc. Courtesy Everett Raymond Kinstler.

"Get out–I don't want you!"

Original illustration for *Cosmopolitan*, 1930, 22¼″ x 28″. Courtesy Berry-Hill Galleries, New York City.

"Strawberries," the girl told Freddie firmly, "and you're jolly lucky, my lad, not to be sent off after the Holy Grail or something."

Original illustration for *Cosmopolitan*, April, 1931, 21½″ x 25¾″. Courtesy Berry-Hill Galleries, New York City.

And the world moved on, forgotten.

Jane leaned swiftly toward Frank and kissed him. He heard her light footsteps as she ran up the stairs.

(Left) Original illustration for *Liberty*, 29″ x 23″. Reprinted by permission of Liberty Library Corp. Courtesy Everett Raymond Kinstler.

(Right) Original illustration for *Cosmopolitan*, December, 1927, 22″ x 11″. Courtesy Berry-Hill Galleries, New York City.

MAGAZINE

ILLUSTRATIONS

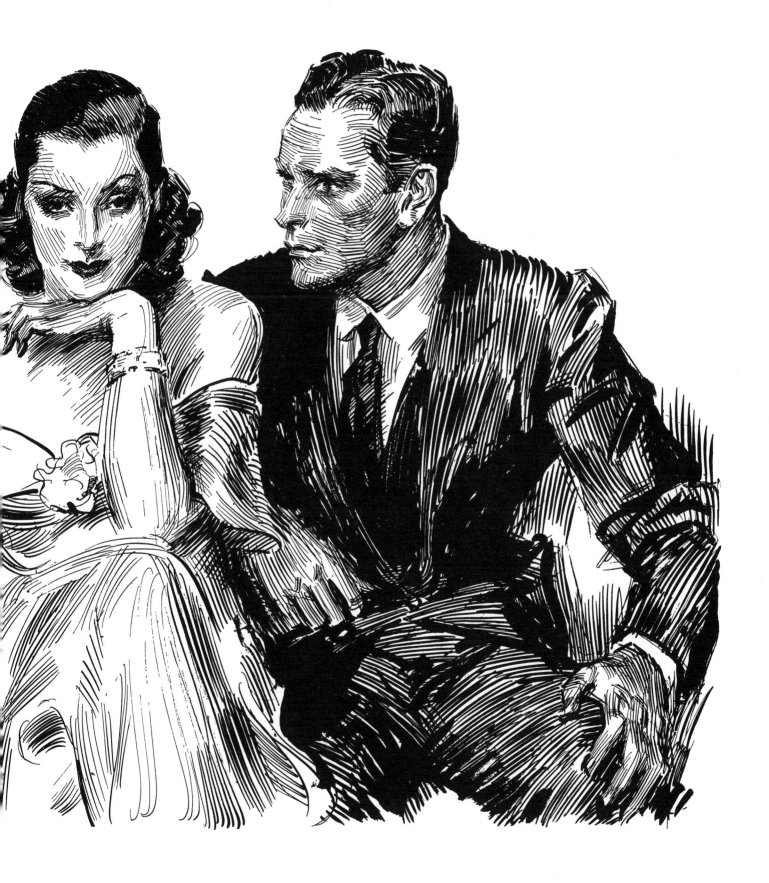

HOME, SWEET HOME

Home Sweet Home (Teddy Roosevelt Rides Again). Cover for *Life*, June 16, 1910. Courtesy Nostalgia Press, Inc.

The First Sunday. Cover for *Life*, December 8, 1910. Courtesy Nostalgia Press, Inc.

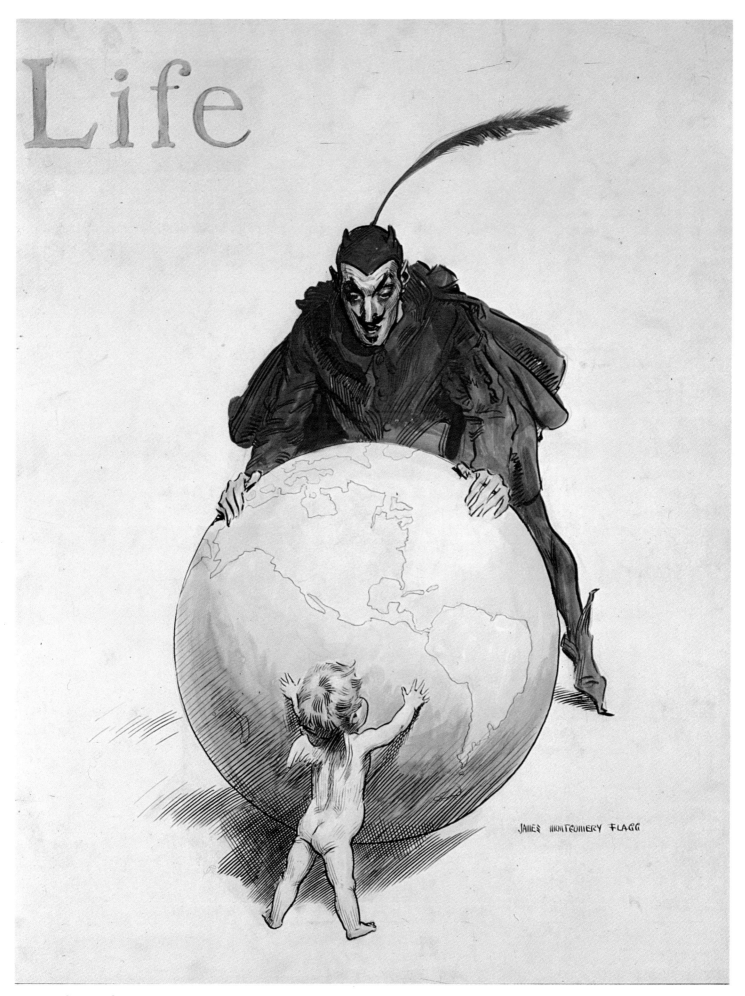

Original cover design for *Life*, 1909. 25″ x 20″. Courtesy Everett Raymond Kinstler.

Four designs for *Life* covers, ca. 1910. Courtesy Everett Raymond Kinstler.

Four designs for *Life* covers, ca. 1911. Courtesy Everett Raymond Kinstler.

"A MAN OF AFFAIRS"

JAMES MONTGOMERY FLAGG

A Man of Affairs. Illustration for *Judge,* 1913. Watercolor, 23″ x 21″. Collection Sheldon Swope Art Gallery, Terre Haute.

In Your Hat. Illustration for *Life*, watercolor on toned paper, 15″ x 19″. Collection Mr. and Mrs. Lewis B. Frumkes. Courtesy Berry-Hill Galleries, New York City.

(Overleaf) **Nervy Nat and his experience with the Mermaids while waiting the arrival of the "Half Moon."** *Judge*, ca. 1909. Courtesy Everett Raymond Kinstler.

1. *Nervy Nat*—"Shades of Anthony Comstock! What have we here? Can that be a regular girl? No, no. Perish the thought! It's a mergirl, and a deep-sea pippin at that! Me for that rocklet. Of course they won't believe this at the club."

2. *Nervy Nat*—"You speak fish[y] land was never like this. So you kn[ow] my! Yes, I know young Crawfis[h] you're a seaffragette. How interesti[ng] *Mergirl*—"Come on down. We'r[e]

4. *Merpresident of Seaffragettes*—"Ah, a convert to the cause. Do you solemnly swear to uphold mermaids' rights?"

 Nervy Nat—"No, but I'll solemnly swear a lavender streak if you don't let me out of this. Why, you lady sardines haven't a leg to stand on. You wouldn't have a chance on earth. No, take it from me, girls, you'd much better go home to your little mud-flats and make up your ocean beds and"——

5. *Nervy Nat*—"Gee! they're ju[st] G'way, now, your attentions have [] before they unchain their watch-dog[s]

NERVY NAT AND HIS EXPERIENCE WITH THE MERM[AIDS]

ly, my dear shrimp. No, indeed, 'ent to a fish-ball they gave. My, r, between you and me. You say e a mass meeting at Conger-eel Hall."

3. *Nervy Nat*—"No, let's sit up here, Doris. I get fearfully peevish under water. I can feel that arm coming out of the socket. I don't believe it was put in very securely. Now, all joking aside, let go or I may forget myself and hand you a wallop that will be heard to the chalky cliffs of Dover. Leggo, you half portion of mackerel!"

household matters as regular girls. me. I hope I can make that rock

6. *Nervy Nat*—"Next—time—I see one—of—those things sitting on—a rock—I'm going—make a noise like a—folding door and—slide away!"

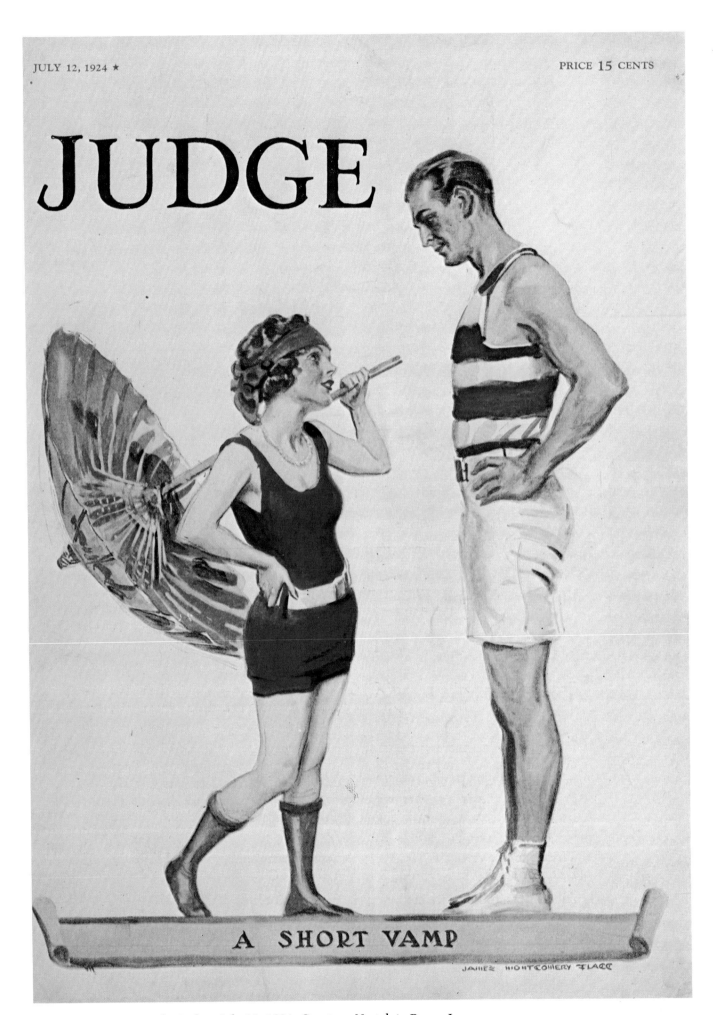

A Short Vamp. Cover for *Judge*, July 12, 1924. Courtesy Nostalgia Press, Inc.

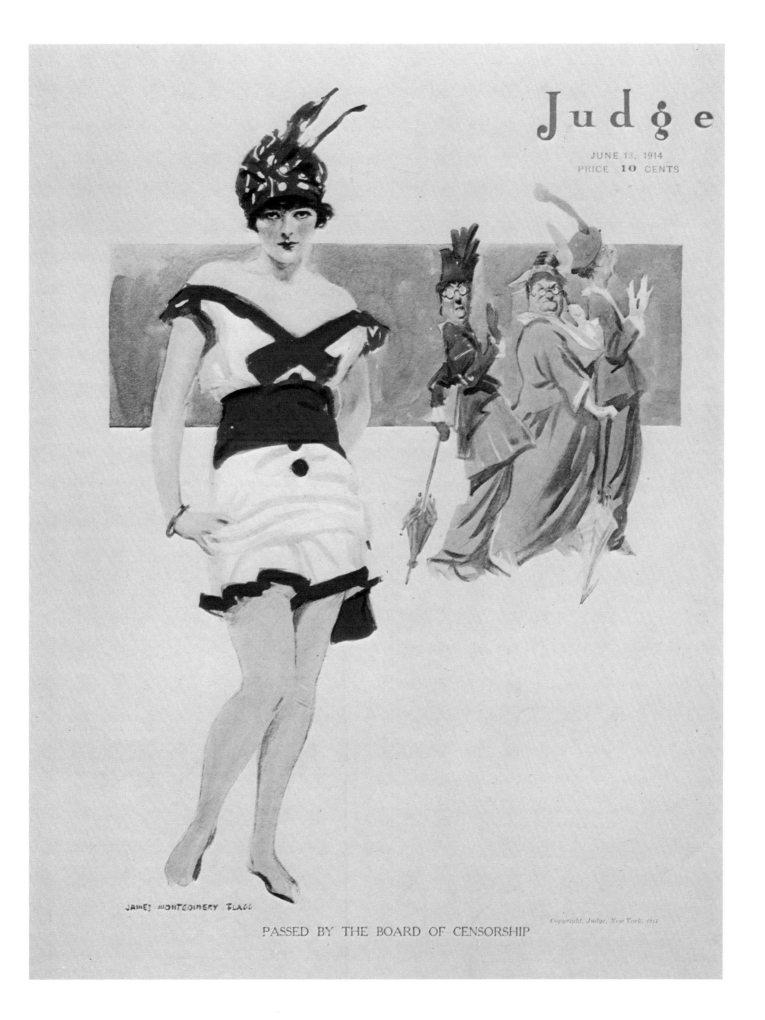

Passed by the Board of Censorship. Cover for *Judge*, June 13, 1914. Courtesy Everett Raymond Kinstler.

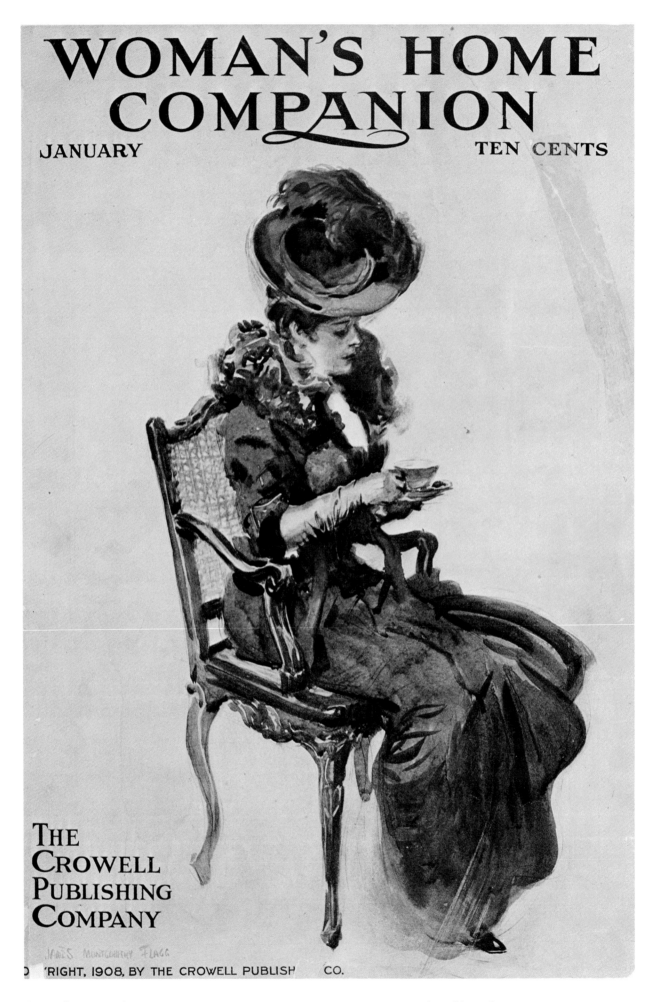

WOMAN'S HOME COMPANION

JANUARY

TEN CENTS

THE
CROWELL
PUBLISHING
COMPANY

'RIGHT, 1908, BY THE CROWELL PUBLISH CO.

Cover for *Woman's Home Companion*, January 1908. Courtesy New York Public Library.

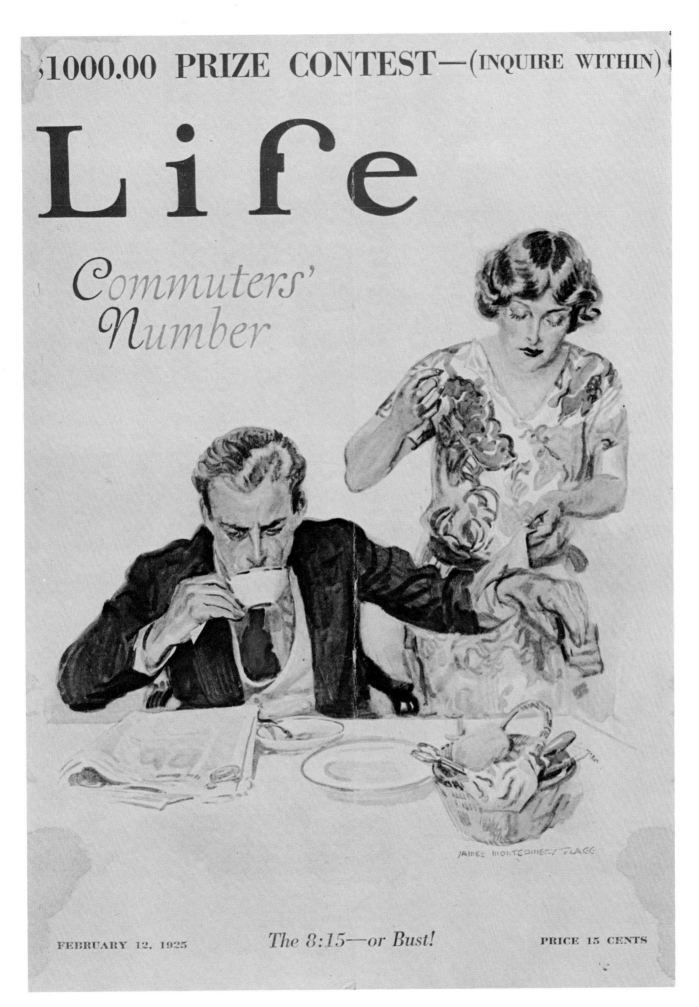

Commuter's Number. Cover for *Life*, February 12, 1925. Courtesy Nostalgia Press, Inc.

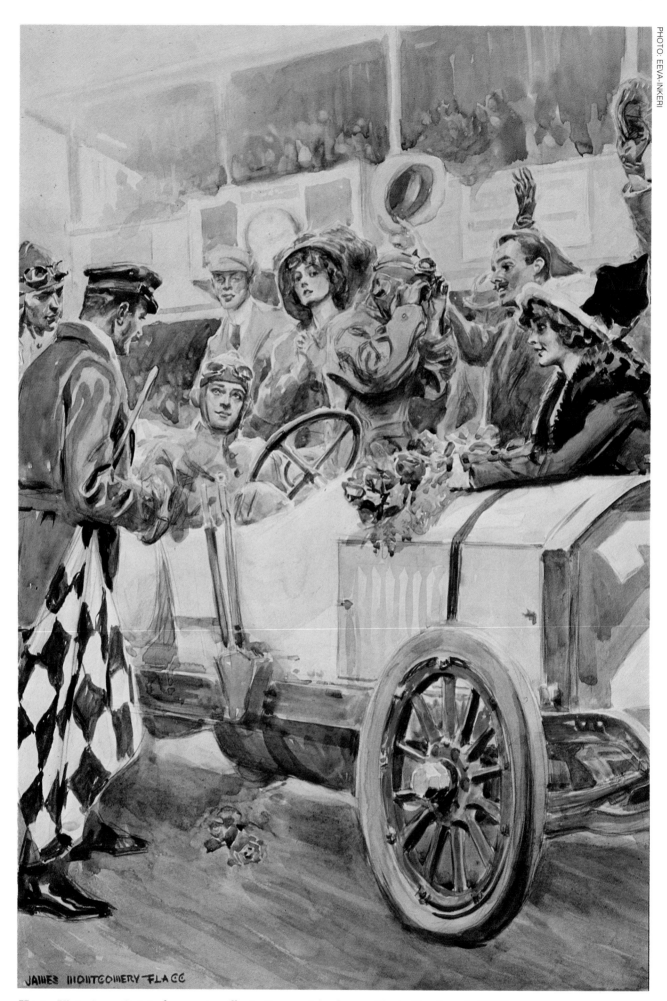

JAMES MONTGOMERY FLAGG

Home Victorious. Original magazine illustration, watercolor on illustration board, 25½″ x 17½″. Courtesy Everett Raymond Kinstler.

PHOTO: EEVA-INKERI

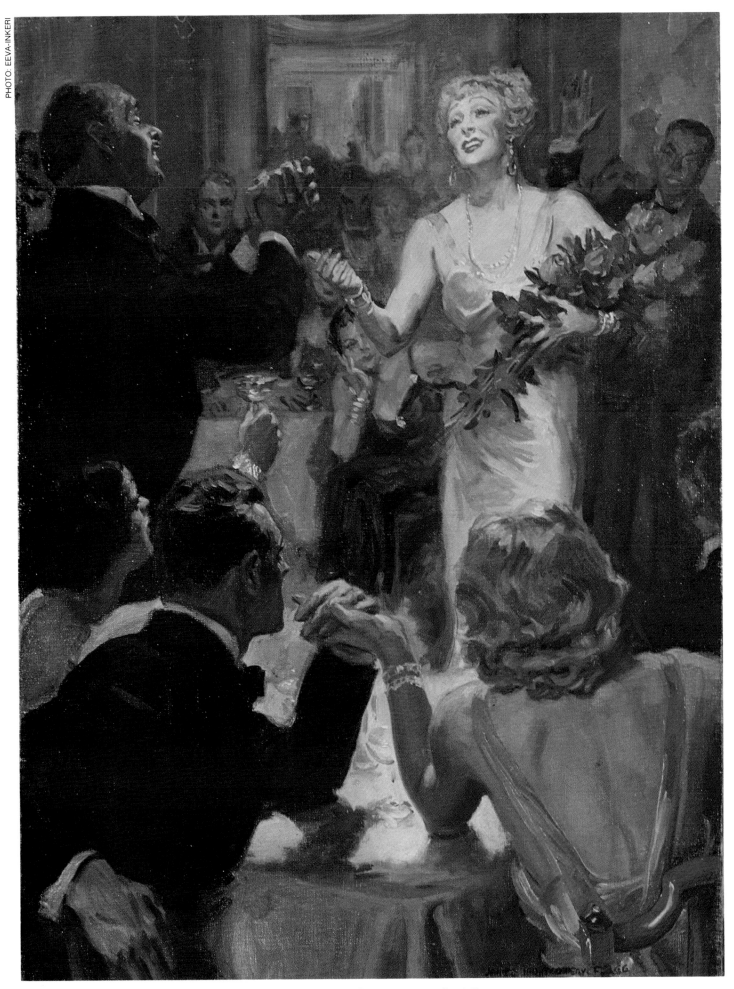

The Primadonna. Original illustration for *Cosmopolitan*, oil on canvas, 32″ x 24″.
Collection Faith Flagg. Courtesy Berry-Hill Galleries, New York City.

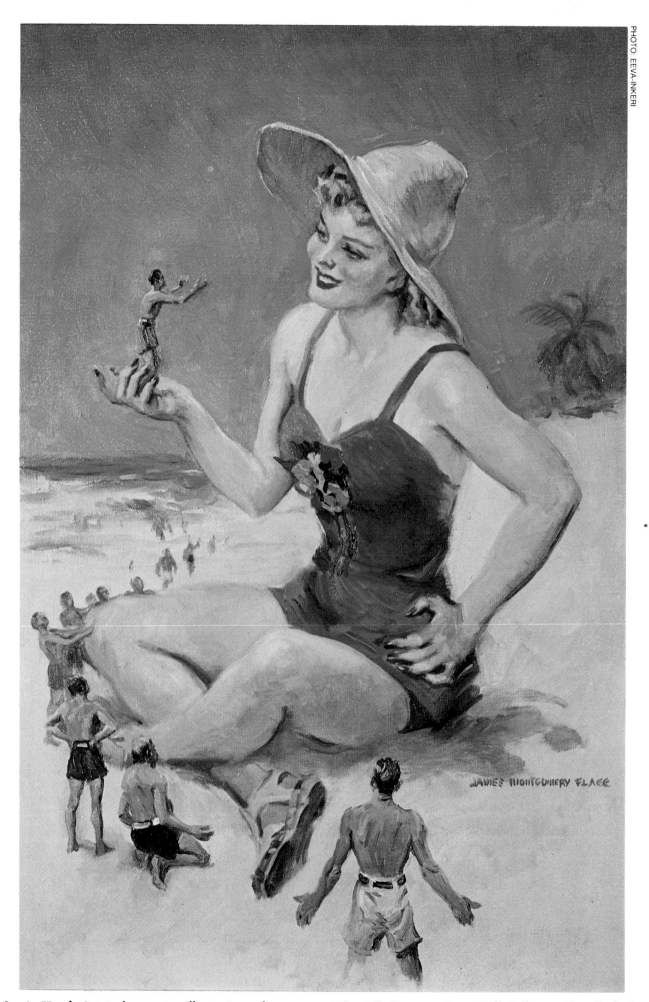

A Man in Hand. Original magazine illustration, oil on canvas, 37″ x 24″. Courtesy Berry-Hill Galleries, New York City.

Nobody saw us but the squirrel.

Original illustration for *Harper's*, 1919. Watercolor on illustration board, 29½″ x 21½″. Courtesy Everett Raymond Kinstler.

Cover for *Atlantic*, August, 1895. Collection Library of Congress.

Cover for *Atlantic*, December, 1895. Collection Library of Congress.

Cover for *The Art of Living* by Robert Grant. Charles Scribner's Sons, 1895. Collection Library of Congress.

Cover for *The Bookman*, April, 1896. Collection Library of Congress.

Original illustration for *Judge,* ca. 1923. Tempera on illustration board, 21″ x 16″. Courtesy Everett Raymond Kinstler.

Mr. Roberts draped the tie around his collar. "Isn't that handsome?" he asked. Theresa, blushing, nodded and said with satisfaction, "It's becoming." "I should say it is," Mrs. Roberts said warmly. "He's perfectly beautiful."

Original illustration for double spread, *Good Housekeeping*, July, 1934. Watercolor on illustration board, each panel 28½″ x 23″. © 1934 the Hearst Corporation. Courtesy Everett Raymond Kinstler.

Cover for *Judge*, January 23, 1915. Courtesy Everett
Raymond Kinstler.

Cover for *Judge*, August 8, 1914. Courtesy Everett
Raymond Kinstler.

Cover for *Judge*, October 3, 1914. Courtesy Everett
Raymond Kinstler.

Cover for *Judge,* March 27, 1909. Courtesy Everett
Raymond Kinstler.

Original design for *Life* cover, ca. 1910. Ink and wash on illustration board, 15″ x 12½″. Courtesy Berry-Hill Galleries, New York City.

Original design for *Life* cover, ca. 1910. Ink and wash on illustration board, 25″ x 20″. Courtesy Everett Raymond Kinstler.

Cover for *Life*, February 1, 1923. Courtesy Nostalgia Press.

Cover for *Life*, July 11, 1912. Courtesy Nostalgia Press.

"My mate!" she said. "My great, strong, wonderful mate!" Ernest did not appear to get it. "Eh?" he said, blinking. "Your what?"

Original illustration for *Redbook*, February, 1936. Watercolor on illustration board, 21¾″ x 28″. Courtesy Berry-Hill Galleries, New York City.

PHOTO: EEVA-INKERI

"*What could I do with those old letters? I looked about for something heavy, and all I could find was one of the fire-dogs. I tied it to the package and walked along the bridge. When no one was looking–plop!–I dropped it into the river. So all lies now at the bottom of the Seine.*"

Original illustration for *Good Housekeeping*, May, 1924. Watercolor on illustration board, 29″ x 23″. © 1924 the Hearst Corp. Courtesy Everett Raymond Kinstler.

"Love me?" he asked.
"Don't be a clown," she said.

Original illustration for *Liberty*, 1931. Watercolor on illustration board, 13″ x 29″. © 1931 by Liberty Publishing Corp. Courtesy Everett Raymond Kinstler.

Stu slept on the porch swing all afternoon while Jennie struggled with the first volume of The Peasants.

Original illustration for *Liberty*. Watercolor on illustration board, 23″ x 29″.Reprinted by permission of Liberty Library Corp. Courtesy Everett Raymond Kinstler.

Original illustration for *Liberty,* October 27, 1934. Watercolor on illustration board, 23″ x 29″.© 1934 by Liberty Publishing
Corp. Courtesy Everett Raymond Kinstler.

"You're fired!" screamed Cynthia. "You give me my baby!" But Miss Pembroke clutched Chubbins tighter to her breast.

Original illustration for *Cosmopolitan*, April, 1935. Watercolor on illustration board, 22″ x 29″.
Courtesy Everett Raymond Kinstler.

DRAWINGS

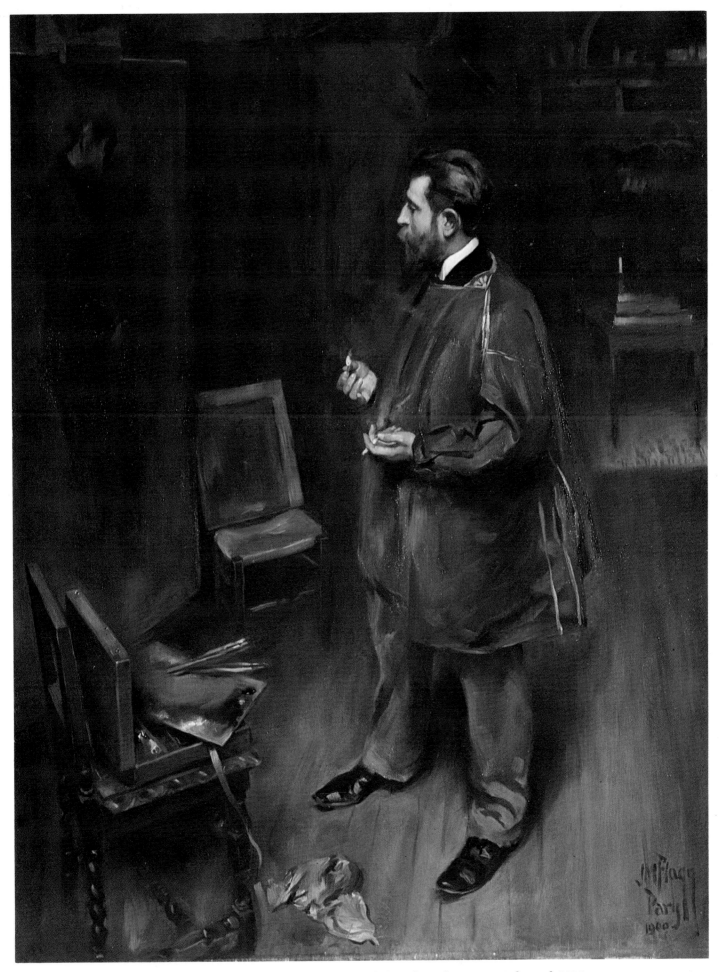

Victor Marec, Paris, 1900. Oil on canvas, 46″ x 35″. Exhibited at the Paris Salon of 1900.
Courtesy Berry-Hill Galleries, New York City.

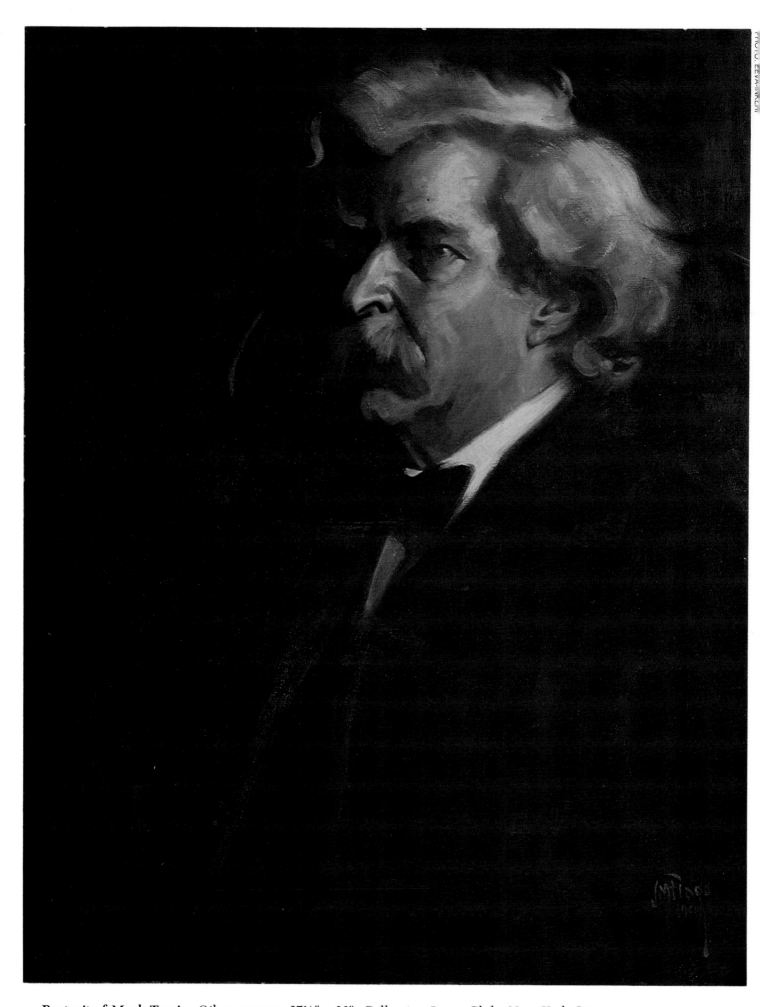

Portrait of Mark Twain. Oil on canvas, 27½″ x 22″. Collection Lotos Club, New York City.

Portrait of Booth Tarkington. Oil on canvas, 40″ x 50″. Collection Indianapolis Museum of Art, The Penrod Society and the Martha Delzell Memorial Fund.

John Barrymore as Hamlet. Oil on canvas, 43¾″ x 53″. Collection the Museum of the City of New York.

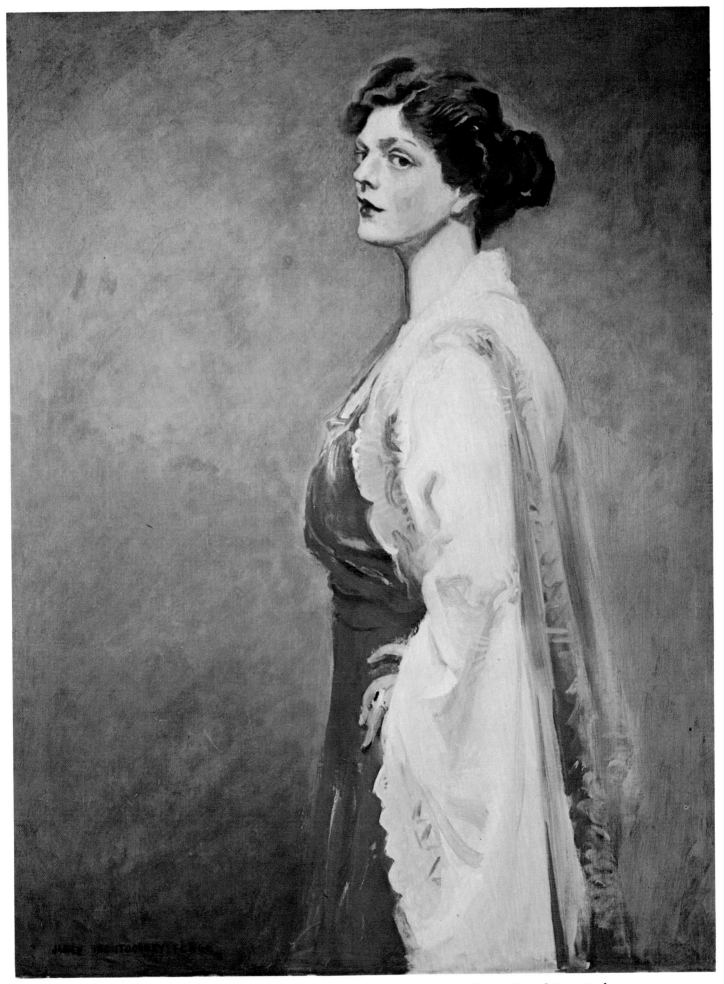

Ethel Barrymore. Oil on canvas, 48½″ x 37½″. Collection the Museum of the City of New York.

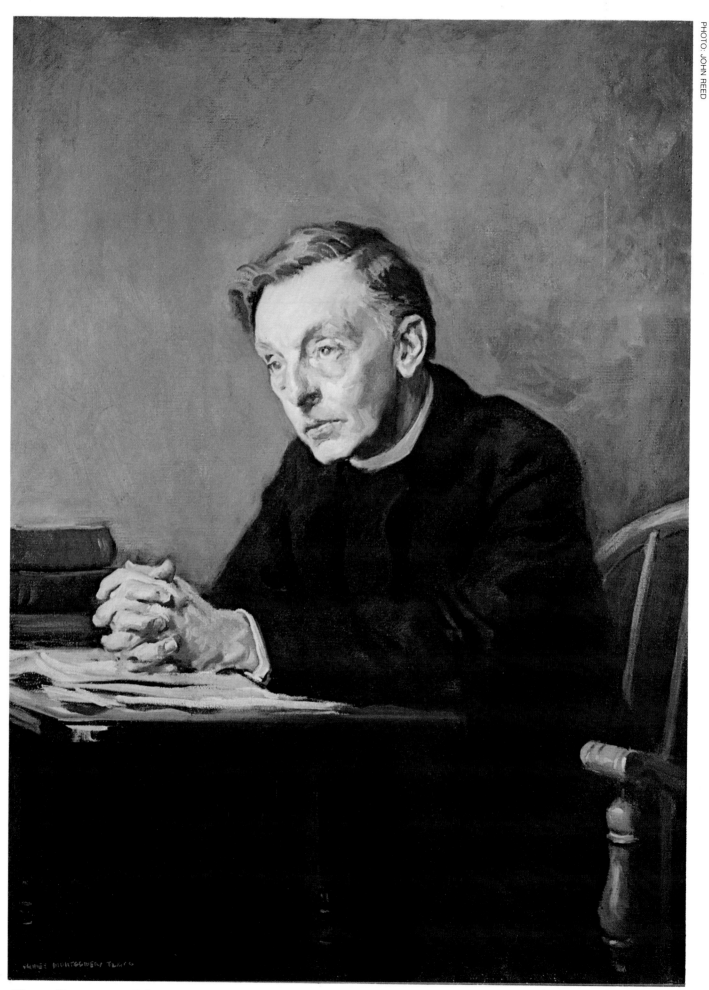

Harry Davenport. Oil on canvas, 39½″ x 29½″. Collection the Museum of the City of New York

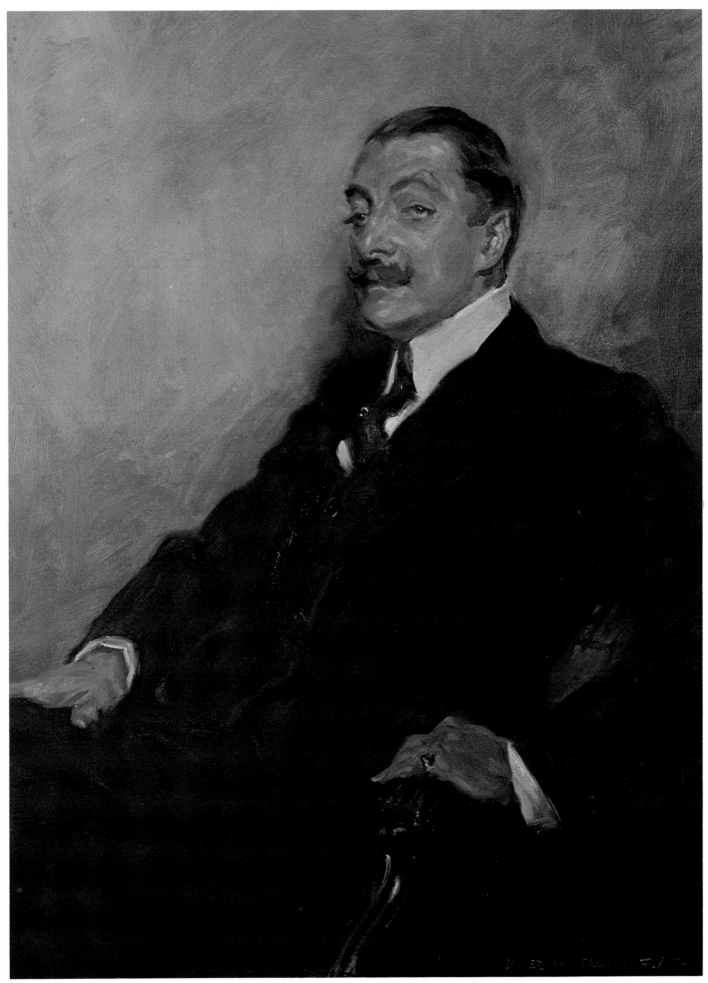

John Drew. Oil on canvas, 50″ x 40″. Collection, Guild Hall, East Hampton, New York.

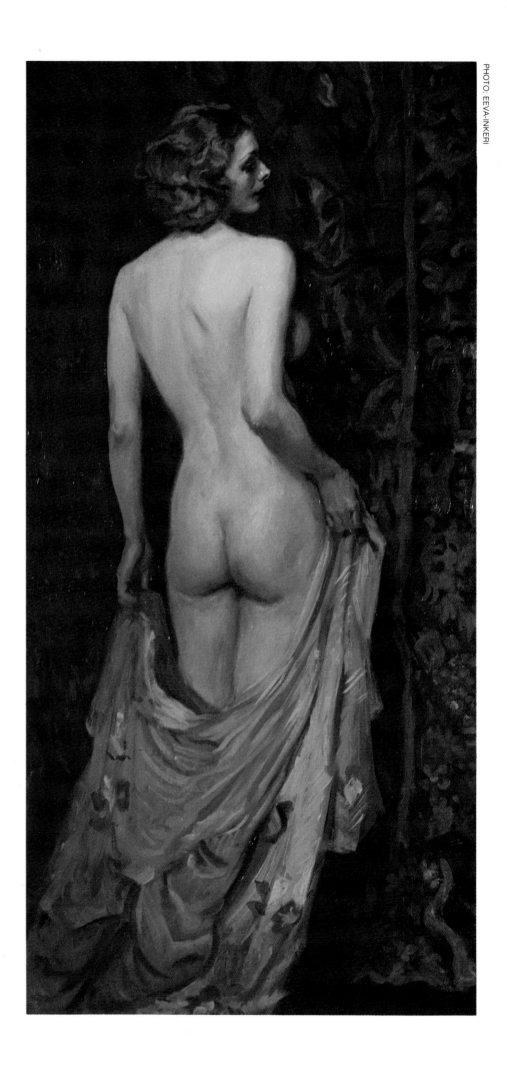

Standing Nude. Oil on canvas, 47½″ x 23½″. Collection Lotos Club, New York City.

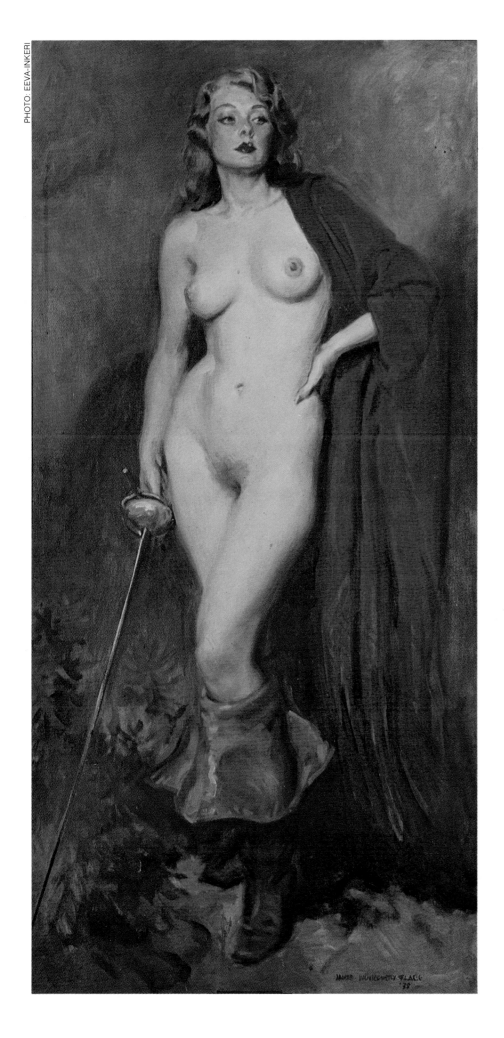

The Fencer. Oil on canvas, 47½″ x 23½″. Collection Lotos Club, New York City. Familiarly called *Puss in Boots*.

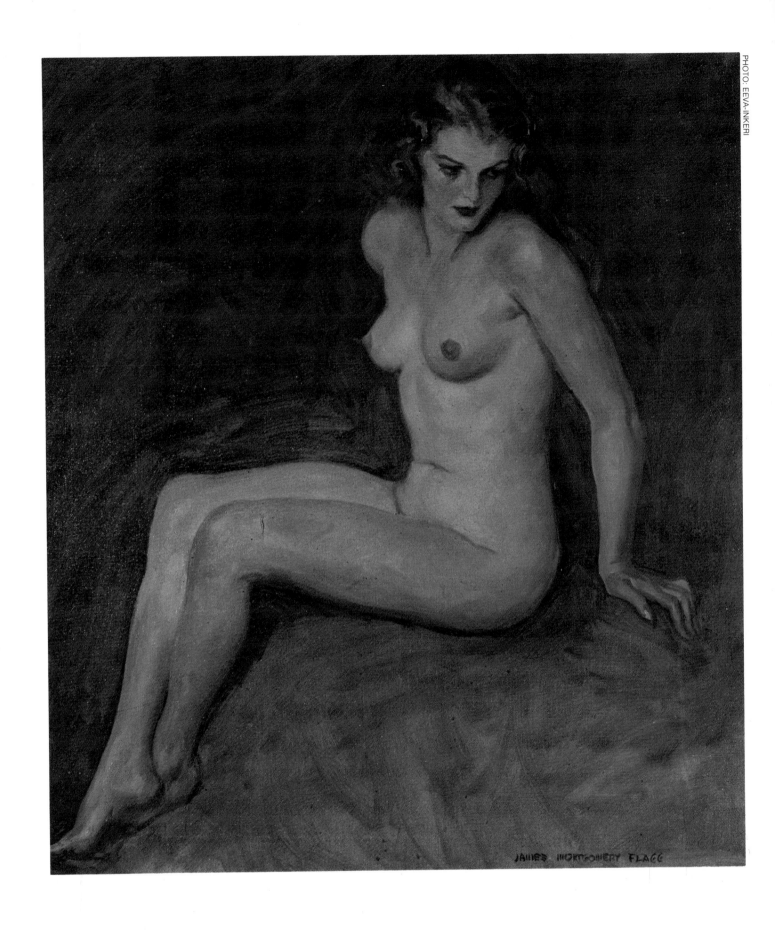

Seated Nude. Oil on canvas, 29¾″ x 26¾″. Collection Lotos Club, New York City.

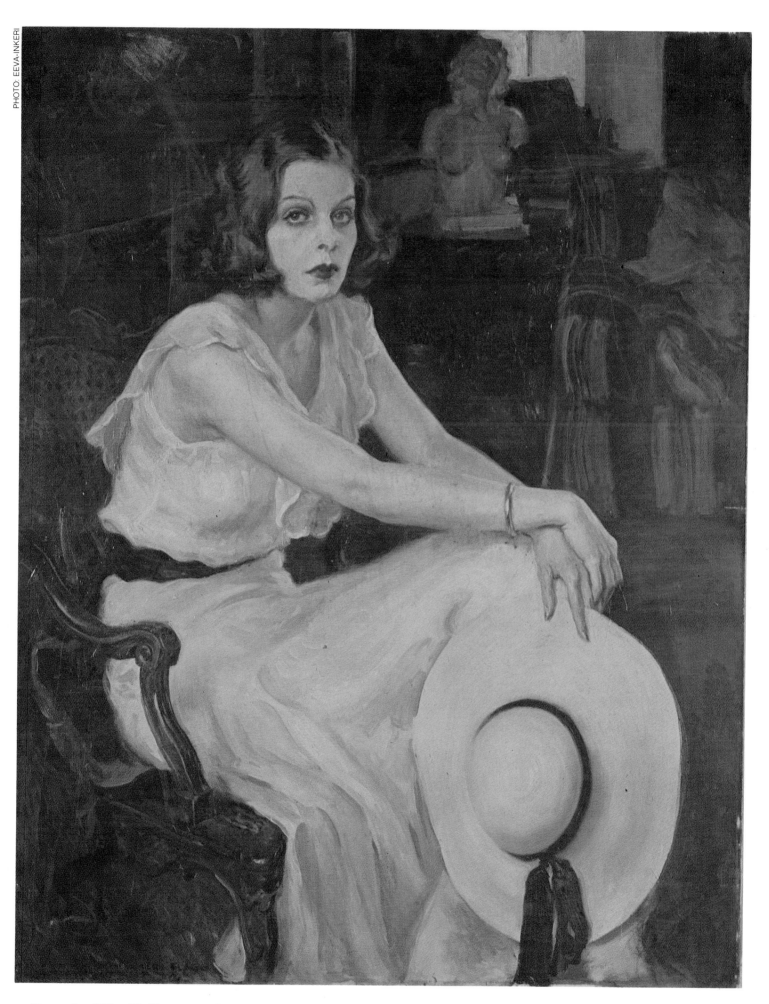

Portrait of Ilse Hoffmann. Oil on canvas, 50″ x 40″. Private collection.

Interior. Oil on canvas, 20″ x 16″. Courtesy Berry-Hill Galleries, New York City.

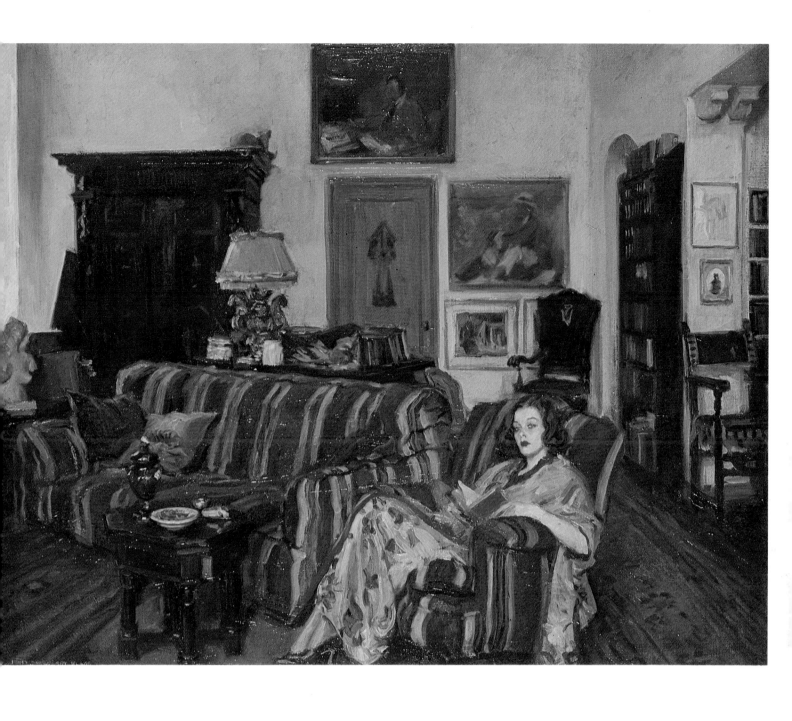

Ilse Seated in the 57th Street Studio. Oil on canvas, 1930, 27″ x 34″.
Courtesy Berry-Hill Galleries, New York City.

Summer Interior. Watercolor on illustration board, 21½″ x 30″. Courtesy Everett Raymond Kinstler.

Charleston, South Carolina. Watercolor on illustration board, 22″ x 15″.
Courtesy Everett Raymond Kinstler.

St. Paul's, London. Watercolor, 22″ x 15″. Courtesy Everett Raymond Kinstler.

Equestrian Monument. Watercolor on illustration board, 22″ x 15″ Courtesy Everett Raymond Kinstler.

James Montgomery Flagg · *Portrait of Charles Dana Gibson*

CHARLES DANA GIBSON

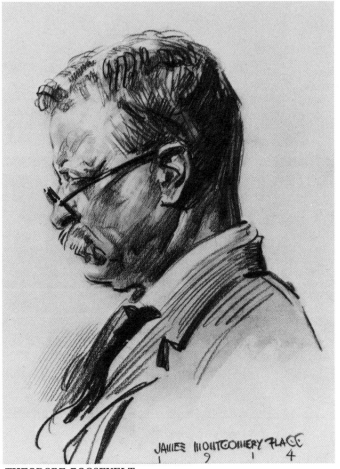

THEODORE ROOSEVELT

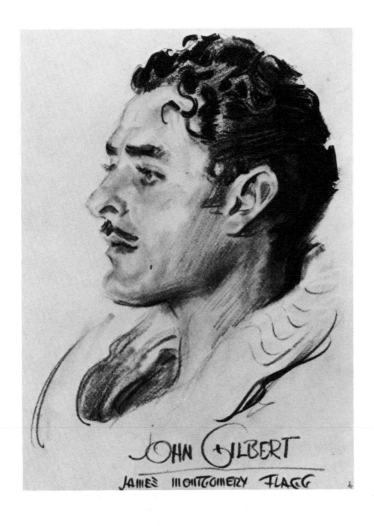

JOHN GILBERT

JAMES MONTGOMERY FLAGG

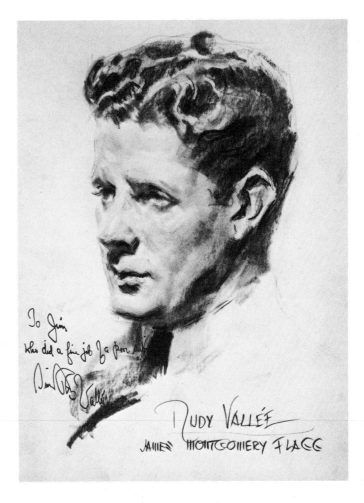

To Jim
who did a fine job for me
Rudy Vallée

RUDY VALLÉE

JAMES MONTGOMERY FLAGG

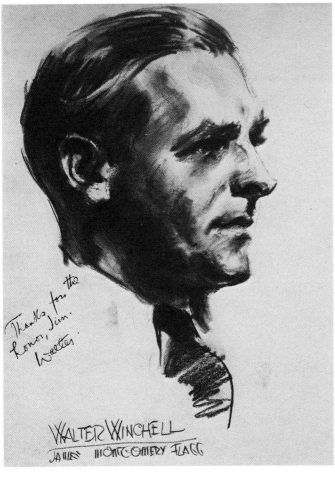

Thanks for the
honor, Jim.
Walter.

WALTER WINCHELL

JAMES MONTGOMERY FLAGG

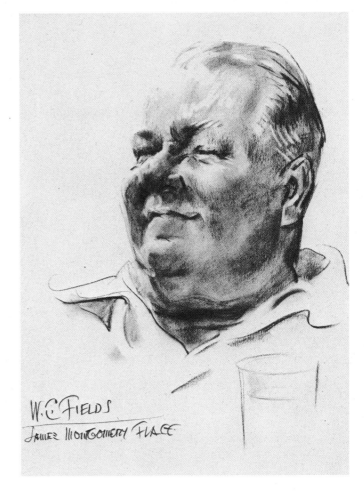

W. C. FIELDS

JAMES MONTGOMERY FLAGG

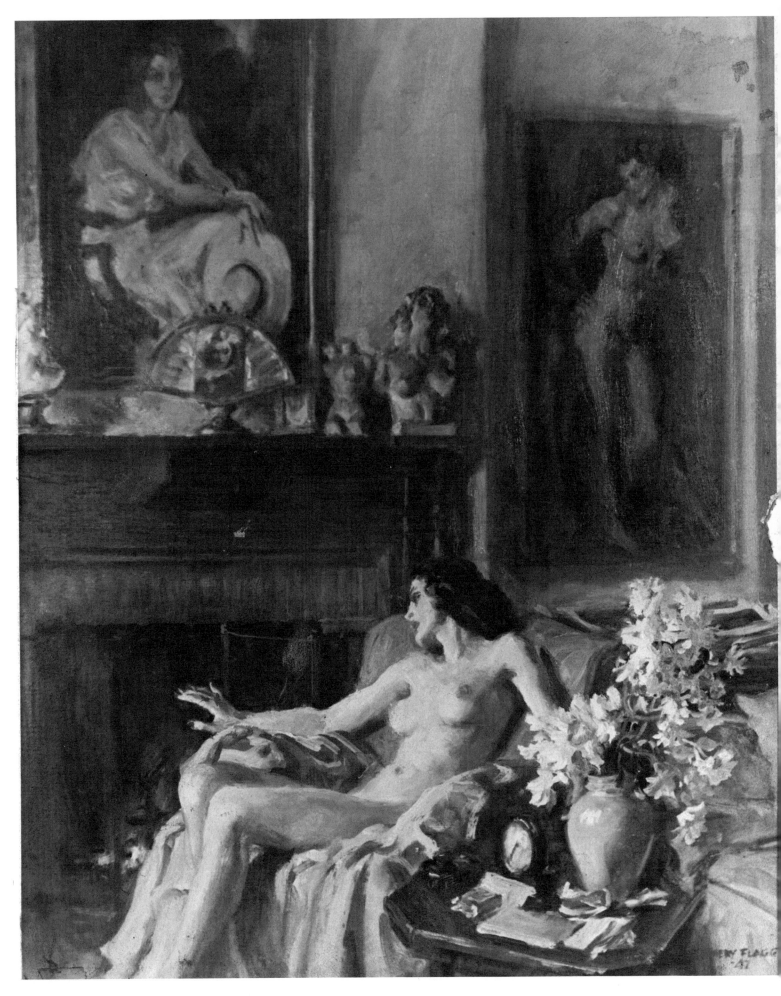

Model by the Fire, 1947, oil on canvas. Photo courtesy Everett Raymond Kinstler.

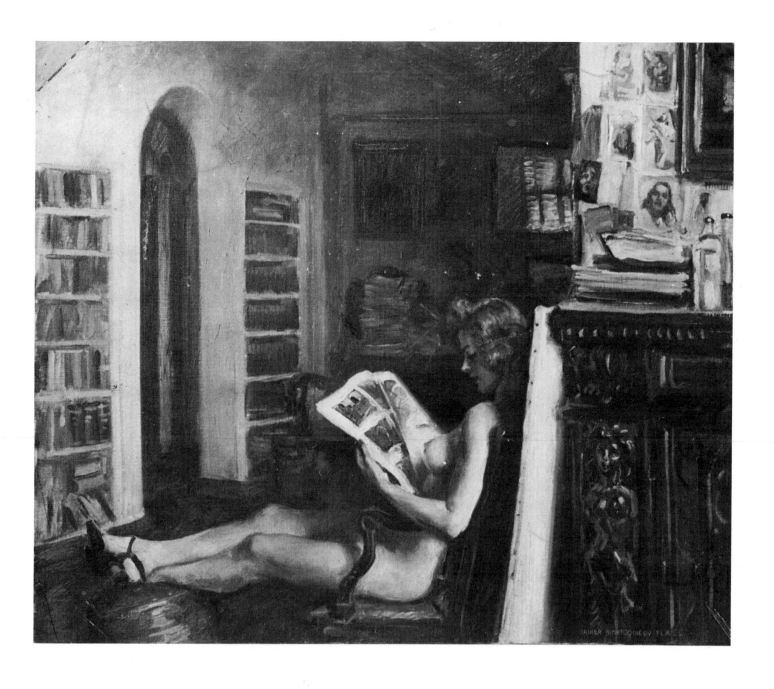

Corner in the Studio. Oil on canvas. Photo courtesy Everett Raymond Kinstler. Flagg's comment on this painting:"There is some still life in it also."

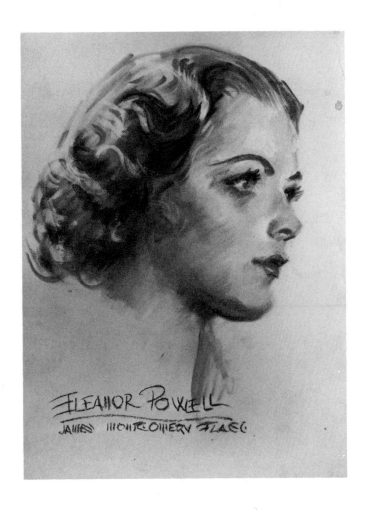

ELEANOR POWELL
JAMES MONTGOMERY FLAGG

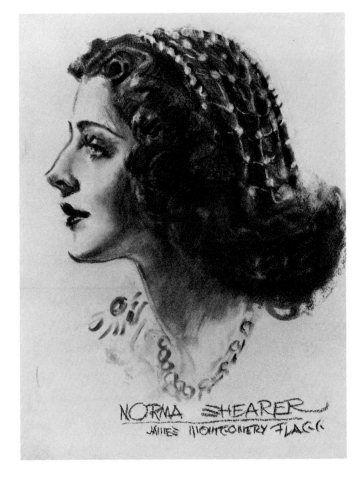

NORMA SHEARER
JAMES MONTGOMERY FLAGG

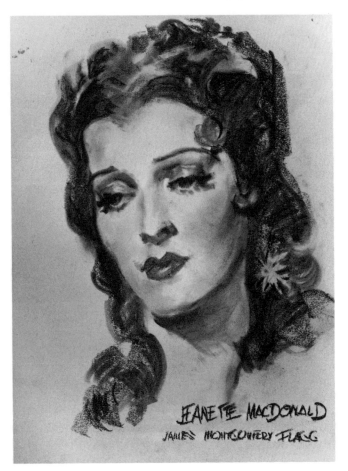

JEANETTE MACDONALD
JAMES MONTGOMERY FLAGG

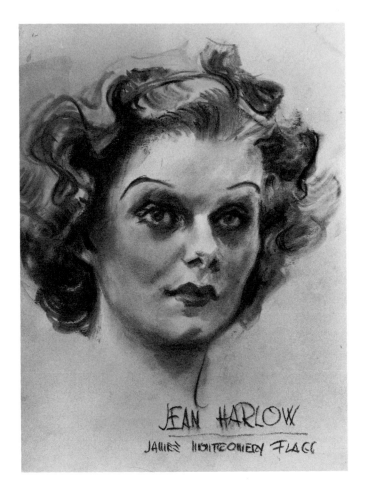

JEAN HARLOW
JAMES MONTGOMERY FLAGG

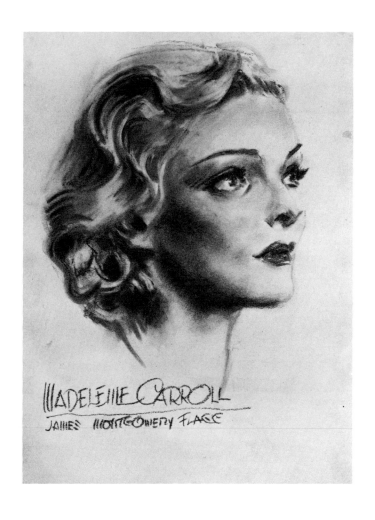

MADELEINE CARROLL

JAMES MONTGOMERY FLAGG

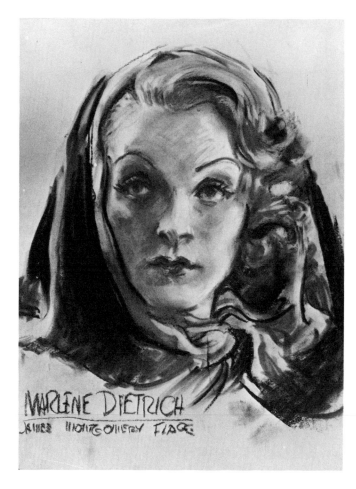

MARLENE DIETRICH

JAMES MONTGOMERY FLAGG

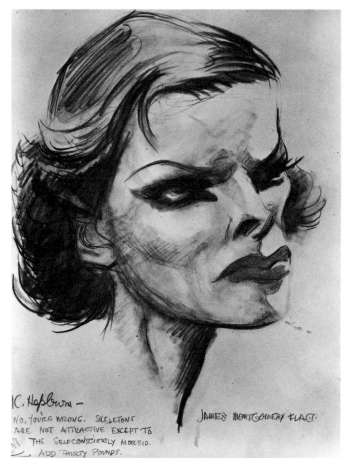

K. Hepburn —
NO, YOU'RE WRONG. SKELETONS
ARE NOT ATTRACTIVE EXCEPT TO
THE SELFCONSCIOUSLY MORBID.
ADD THIRTY POUNDS.

JAMES MONTGOMERY FLAGG

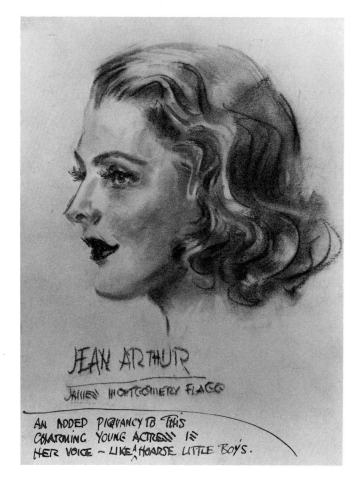

JEAN ARTHUR

JAMES MONTGOMERY FLAGG

AN ADDED PIQUANCY TO THIS
CHARMING YOUNG ACTRESS IS
HER VOICE — LIKE A HOARSE LITTLE BOY'S.

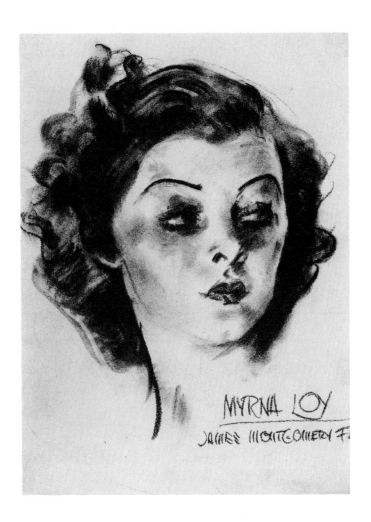

MYRNA LOY
JAMES MONTGOMERY F...

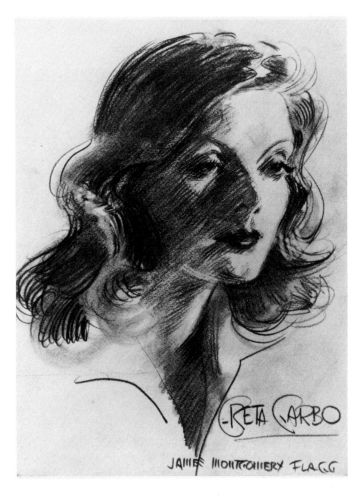

GRETA GARBO
JAMES MONTGOMERY FLAGG

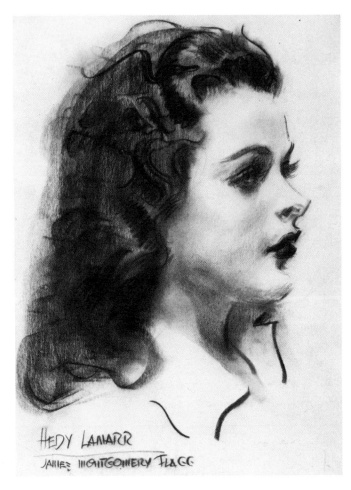

HEDY LAMARR
JAMES MONTGOMERY FLAGG

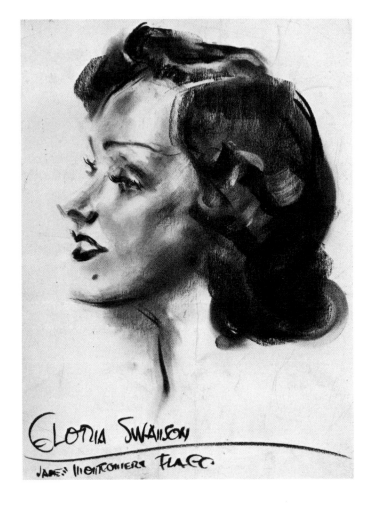

GLORIA SWANSON
JAMES MONTGOMERY FLAGG

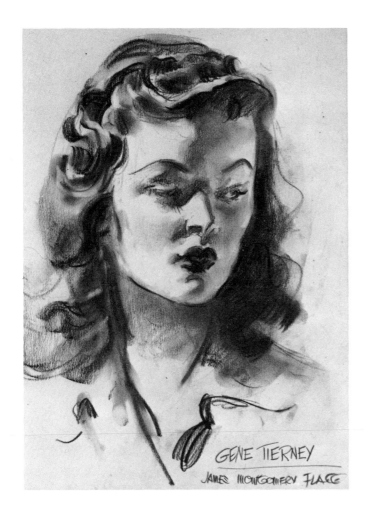

GENE TIERNEY
JAMES MONTGOMERY FLAGG

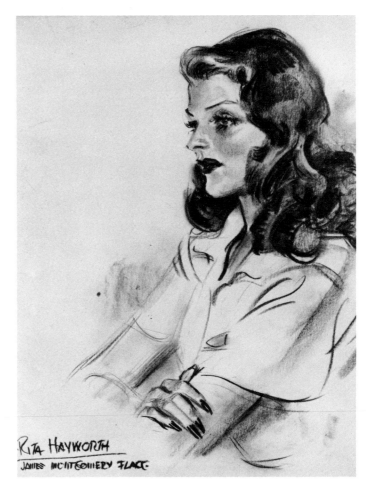

RITA HAYWORTH
JAMES MONTGOMERY FLAGG

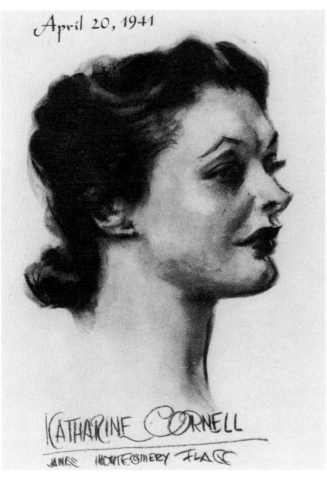

April 20, 1941

KATHARINE CORNELL
JAMES MONTGOMERY FLAGG

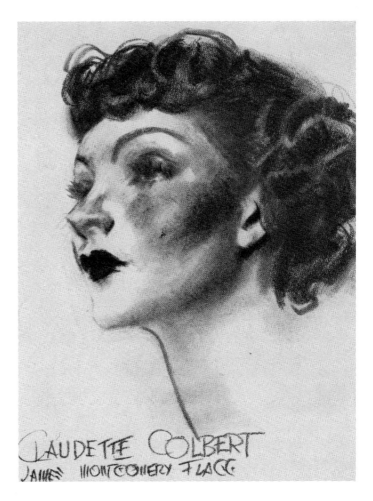

CLAUDETTE COLBERT
JAMES MONTGOMERY FLAGG

Charlie Chaplin. Watercolor and ink drawing. Collection Museum of the City of New York.

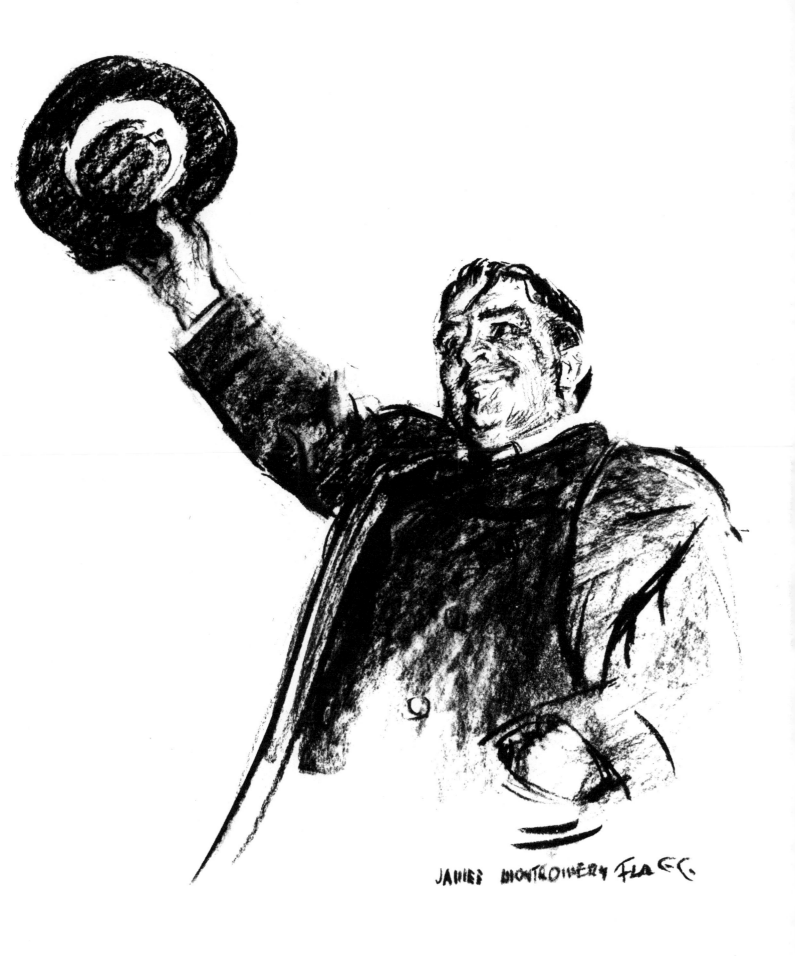

Mayor Fiorello LaGuardia. Charcoal. Collection Museum of the City of New York.

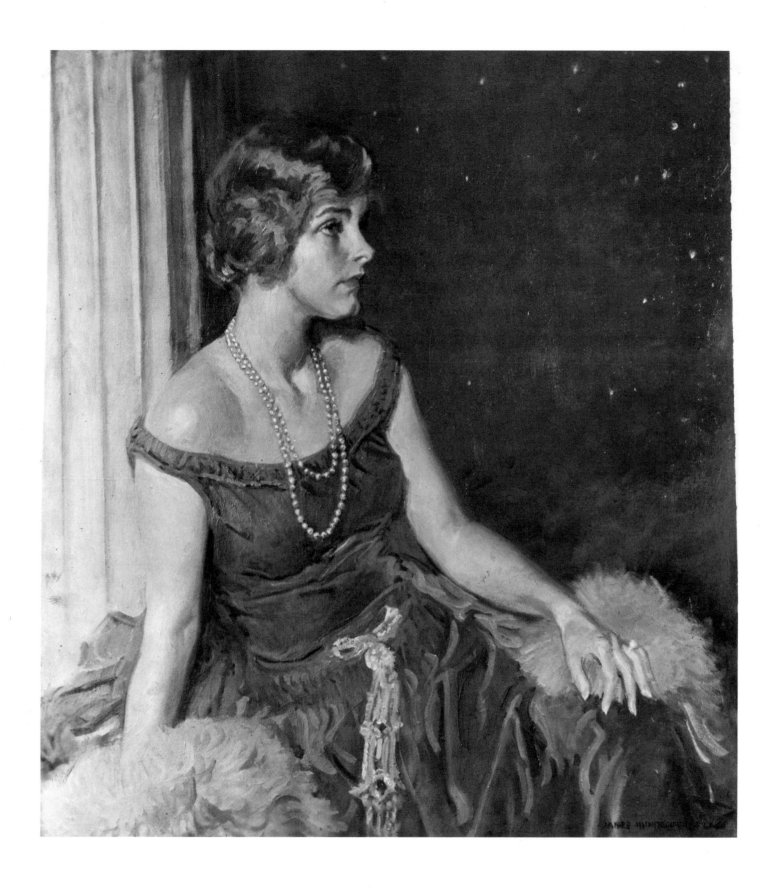

Portrait of Catharine Dale Owen. Oil on canvas. Photo courtesy Everett Raymond Kinstler. Flagg considered this actress the most beautiful in America.

Holyrod, Edinburgh. Watercolor, 15″ x 21″. Courtesy Everett Raymond Kinstler.

INDEX

Edited by Sarah Bodine
Designed by James Craig and Bob Fillie
Set in 10 point Caledonia by Gerard Associates/Graphic Arts, Inc.
Printed and bound by Rochester Polychrome Press, Inc.